# Michelangelo

Author: Eugene Müntz

Layout:
Baseline Co. Ltd
61A-63A Vo Van Tan Street
4th Floor
District 3, Ho Chi Minh City
Vietnam

ISBN: 978-1-906981-39-6

Printed in Italy

Eugene Müntz

# Michelangelo

PARKSTONE
INTERNATIONAL

Vostro michelagnolo

# Contents

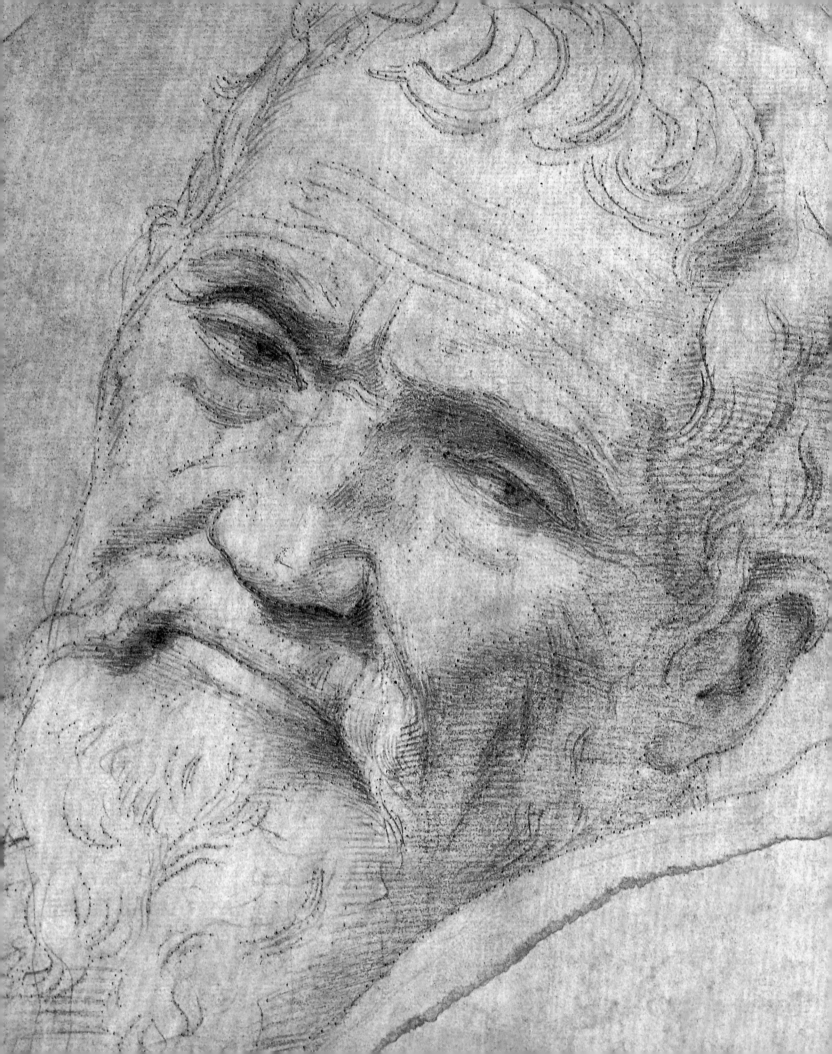

# INTRODUCTION

The Brancacci Chapel and Uffizi Gallery in Florence amply illustrate the powerful influence on Michelangelo of his fellow masters. Cimabue's *Madonna and Child Enthroned with Eight Angels and Four Prophets* and Giotto's *Ognissanti Madonna*, both at the Uffizi, as well as Masaccio's *Adam and Eve Expelled from Paradise* at the Brancacci, all feed directly into one of the most talented and famous artists of Italy's 16th century.

Up until the 14th century, artists ranked among the lower-class manual labour workers. After many years of neglect, Florence began importing Greek painters to reinvigorate painting, which had become stuck in a Byzantine style that was stiff, repetitious, and top-heavy with gold.

Born in Arezzo, Margaritone was one little-known 14th-century painter who broke away from the 'Greek style' that permeated painting and mosaics. Though a true pioneer, he is less remembered than Cimabue and Giotto. Also greatly influenced by Greek painting, Cimabue was a Florentine sculptor and painter who quickly injected brighter, more natural, and vivacious colours into his paintings. We are still a long way from Michelangelo's Sistine Chapel, but painting was now moving in its direction.

No later than the early 14th century, Giotto di Bondone had fully emancipated Florentine painting from the Byzantine tradition. A student of Cimabue, he redefined the painting of his era. Between the aforementioned works of Cimabue and Giotto, a new trend stands out in the rendering of the Virgin's face and clothing. Cimabue was breaking out of the Byzantine mould. In a later work, he would find himself influenced by one of his own students: Giotto's *Holy Virgin* has a very lifelike gaze and cradles her infant in her arms like any normal caring young mother. The other figures in the composition appear less Byzantine and wear gold more sparingly. The pleating on her garb outlines the curves of her body. These features define his contribution to a 14th-century revolution in Florentine art. His skills as a portrait and landscape artist served him well when he later became chief architect of the Opera del Duomo in Florence, the bell tower of which he started in the Florentine Gothic style. Like Michelangelo after him, he was a man of many talents. The 14th century proved most dynamic and Giotto's style spread wide and far thanks to Bernardo Daddi, Taddeo Gaddi, Andrea di Cione (known as Orcagna), and other heirs.

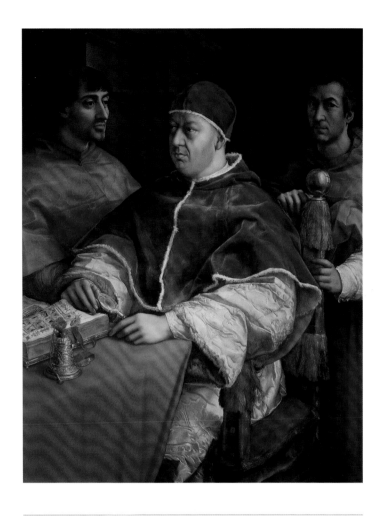

**Daniele Ricciarelli da Volterra,**
*Portrait of Michelangelo*, c. 1533. (opposite)
Black chalk.
Teylers Museum, Haarlem.

**Raphael,** *Portrait of Leo X with Cardinals Giulio de' Medici and Luigi de' Rossi*, c. 1517. (above)
Oil on wood, 154 x 119 cm.
Galleria degli Uffizi, Florence.

**Cimabue,** *Santa Trinita Madonna*, c. 1260-1280. (p. 8)
Tempera on panel, 385 x 223 cm.
Galleria degli Uffizi, Florence.

**Giotto di Bondone,** *Maestà (Ognissanti Madonna)*, 1305-1310. (p. 9)
Tempera on wood, 325 x 204 cm.
Galleria degli Uffizi, Florence.

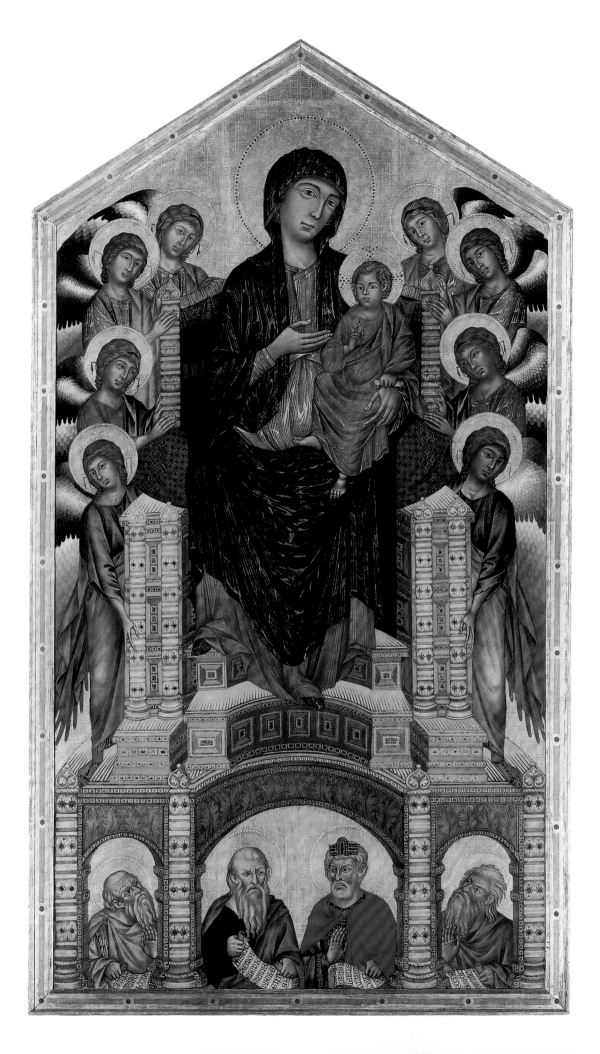

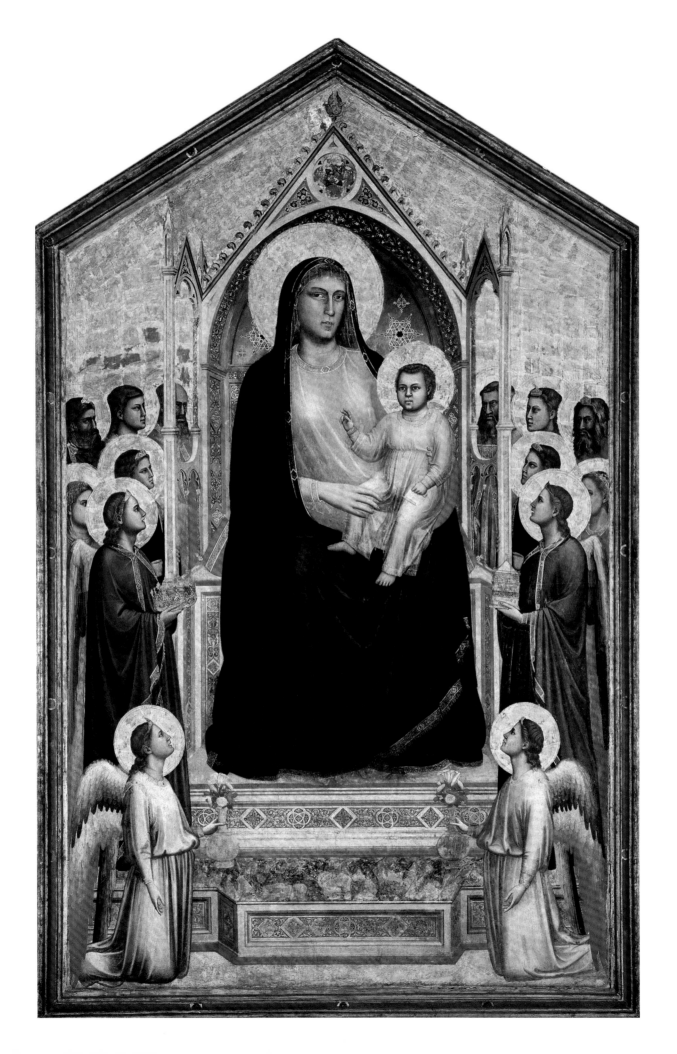

9

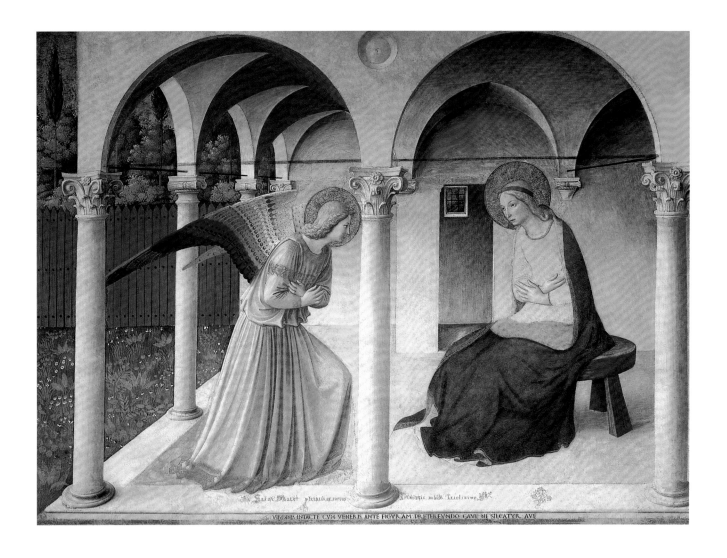

Next came a period of International Gothic influence in the 15th century, just as Masaccio erupted into the Florentine art scene with his rich intricacies of style. His impact on Michelangelo would be dramatic. Masaccio's actual name was Tommaso di Giovanni Cassi; born in 1401, he died after only twenty-seven hyperactive years. He was among the first to be called by his given name, a sure sign of the new, higher social status for artists. Two of his noteworthy works include *Trinity* at the Santa Maria Novella and *Expulsion from Paradise* in the Brancacci Chapel. This leading revolutionary of Italian Renaissance art upset all the existing rules. Influenced by Giotto, Brunelleschi's new architectural attitude to perspective, Donatello's sculpture, along with other friends or cohorts, Masaccio added perspective into his frescoes alongside those of Brancacci, populated with figures so lifelike the eye almost senses their movements. Masaccio steers attention towards exactly what he wants you to notice, leaving viewers no leeway for apathy. *Expulsion from Paradise* is easily his masterpiece: hunched over with sin and guilt, the two figures radiate pure shame and

suffering. It is distinctly more terrifying than Masolino's treatment of the same theme opposite it. Late 20th-century restoration work on the chapel abolished the fig leaves, bringing all genitalia back into full view: this was the first nude painting in history and Masaccio was now contributing art that was far removed from anything Byzantine. His painting was so original that Fra Angelico, Leonardo da Vinci, Raphael, Caravaggio, Ingrès, and even Michelangelo himself all went out of their way to see it. Whatever direction their works took, each owed his debt to Masaccio.

Masaccio's legacy is vast. Fra Giovanni da Fiesole (known as Fra Angelico) was deeply influenced by him, though many years his senior. This pious and humble Dominican friar completed lovely frescoes for the cloisters and cells of the San Marco Convent, including the *Annunciation*. Then came Domenico Veneziano, who ripened Fra Angelico's style into the full firm substance and refinement specific to Florentine Renaissance art. In the mid-15th century, humanist philosophy turned its back on the Middle Ages and reached out to Antiquity for inspiration. Meanwhile, art was

looking to its Greco-Roman heritage as it, too, shunned all things medieval. Yet the term 'Renaissance' was only invented in the 19th century when Jules Michelet published his *History of the Renaissance* in 1855.

Before going any further, we should review the different stages of the Renaissance. It is generally agreed that an initial 'Primitive' Renaissance spanned 1400 to 1480, followed by the 'Golden Age' from 1480 to between 1520 and 1530, closing with the Late Renaissance covering 1530 to 1600. Long considered decadent, this last period is only the logical end of a movement that dominated the 15th and early 16th centuries. Michelangelo started in the Golden Age and continued into the Late Renaissance when Mannerism came to the fore. By the mid-15th century, Plato's works had reached Florence and, with leveraging from the printing press, Marsilio Ficino helped spread the humanist view that placed man at the centre of the universe throughout Europe. The new focus on Antiquity stimulated painting, sculpture, and architecture, but by building on it rather than just borrowing. Florence was the cradle of the Italian Renaissance and from there it spread to Rome in ways we shall see.

The Renaissance was characterised by refinement in literature as much as art. Filippo Lippi and Benozzo Gozzoli are but two protégés of the Medici. Lorenzo de' Medici (known as Il Magnifico) stood out as the patron of numerous artists but other prominent families followed his example. One such beneficiary was Leonardo da Vinci, who studied in the workshop of Andrea del Verrocchio, only to quickly surpass his mentor and drive him to despair. Da Vinci and Michelangelo went so far as to creatively emulate each other on occasion.

This was also the era of Sandro Botticelli's *Spring* and *Birth of Venus.* If Botticelli's strength lay in rendering the beauty, balance, grace, and harmony that typified 15th-century Florence, Michelangelo's focus lay entirely elsewhere. After Masolino and

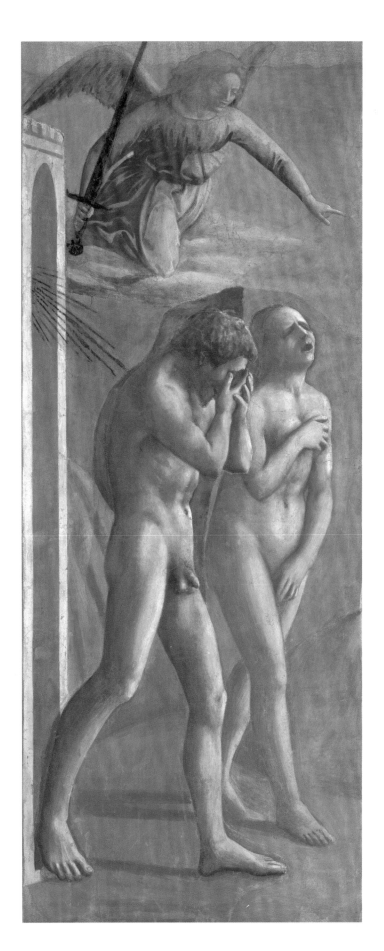

**Fra Angelico**, *The Annunciation* (landing of the second floor), 1450.
Fresco, 230 x 321 cm. (opposite)
Convento di San Marco, Florence.

**Masaccio**, *Expulsion from Paradise*. Fresco.
Brancacci Chapel, Santa Maria del Carmine, in Florence.

**Botticelli**, *Primavera*, c. 1482-1485. (pp. 12-13)
Tempera on wood, 207 x 319 cm.
Galleria degli Uffizi, Florence.

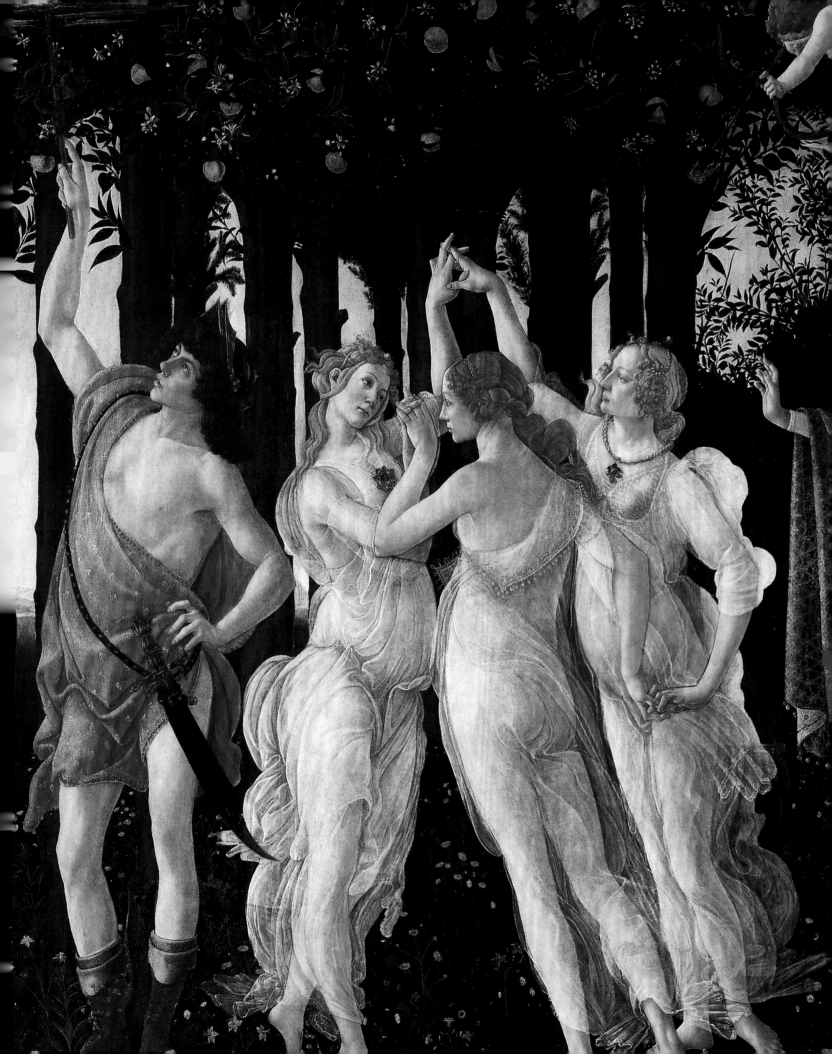

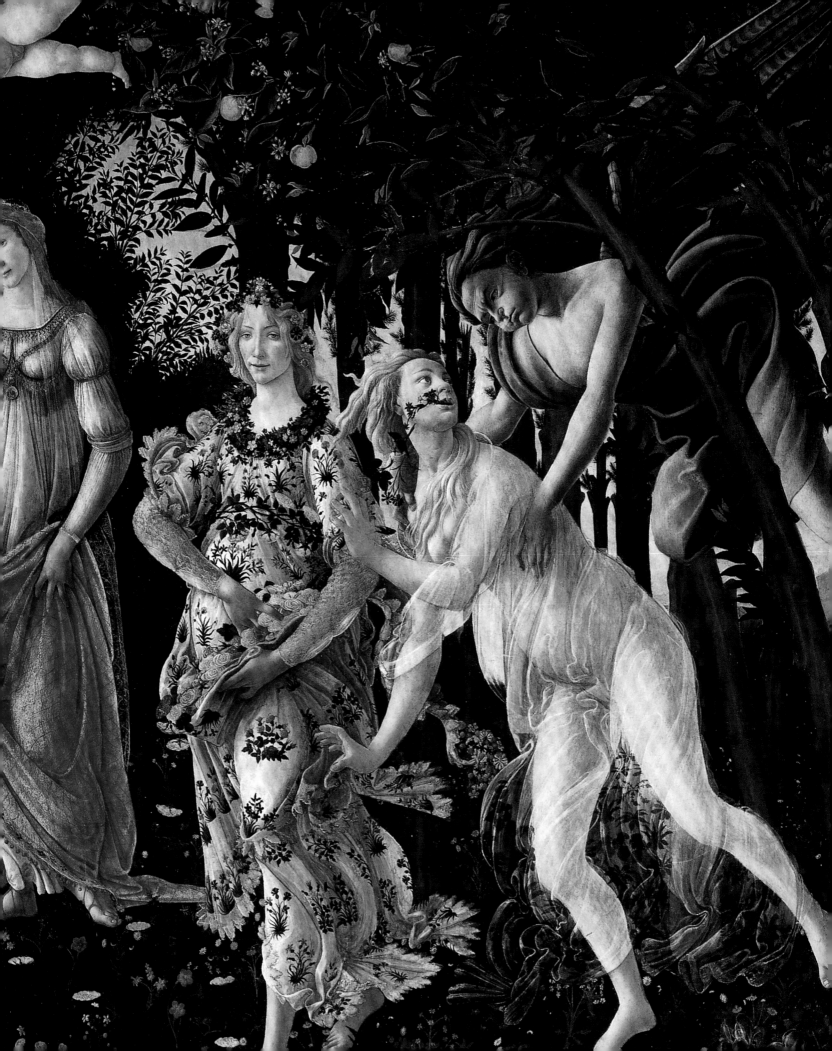

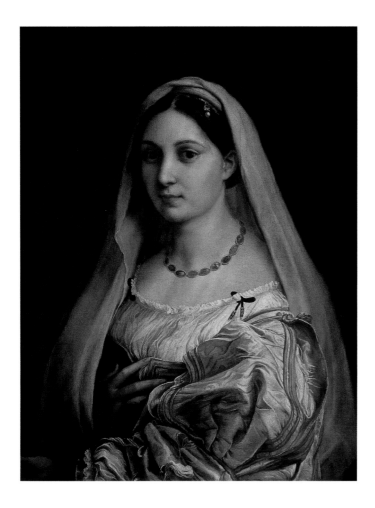

Masaccio, Fra Filippo Lippi's son Filippino, also a student of Botticelli, went on to work on the Brancacci Chapel. Lippi's frescoes in the Santa Maria Novella Church were already heralding the shift from the Golden Age to the Mannerism of the Late Renaissance.

The 15th century was as intense for religion as it was for art. The Dominicans of San Marco exerted strong influence on art, as witnessed in the works of Fra Angelico. At the close of the century, the general mood in Florence was fast deteriorating with the death of Il Magnifico and the extremist preachings of the self-styled fundamentalist prophet and book burner, Girolamo Savonarola.

---

**Raphael**, *Portrait of a Woman*, known as La Velata, c. 1512-1516.
Oil on canvas, 82 x 60.5 cm.
Palazzo Pitti, Galleria Palatina e Appartamenti Reali, Florence.

**Leonardo da Vinci**, *Mona Lisa*, 1503-1505. (opposite)
Oil on canvas, 77 x 53 cm.
Musée du Louvre, Paris.

Savonarola had been out to eradicate immorality and corruption in the Medici family, clergy, and general population until he was finally arrested by the Inquisition, tortured, excommunicated, hanged, and then burned at the stake for good measure. Moreover, the Medici went into exile. All of these events seriously mutilated the local art scene. One upshot was that Botticelli, Filippino Lippi, Benozzo Gozzoli, and Michelangelo all veered into more dramatised depictions.

The Flemish School also had an impact on 15th-century Florence; strong trade links to Flanders enhanced the arts of Florence too. The Flemish used oil paint with a particular approach to colour, along with the addition of aerial perspective while the Florentines were discovering linear perspective. Influential Flemish masters include Jan van Eyck, Hugo van der Goes, Hans Memling, and Rogier van der Weyden. Michelangelo's early 16th-century *Madonna of Bruges* (p. 32) was commissioned by Flemish merchants. But Michelangelo remained faithful to fresco painting though he once said that Flemish painting could make him cry, which Italian works could not.

Early in the 15th century, the figurative trend started by Fra Angelico in San Marco's was picked up by fellow friar Fra Bartolomeo, a disciple of Savonarola's. The style concentrated on incarnating religious ideals. Fra Bartolomeo's *Portrait of Girolamo Savonarola* was one work that gave a neat, sharp picture of its feisty, fiery subject and this artist's use of colour was to have an impact on Raphael, who would, in turn, pass on the influences to Michelangelo, some more obviously than others.

The early 16th century was of capital importance to Florentine art, the unprecedented wealth and variety of the 15th century notwithstanding. Michelangelo was facing difficult years at the time when he studied under Ghirlandaio in 1488 before turning his attention to the works of Antiquity in the San Marco Garden under the patronage of Lorenzo de' Medici. Responding intensely to Donatello, Giotto, Masaccio, and Signorelli, Michelangelo scrutinised them and copied any gesture, pose, drapery arrangement, or facial expression that took his fancy – something intellectual property lawyers would frown upon today. And he invariably refused to show any works in progress, even when the patron was the Pope himself: he copied prolifically but had no intention of being copied himself! He also hated reproducing the features of living persons unless he thought their beauty infinite. He was furthermore the first artist to claim beauty as the absolute baseline for his work. All his output was grounded in his imagination, in contrast to other art that followed the precepts of

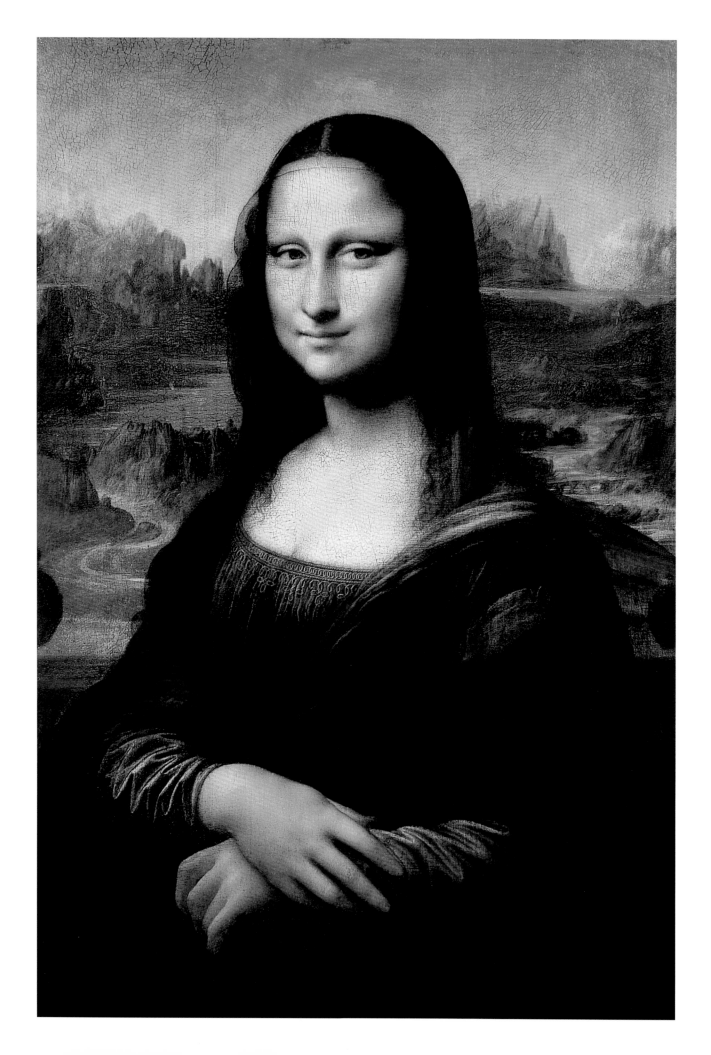

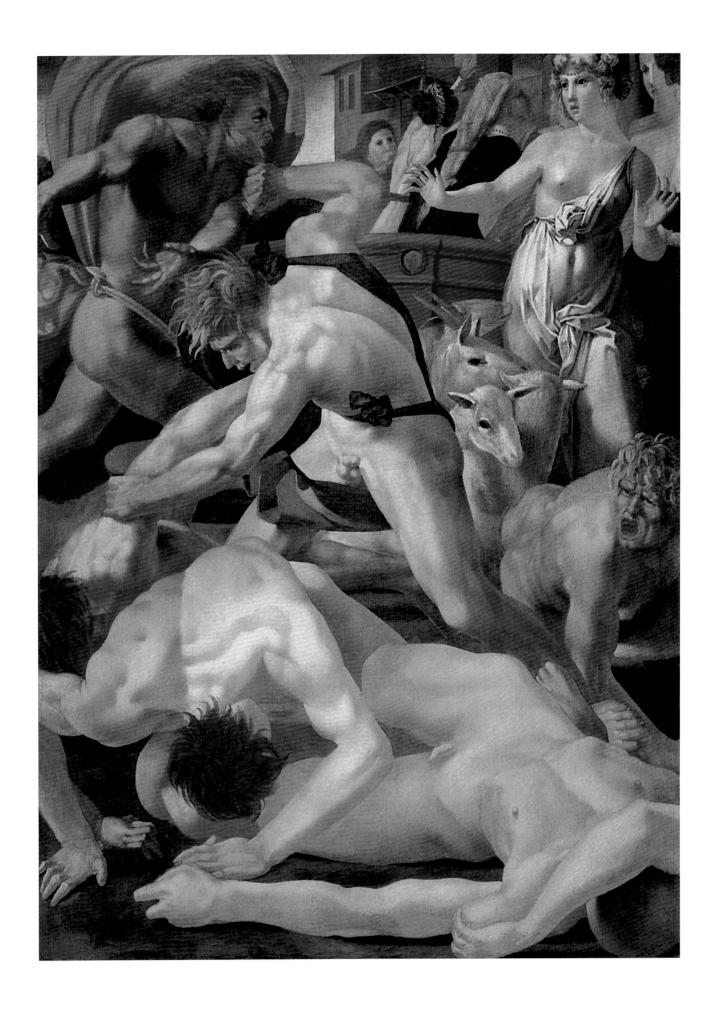

Raphael and the Primitives. All his life, Michelangelo would remain torn between Florence, where his career truly began, and Rome, where he decorated the Sistine Chapel for the Popes.

Michelangelo, Raphael, and Leonardo da Vinci were the nucleus of 15ᵗʰ-century Florentine art. Also worth citing is the painter and historian Giorgio Vasari, whose *Lives of the Most Excellent Painters, Sculptors and Architects* first came out in 1550, with the enlarged edition appearing in 1568. Lastly, there was Michelangelo's close friend and first biographer, Ascavio Condivi. Whatever the shortcomings of these two men's works, they provide invaluable insight into the Florentine Renaissance and the people who made it happen.

Michelangelo and Da Vinci stood out as strong and mighty personalities with two irreconcilably opposed attitudes to art – yet Vasari reports a bond of deep understanding between them. Da Vinci was twenty years Michelangelo's senior and each had his own set vision about art. Their fierce independence led to clashes whenever circumstances, such as simultaneous commissions for cartoons of the Palazzo Vecchio, brought them face-to-face. From Donatello and Verrocchio, Da Vinci developed his *sfumato* style, best defined as "blending light and shadow without trait or sign, like smoke" and best witnessed in the *Mona Lisa* at the Louvre Museum of Paris. It obtains hazy contours and dark colours, opposite to Michelangelo's technique seen in his *The Holy Family* (*Tondo Doni*) (p. 82, 84) at the Uffizi in Florence. Da Vinci spent years under Verrocchio while Michelangelo lasted just one at the Ghirlandaio workshop before studying under Bertoldo: Michelangelo saw himself primarily as a man who worked stone.

For Da Vinci, the essential concern was the long quest for truth while Michelangelo was dogged all his life by the meaning of art itself. Both had dissected cadavers to learn anatomy but for different reasons: Da Vinci was out to render the truth of a gesture in order to better represent action and emotion while Michelangelo simply had a hardwired interest in crafting nudes, which Da Vinci never painted. Michelangelo's *David* (pp. 20, 42, 43) standing in *contrapposto* is the direct result of his anatomical studies. In short, anatomy affected the two great artists very differently.

Each of these rivals also had a penchant for *non finito*, the abandonment of artworks in progress. Da Vinci would regularly abandon canvasses while Michelangelo would leave off sculptures. Da Vinci blends *non finito* into *sfumato* until they become hard to distinguish while in Michelangelo *non finito* is only rarer in his paintings. Either Michelangelo abandoned a work because of pressure from other commissions or he was deliberately

toying with a novel form of particularly dynamic and expressive art. After sculpting a model, he would apply himself erratically to the actual statue, with hyperactive frenzy powering him through some sessions and cool detachment through others. The fury he hurled at marble would pare away the excess and liberate the stone's soul but he didn't always follow through; *non finito* was a spin-off of his exceptional creative talent. Instead of aping his predecessors in Christian figurative painting, he opted to start off in stone. He even painted his *The Holy Family (Tondo Doni)* as if it were a work of stone. When Pope Julius II handed him the commission for the Sistine Chapel, Bramante, Raphael and other rivals were hoping he would wheedle his way out of it. Yet, instead, he made a success of it and, in the end, Michelangelo demonstrated excellence in painting, too. When it came to architecture, Michelangelo had amassed the maturity to integrate Bramante's way of empowering buildings with dimensions proportionate to those of the human body.

Alongside him stood the slightly younger Raffaello Sanzio d'Urbino (known as Raphael) who died at the young age of thirty-seven. His personality also contrasted sharply with Michelangelo's. To begin, Raphael was very sociable and he, too, had evolved a style of his own. Probably arriving in Florence in 1504 after solid training under Perugino, he mixed easily with his peers as he studied the cartoons of Michelangelo and Da Vinci at the Palazzo Vecchio and savoured Fra Bartolomeo's palette of colours while borrowing odd touches from Ghirlandaio. After a few private commissions, he headed to Rome in 1508 (the same year as Michelangelo) where he painted the *Vatican Stanze*, the private apartments of Pope Julius II in the Vatican. Beyond his stunning flair for colours, Raphael excelled at rendering drape, velvet, damask, and silk distinctively – *La Velata* at the Pitti Palace is a prime example. The real rivalry between Raphael and Michelangelo was never actually aggressive – their technique and personalities were simply too different. Raphael's premature death left Michelangelo missing a true peer. Given that Raphael's works instilled the latter's output with a certain gentle sweetness and way of handling skin colour and fabrics, Michelangelo undoubtedly had a passing to mourn. In 1534, Michelangelo made his final move to Rome, leaving a trail of unfinished works behind him at

---

**Rosso Fiorentino**, *Moses Defends Jethro's Daughters*.
Oil on canvas, 160 x 117 cm. Galleria degli Uffizi, Florence.

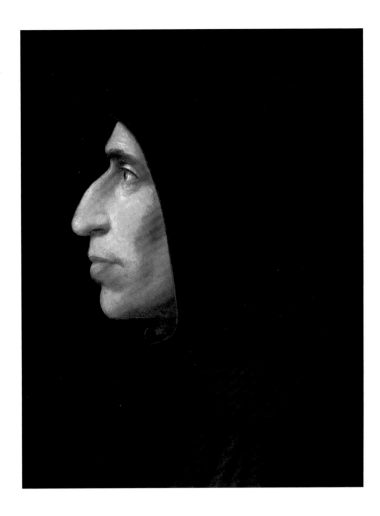

tension he created for the San Lorenzo Church. Mannerism even affected gardening. The gardens around the great private estates were rife with eccentricities, oddities, curious caves, fountains, and statues of animals – examples are in the Boboli Gardens of the Pitti Palace. But Michelangelo opened up new horizons in sculpture too. Though botched, Bartolomeo Ammannati's statue of the sea god at Piazza della Signoria was nonetheless based on Michelangelo's *David*, while Cellini's *Perseus* at the Loggia dei Lanzi is magnificent. A final worthy successor was Giambologna (known as Jean Boulogne or Giovanni Bologna) and his *Rape of a Sabine Woman* in the same loggia. But in the 16th century, the best artists were deserting Florence, Mannerism was floundering in the finer points, and real art now found itself in Rome.

Let us return to Sarto, an artist influenced by Raphael and Michelangelo, who completed Mannerism-based pieces. Mannerism was a response to the general unrest permeating Florence at the time due to the local political situation and the broader background of the Reformation. Around 1520 to 1524, Florentine painting began shifting from the Golden Age into the Late Renaissance.

For all his genius and social prominence, Michelangelo was never immune to the whims of his patrons, yet he, nevertheless, devoted his life to exercising his talents as a sculptor, painter, architect, and poet, leaving an enormous body of work in his wake.

In his late 19th-century *History of Art during the Renaissance*, Eugene Müntz includes a very thorough study of Michelangelo. However, the study needs updating to incorporate new data, transfer of works to new locations, discovery of additional drawings, recent issues, restorations and more compassion for Italian art prior to the 16th century. Nonetheless, Müntz did an enormous job and, in recognition of that, the only editing of his clear and straightforward style concerns a few idiomatic turns of phrase that would sound precious today.

*The Publisher*

the Church of San Lorenzo. He had been called to execute the *Last Judgment* (p. 132) for the Sistine Chapel, along with an assortment of jobs for San Marco. This was when he met Daniel da Volterra, who was to become his lifelong disciple.

Meanwhile, the Mannerist School was also taking shape in Florence, with the likes of native-born Andrea del Sarto executing commissions for the Servi de la Nunziata too. Even today, the Santissima Annunziata Church remains a black sheep of Florentine Renaissance art. There on display are the works of Rosso Fiorentino, Pontormo, and Sarto, works typified by a Mannerist upset of harmony, overextended forms, wavy bodies, and various bodily contortions with occasional recourse to dissonant colour combinations. In short, Mannerism was a radical reaction to Golden Age Classicism. The *Last Judgment* in the Pauline Chapel as well as Michelangelo's later figurative works are textbook examples of this school. And in the *The Holy Family (Tondo Doni)* itself, Michelangelo's new *manner* is plain for all to see. His works would go on to demonstrate a fusion of drama and fantasy. In architecture, Michelangelo blazed the trail with the curves and

**Fra Bartolomeo**, *Portrait of Girolamo Savonarola*, c. 1498.
Oil on wood, 47 x 31 cm.
Museum of San Marco, Florence.

**Vasari**, *Portrait of Lorenzo de Medici*. (opposite)
Oil on canvas, 90 x 72 cm.
Private collection.

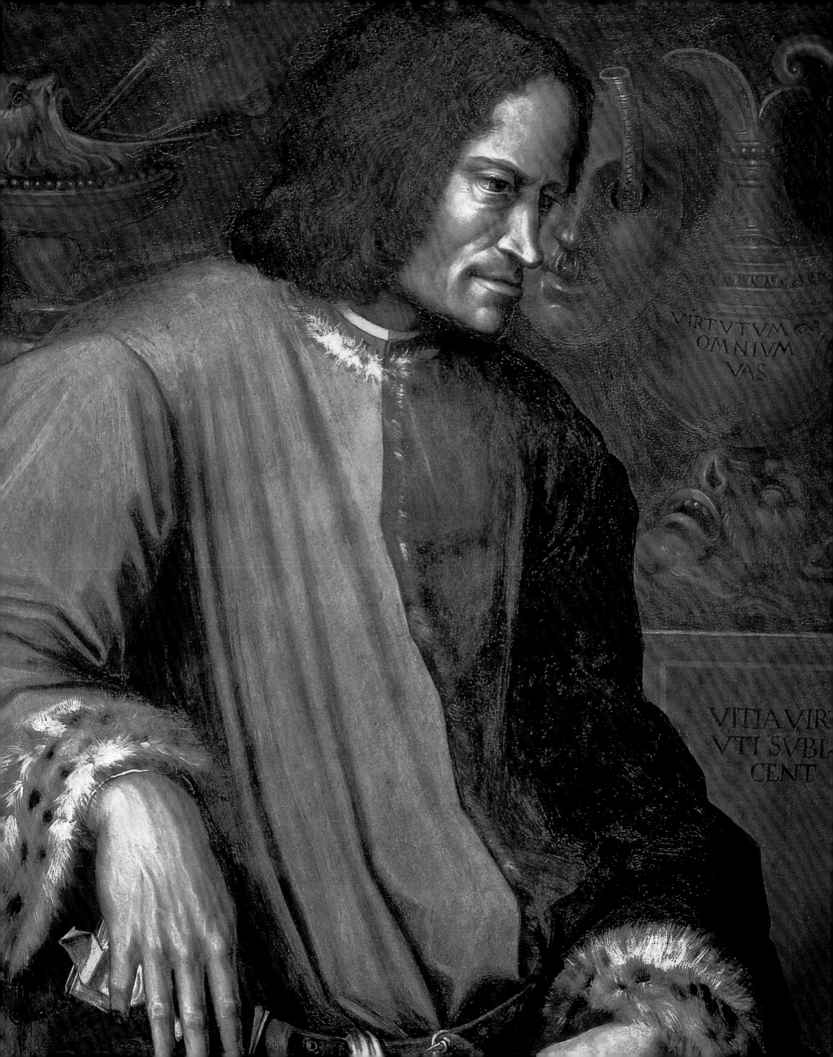

VIRTVTVM
OMNIVM
VAS

VITIA VIR
TVTI SVBI
CENT

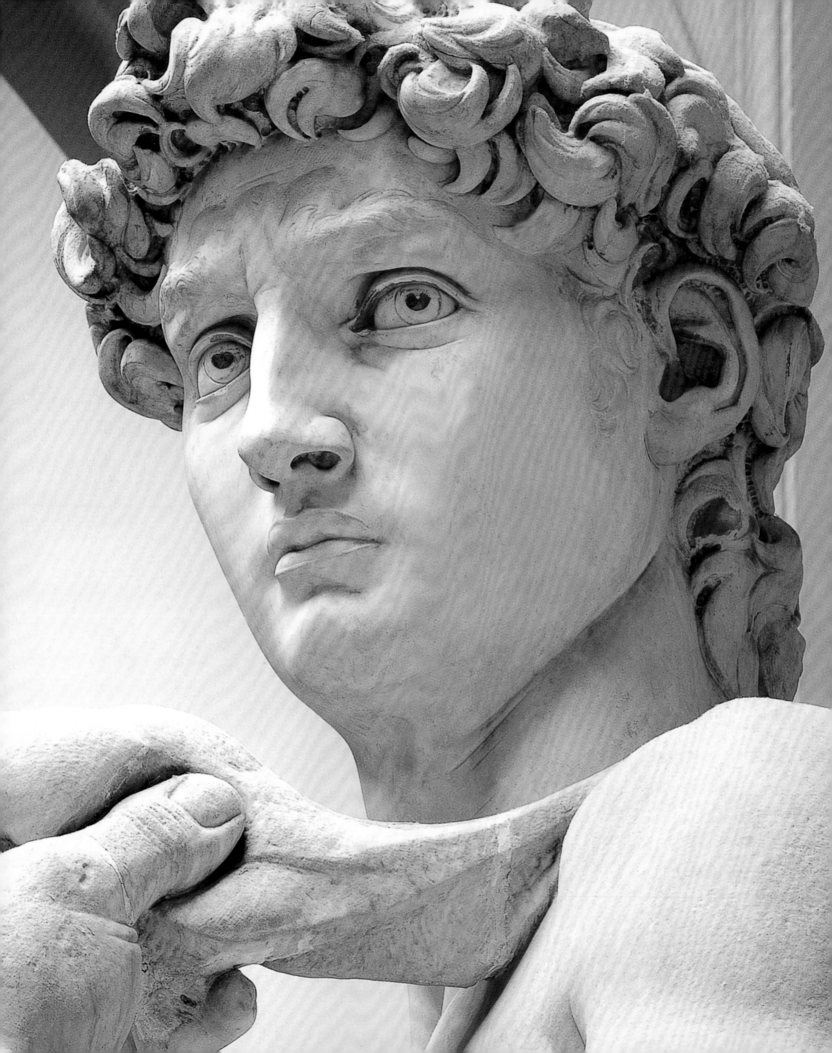

# THE SCULPTOR

## Late Renaissance Sculpture

Michelangelo not only outshines all his predecessors; he remains the only great sculptor of the Renaissance at its best. Sculpture flourished in the 15th century only to fade and die off in the next. Having progressed too far ahead of painting, it was only natural for sculpture to be the first to peak and decline.

What most Late Renaissance sculptors lacked was not talent, but the ability to use their own eyes and share a vision with either their contemporaries or posterity. We should immediately add that the era was unfavourable to them: Michelangelo's extreme genius left little scope for works that escaped his influence, damning all his contemporaries to settle for aping him.

The decadence had yet another cause: Michelangelo had brilliantly solved every essential problem facing sculpture at the time, thus freeing fellow artists from research and inclining them towards carefree routine work where they soon found themselves copying readymade techniques, which is the death of all art.

Assuredly, the quest for character and movement was germinating in the works of Donatello, but it was tempered by a strong dose of naturalism; their matter invariably counterbalanced their spirit. Donatello made a major contribution up until the heart of the 16th century; his influence was in marked conflict with Michelangelo's, especially when it came to low relief, a genre Buonarroti practiced little. But when it comes to Michelangelo's successors, neurosis prevails: anything you would call bone structure, musculature, vitality, or health deteriorates. Who would still look at such eyesores? And nonetheless, it is the vanquished copycats who give power and flavour to the whole period.

Vasari detailed all the techniques of contemporary sculpture, reviewing the manufacture of wax and earthen models, scaling techniques, low and high relief, casting, stucco, and woodwork. For his part, Cellini offers a comprehensive body of practical information about working wood in his memoirs and a treatise on sculpture. Since the early Renaissance, only bronze and marble have found favour with the public. You would imagine Michelangelo's preference for marble might tilt tastes his way but both continued to flourish, whether for low relief or in the round.

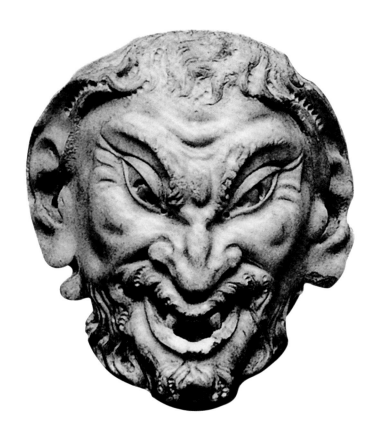

Giambologna's biography gives insight into the set-up of a Florentine Renaissance sculptors' workshop: artists would make smaller works of marble themselves from a model but brought in help for larger ones. For bronze statuettes, the artist does an easily fashioned model in wax or clay and turns over execution to helpers supplied by the grand duke. Marble sculpture happened then as it does now. It was wrongly claimed that Michelangelo used to rough-hew a marble right after finishing

*David* (detail), 1504. (opposite)
Marble, height: 434 cm.
Galleria dell'Academia, Florence.

Copy of *The Head of a Faun*, attributed to **Michelangelo**, original disappeared.
Museo del Bargello, Florence.

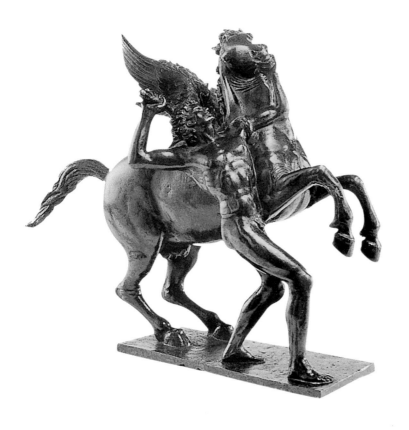

up the small-scale model. Cellini adamantly declares that, though he used to settle for this shortcut, Michelangelo made a point of doing a preliminary full-scale clay model. As he says:

> That's what I saw with my own eyes in Florence. While working on the Sacristy of San Lorenzo, that's what Michelangelo did, not only for the statues but also for the architectural works. He often realised the ornaments needed for his constructions through models built to the exact size of his intended sculptures. When the artist is satisfied with his model, he turns to charcoal and carefully sketches his statue from its principal angle. Failing this, he risks being easily fooled by his chisel. Until now, the best

**Bertoldo di Giovanni**, *Bellerophon Taming Pegasus*, 1481-1482. Kunsthistorisches Museum, Vienna.

*Madonna of the Stairs*, c. 1490. (opposite)
Marble, 56.7 x 40.1 cm.
Casa Buonarroti, Florence.

method is Buonarroti's: after sketching the model from its principal angle, [the artist] starts producing from the drawing with a chisel, proceeding exactly as if sculpting a figure in semi-relief. This is how this marvellous artist gradually hewed his figures out of marble.

But while Michelangelo took all sorts of precautions at this level, he all too often neglected the finishing touches. Attacking the marble with his characteristically spirited fury, he often exposed himself to mishaps, as occurred with the literally atrophied right arm of the *Medici Madonna* (p. 34) in the Medici Chapel of San Lorenzo Church.

Although polychrome enthusiasts became ever fewer, works of coloured marble sustained a following for some time. Juxtaposing marbles of different colours, Vasari argued, enabled sculpture to compete with painting.

Terracotta had few faithful disciples left. As for Della Robbia's style of enamelled terracotta, it was definitely relegated to the countryside. Bronze castings held many surprises and disappointments. We know how Benvenuto Cellini's picturesque and dramatising description immortalised the misadventures of casting his *Perseus*. As for Giambologna, he subcontracted the door casting for the Dome of Pisa, sculptures for the Salviati Chapel, and statues of Cosimo I.

Wood and ivory sculptures were almost non-existent and stuccos were earning wider appeal. Pasteboard was commonly used for copies of greater works and execution of ornaments. And finally, wax sculpture blossomed brilliantly. In Vasari's time, no goldsmith would model effigies without it.

Michelangelo dominated and even snuffed out the rest of Late Renaissance sculpture with his style, and even more so with his technique. Given this dazzling superiority, need we add that his influence was more harmful than fertile? The master focused on sobriety and concision while his imitators mostly delivered empty output of remarkable poverty. He sought out robustly rounded forms and palpable contours; his imitators fell for clumsiness and exaggerated swelling. He exalted and exasperated everyone's feelings: what was emotion and eloquence to him became bombastic through other chisels. He uplifted the manifestation of brute force into moral statements: in his wake, people swore by only the former. If the Primitives approximated the slender, distinct forms of their Ancient Greek peers and if Michelangelo became one with Phidias through the

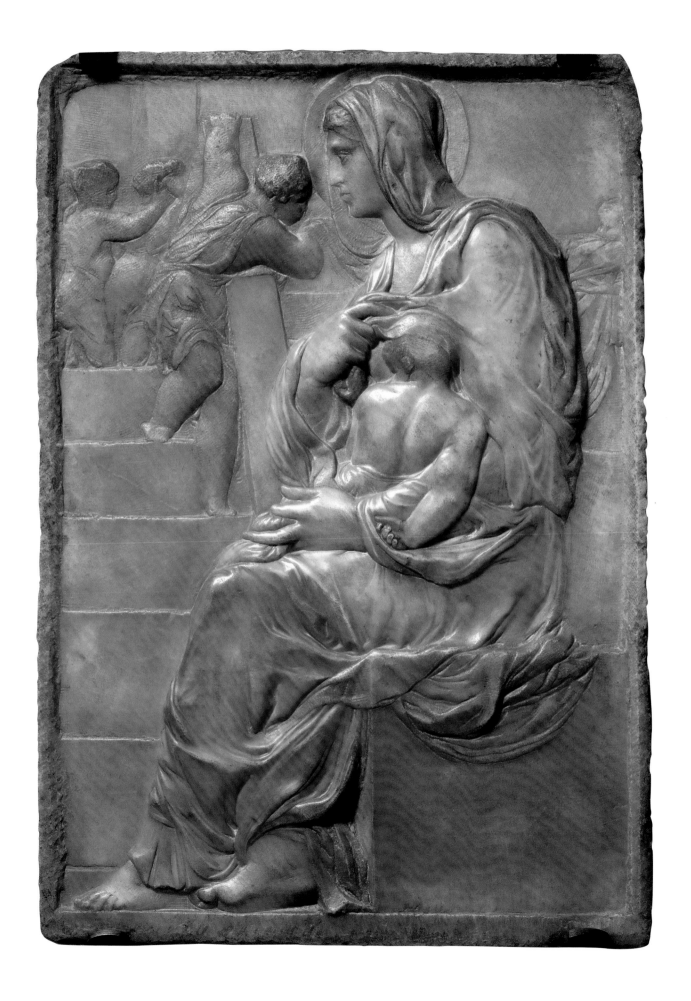

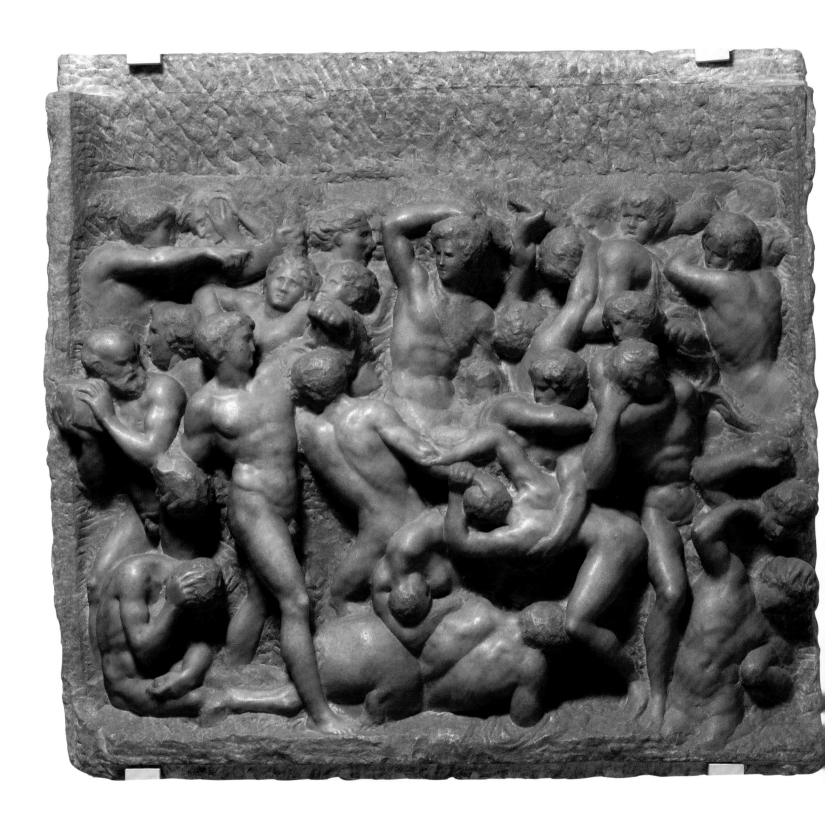

24

Medici tombs, the last heroes of the Renaissance had apparently taken example from the *Farnese Hercules* and other examples of Roman decadence. With such high moral ambitions, such moving emotional hang-ups, and all the morbid melancholic expression of Christian passion, the master pursued; the *Slaves* in the Louvre (pp. 46-47), the *Pensieroso* and *Moses* (p. 53) were more beautiful for the feelings they capture than for their technique and none inspired a single attempt at imitation. It is as if, in the eyes of the Bandinellis, Ammannatis, Tribolos, and Benvenuto Cellinis, Michelangelo had never sculpted anything except his *Bacchus* (p. 38, 39), *Adonis*, and *Cupid* – in short, it is as if all his themes had been pagan. Here, the influences of antiquity and of Michelangelo combined to finish off the destruction of Italian art. Instead of drawing inspiration from modern feelings, the epigones worried only about representing the gods of Mount Olympus and heroes of Rome or Greece; in short, they depicted a dead world. So if the technique of these statues is so mannered and empty, and if expressiveness is totally absent, what remains? Nothing. Except maybe invincible boredom.

Moreover, the exaggerated quest for suppleness and movement, backed by a passion for dazzling feats gave fatal impetus into Mannerism. What can be more pretentious and less monumental than these statues: Giuliano da Sangallo's *Julius II* in St Peter's Basilica, the *Paolo Giovio* or the *Piero de' Medici* amongst others. They may have been completed in an extraordinarily short amount of time, but what jerky, graceless lines and what dearth of elegance! Better than anywhere else, funerary art nicely reflects all the struggles, conflicts, and excesses of the Renaissance. Let us briefly review examples of the output.

In northern Italy, traditional architectural values still had followers such as Sansovino, San Micheli, and the sculptor of the tomb of Soriano da Rimini at the Santo Stefano Church in Venice (1535) – it is a sort of funerary niche inhabited by a sarcophagus supporting a statue of the deceased between two columns.

In central Italy, the tombs of Julius and the Medici, where architecture abdicates entirely before sculpture, were the rule. These monuments contain Michelangelo's chief innovations: in the 15th century, allegorical figures of almost invariably small size were entirely subordinated to a statue of the deceased but became preponderant in Michelangelo's works because they stimulated his imagination. For Italy, this was a new way of handling funerary art. Michelangelo's colossuses contain high spiritualistic aspirations that incarnate a universe of abstract impressions. Need it be said that this is no longer the cold banal allegory of the 15th century, these are no longer the *Theological Virtues*, *Cardinal Virtues*, *Arts*, or *Sciences* in relaxed poses or, it must be said, somehow parasitical motifs placidly lined up next to each other. Michelangelo liked to penetrate deeper into the conception of a subject: to him all the allegorical characters bond intimately to the deceased whose virtues they celebrate. Indignant or humiliated prisoners, victors savouring the full joy of triumph and personifications of natural forces such as *Rivers*, *Day*, *Night*, *Dusk*, and *Dawn* are all so many chords plucked by the soul of the deceased; each rings out its own sound in memory of his noble qualities, of the splendour of his victories and of the pain triggered by his premature death. In short, they are the actors of a tragedy whose hero is Julius II, Giuliano de' Medici, or his brother Lorenzo. How can such a conception not be more dramatic than that of the Primitives?

The need for movement soon made it impossible to settle for representing the deceased in a posture of eternal rest: the dead are now rubbing elbows, chatting, or doing something else.

As to the themes of the last Renaissance sculptors, the theory of art for art's sake prevailed increasingly over art as a statement of great ideas and noble sentiments. Here, no example is more edifying than a comparison between sculptures commissioned by the Medici with those of the Florentine Republic for the Piazza dei' Signori or the Loggia de' Lanzi. The Republic displayed Donatello's *Judith and Holofernes* only after adding an inscription reminding viewers that the Jewish heroine's exploit stood as a warning to all tyrants. In addition, it essentially commissioned Michelangelo to do a *David* because it saw the latter as an example of a young herdsman who had saved his country from the yoke of Philistine rule. But the concerns of the Medici lay elsewhere: they sought only to embellish the piazzas with beautiful sculptures free of any signification; in short, they were essentially platonic, i.e. *Hercules and Cacus*, *Neptune*, *Perseus* and the *Rape of the Sabine Women*. Official art must have singularly annihilated all patriotism for 16th-century Florence to have so hastily accepted

---

*Battle of the Centaurs*, 1490-1492.
Marble, 80.5 x 88 cm.
Casa Buonarroti, Florence.

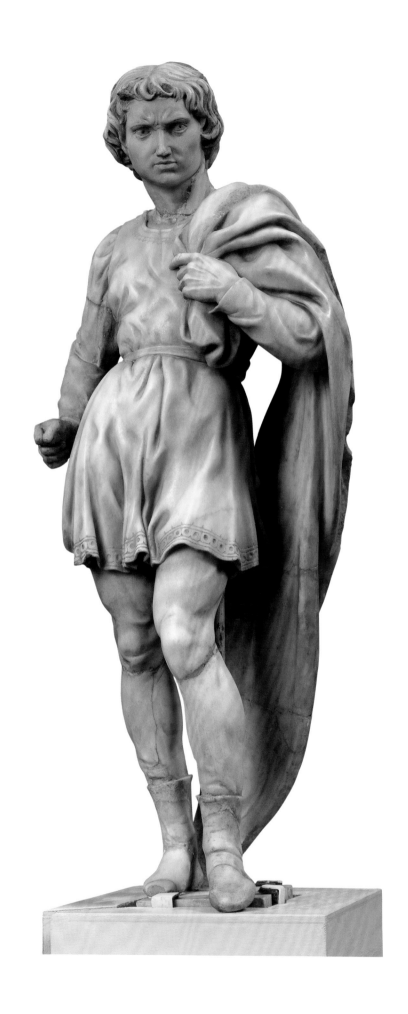

*St Proculus*, 1494.
Marble, height: 58.5 cm (with base).
Church of San Domenico, Bologna.

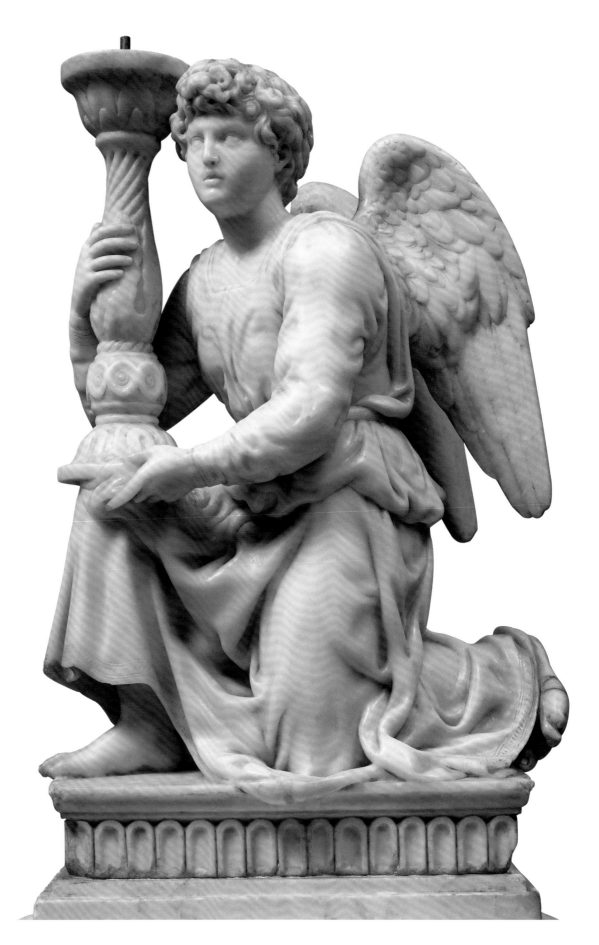

*Angel Holding a Candelabra*, 1495.
Marble, height: 51.5 cm.
Church of San Domenico, Bologna.

compositions based merely on artistic merit instead of on the glorification of a saint, folk hero or military victory. When art becomes that contrived, what breathing space survives for emotions, inspiration, or even personal conviction?

## The Oeuvre

Although Michelangelo excelled as a sculptor, painter, and architect, he was most ardently and consistently fond of sculpting: *scultore* was the only title he ever used. We, therefore, need to use this discipline as the baseline for mapping the biography and efforts of this prodigious artist. Among the wealth of publications devoted to Michelangelo, those of Condivi and Vasari deserve special mention.

Michelangelo is an infinitely more faithful representative of the modern era than his supremely serene fellow geniuses Da Vinci or Raphael, although he was older than the latter. He was a sublime misanthrope who sensed melancholy, fears, inner doubts, and the soul's rebelliousness against society, which he translated with a uniquely personal style of vehemence.

The most incisive research into the Florentine School is helpless to explain the genesis of Michelangelo: his career was stunning and unexpected in equal measure. After a fairly long period of decline in Italian statuary art, this supernatural being suddenly burst in, brushed away the past, and revitalised the then present with the most prodigious temperament for statuary art that the Western world had seen since Phidias.

Michelangelo was born on 6 March 1475 in Arrezo, in the province of Caprese near the Franciscan order's famous La Vernia Monastery, immortalised by the visions of St Francis of Assisi. The area has some of the roughest and mightiest terrain in Tuscany, generously endowed with bold naked rock, centuries-old beech forests, brisk clean air, and some of the highest peaks in the Appenines.

At the time of Michelangelo's birth, his father Lodovico Buonarroti (1444-1534) was district commissioner of the market towns of Chiusi and Caprese (*not* the Caprese between the Vatican State and Tuscany River). He belonged to a very old family that 16th-century genealogists linked to the counts of Canossa – belated ennoblements are always vaguely dubious and in turn somewhat laughable when they concern an ancestor like Michelangelo. At the end of his six-month appointment, Lodovico returned to Settignano outside Florence where he owned a small estate and put Michelangelo out to nurse with a stonecutter's wife. At the age of six, his mother died. He then took up drawing under Granacci before apprenticing under the Ghirlandaio brothers in August 1488. Domenico Ghirlandaio helped decorate the Sistine Chapel in Rome and did a number of frescoes for the Santa Maria Novella Church in Florence.

Whatever his talents, Ghirlandaio was not the inquisitive sort of soul who could poke away at technique from different angles and revitalise art. His works are admirably assertive and precise and the style is clear-cut, but lack any inspiring principle or transcendent vision.

Michelangelo's earliest schooling remains unresearched in any real depth and insufficiently understood. However, external influences exert little impact on such solid geniuses. From his first works in Florence through to the figures he painted and shaped in Rome with half frozen fingers, Michelangelo's oeuvre shows overall unity despite the diversity of his output. As hard as you look, you cannot distinguish, say, a Florentine or Roman period in his works as you can with Raphael – not to mention any Umbrian one. At best, different time frames show only differences of quality but with no intrinsic change of character. In this way Michelangelo, the paradigm of iron will and personal convictions, resembles the sublimely imaginative Da Vinci. Each came into this world with a personal ideal, something Raphael only gradually developed from the role models around him. As Michelangelo aptly described his younger rival's genius: "Raphael owed his superiority not to Nature but to studying."

We would be going too far if we subscribed to Klaczko's statement in *Causeries Florentines – Dante et Michel-Ange* (Paris 1880) that, "Michelangelo seems a haughty loner, unrelated to the School of his time, undescended from that of the past." It is hard to believe in such a spontaneous generation. As we shall see, Michelangelo never hesitated to draw inspiration from his predecessors. It hardly belittles the unassailable master to seek affinities between his style and that of Donatello, Jacopo della Quercia, and their like: the issue is to establish the roots that connect him to his era and any lost traditions he may have fingered and revived, however subconsciously.

*Crucifix*, 1492.
Wood polychrome, 142 x 135 cm.
Santo Spirito, Florence.

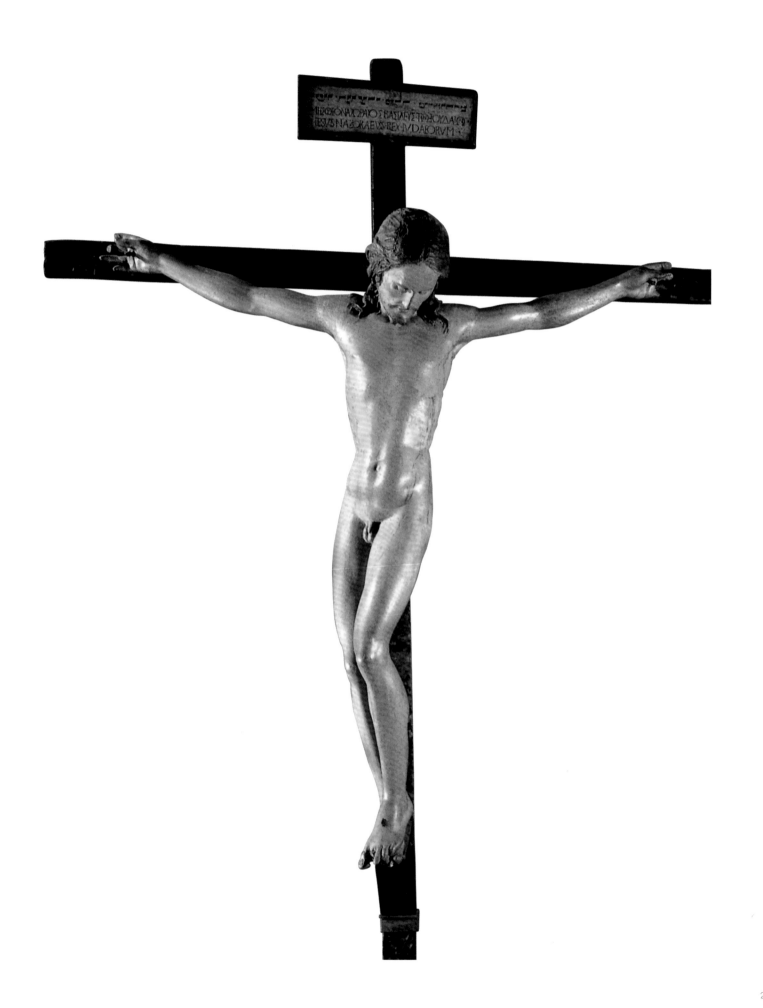

29

The first models Michelangelo studied were those that attracted every young artist in Florence at the time, i.e. the marbles of Antiquity in the San Marco Gardens as well as the frescoes in the Brancacci Chapel of the Church of the Carmine – which is where the sculptor Pietro Torrigiano threw a punch that broke the young master's nose, disfiguring him for life. A handful of drawings at the Louvre in Paris, the Staatliche Graphische Sammlung in Munich, and the Albertina in Vienna show that Michelangelo borrowed from the works of Giotto, Masaccio, and other 14ᵗʰ-century artists. In the Louvre drawing, he copied

*Virgin with Child and St John the Baptist as a Child* (Tondo Taddei), 1504-1505.
Marble, diameter: 106.8 cm.
Royal Academy of Arts, London.

two figures from Giotto's painting *St John's Disciples Discovering the Empty Tomb* at the Peruzzi Chapel in Santa Croce. In the Munich drawing, he copied characters from Masaccio's *Christ Ordering St Peter to Pay the Tribute*. And in the Albertina drawing, he reproduced a composition by a still earlier master.

Although his style and manner were by now ripe and distinct, Michelangelo's convictions remained vague. This transpires in the diversity of his studies. He had fun co-opting into paint the *Temptation of St Anthony*, a print by the Alsatian painter and engraver Martin Schoen, although the theme lay well astray of his personal focus: what did this youthful lover of round fulsome forms have in common with Schoen's skinny, tortured, almost caricatured figures?

Michelangelo soon moved on to other role models. Among the deceased, Donatello ranked topmost. His teachings carried on through both his works displayed across Florence and

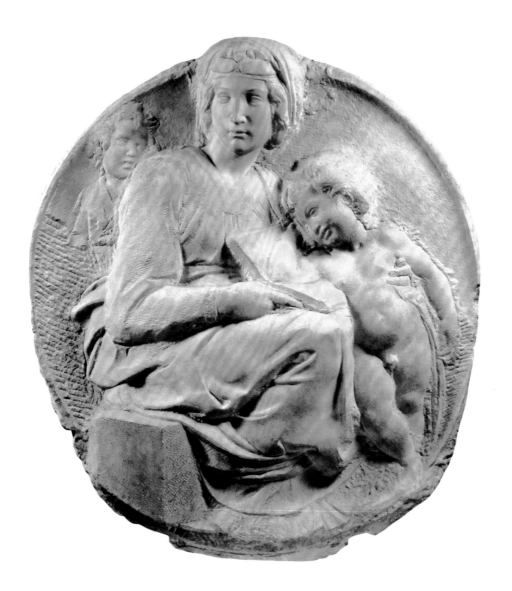

through the tradition fostered by his students such as Bertoldo, even as they leaned ever more heavily into Mannerism. Michelangelo could not have avoided the fascination of Donatello's own powerful genius, with which he had so much in common. He studied this master with a passion, if not without an occasional glance of approval at Ghiberti's masterpiece, the doors of the baptistery he called "fit to stand at Heaven's gate".

Michelangelo imitated Donatello both deliberately and subconsciously. And it persisted with numerous interruptions from his early *Madonna della Casa Buonarroti* to his late *Moses*, inspired by Donatello's *St John* for the Cathedral of Florence. He managed to lock in the gist of style, his secret way of electrifying figures with life and vibrancy and of injecting passion and eloquence right into the drapery. In short, he captured the spirit of the deeply dramatic emotion and feverish agitation so distinctive in that era of change. Other

borrowings are even more obvious: Donatello's bronze door at San Lorenzo shows a standing figure facing to the right with the left arm outstretched to herald God the Father in the *Creation of Adam* and *Creation of Eve* at the Sistine Chapel. Here, Michelangelo only raises the hand a touch higher and arranges the drapery more carefully than his predecessor. Both heads move almost the same way and the rest is equally analogous. Strong resemblances also appear between the *Madonna* of *Bruges* and *Judith* in the Lanzi Loggia as well as Michelangelo's *David* and Donatello's *Saint George*.

---

*Virgin with Child and St John the Baptist as a Child* (Tondo Pitti), 1504-1505.
Marble, 85.8 x 82.5 cm.
Museo del Bargello, Florence.

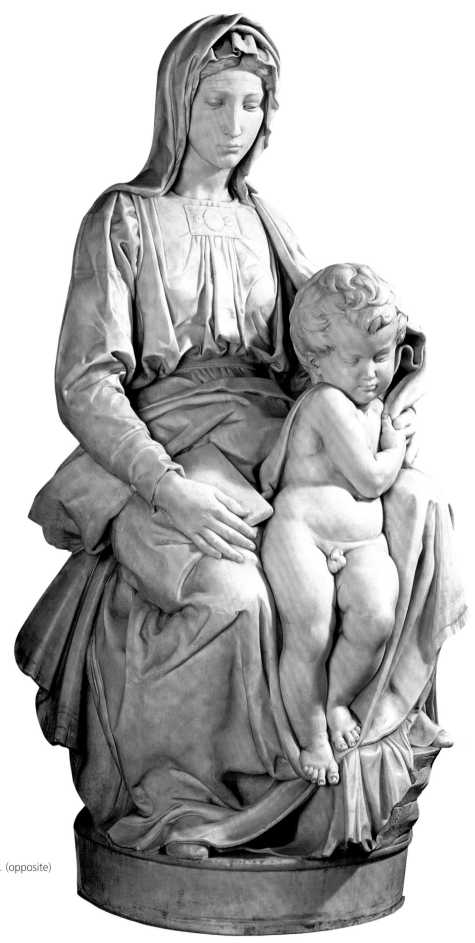

*Madonna of Bruges*, 1501-1505.
Marble, height: 120.9 cm.
Church of Our Lady, Bruges.

*Madonna of Bruges*, detail, 1501-1505. (opposite)
Marble, height: 120.9 cm.
Church of Our Lady, Bruges.

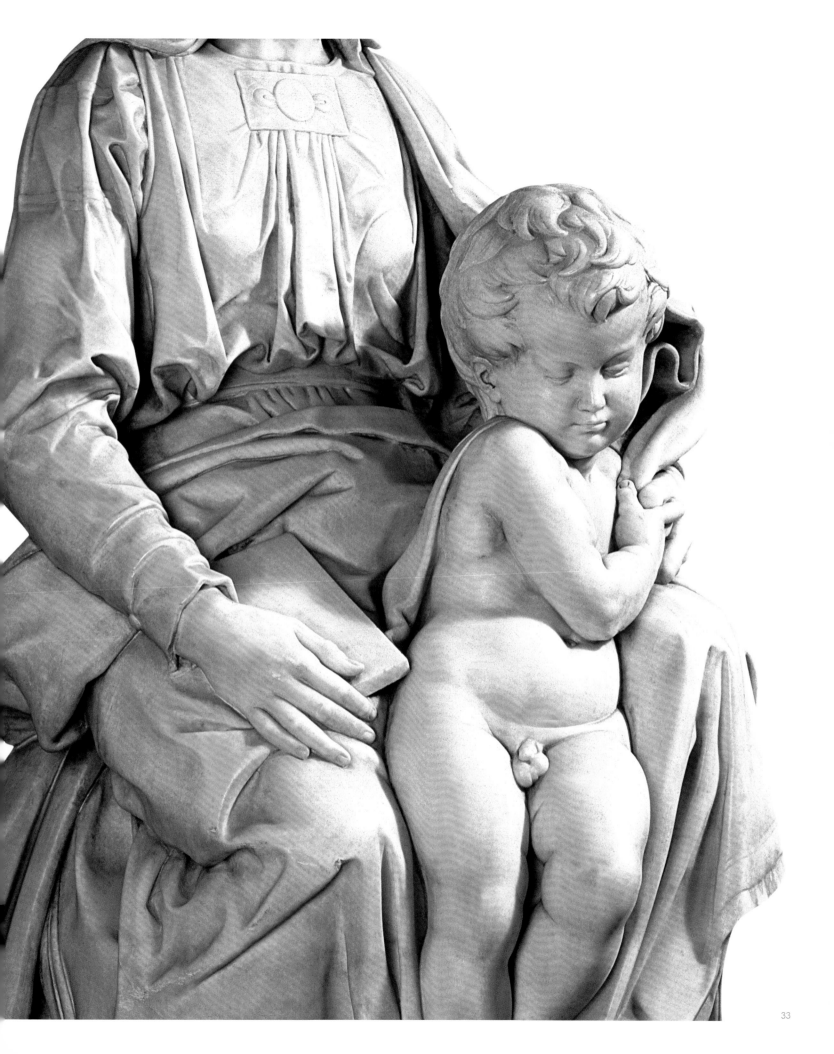

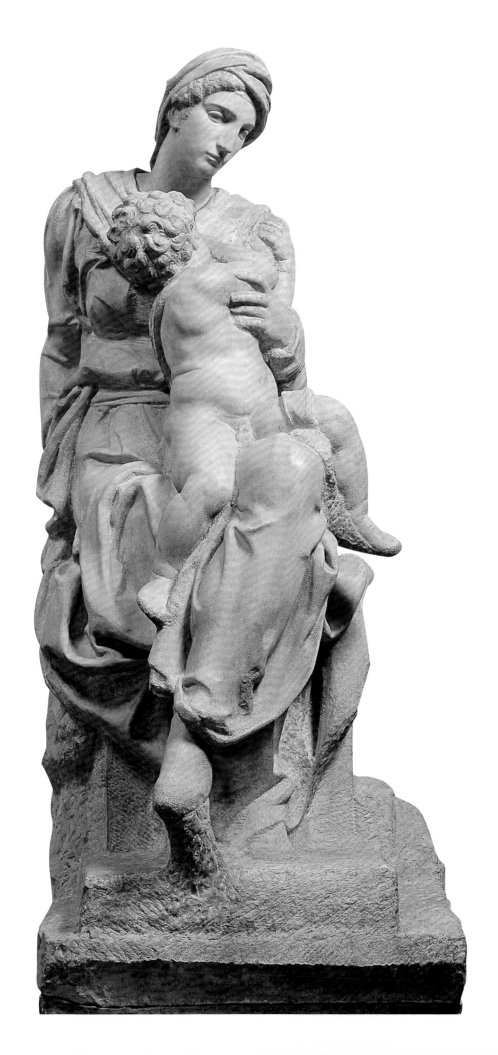

We should also mention here the strong influence of the sculptors Jacopo and Giacomo della Quercia (1371-1438 and 1412-1480 respectively) although it would only become manifest after Michelangelo's stay in Bologna years later. Did Michelangelo borrow nothing from the charm, purity, and refinement of his more recent 15th-century forebears? That might sound doubtful until stumbling on a series of *St Sebastian* statues by Mino da Fiesole, Antonio Rossellino, and Benedetto da Maiano. Though somewhat shaky, unaccentuated, and non-committal, they herald the *Dying Slave* (p. 46) at the Louvre and each is a step along the path to either of the masterpieces. The prime comparison is between the *Slave* and Da Maiano's *St Sebastian* at the Misericordia Museum in Florence: the heads tilting backwards and leg positions match. But Michelangelo unties the hands from behind the back, placing one on the chest and the other on the head – a stroke of genius that gives the figure astonishing eloquence and pathos. Another example is the *Madonna of the Stairs* (p. 23), a straightforward copycat drawing of a low-relief attributed to Desiderio de Settignano.

However, the case of Luca Signorelli is trickier. Usually marked as a precursor of Michelangelo, he painted the *Last Judgment* in Orvieto. It is endlessly repeated that Michelangelo started out from Signorelli's anatomical and muscular studies, assimilating the latter's fascination for torso effects. The standard justification is the resemblance between the naked children in the background of Michelangelo's *The Holy Family (Tondo Doni)* and those of Signorelli's *Madonna*, both now in the Uffizi. In fact, Signorelli started his *Final Judgment* in 1499 and finished it in 1505 while Michelangelo had already demonstrated, with powerful relief, a fine command of human anatomy by 1492 in his *Battle of the Centaurs* (p. 24). In fact, he only borrowed from Signorelli's *Last Judgment* for his own *Last Judgment* (p. 132) in the Sistine Chapel: note the swooping demon with a woman on his back whose general layout recalls a demon in Signorelli's.

The blind force of destiny, however, had more to do with their meeting than any wilful choice of Michelangelo. He definitely never deliberately imitated Signorelli, whom the Renaissance widely considered outdated, the way he did Jacopo della Quercia or the masters of antiquity. And then Signorelli went on to copy his "plagiarist's" *Pietà* in grisaille at St Mark's in Rome!

From this angle, we can spot Michelangelo's forebears in Andrea Verrocchio and Antonio Pallaiuolo, whose dogged anatomical research spawned breakthroughs in anatomical studies. True, both had long left their home towns for Rome or Venice but, given the effervescence of Florence at the time, their teachings must have reached that city and deeply affected its art scene. Michelangelo was still young when he first studied anatomy at the Santa Maria Novella poorhouse in Florence before continuing the pursuit in Rome. In Oxford, one drawing shows him dissecting a cadaver by candlelight.

As Klaczko notes:

> No master definitely ever outclassed or even equalled him in the science of the human body. How the athletic builds, extended necks, tortured poses and troubled facial expressions of these characters rattle our sense of reality nonetheless! How the entire corpus of anatomical science is helpless to inspire such occasionally crushing but invariably destabilising faith in the existence of this world of colossuses! It is rightly said that not a single figure of Michelangelo's could stand up and walk without making the universe tremble and disrupt the very foundations of Nature.

In his *Anatomie des Maîtres* (1890), the eminent anatomist Mathias Duval adds a precious quip:

> Although Michelangelo is an impeccable anatomist, as much cannot be said about him as a physiologist; all the muscles in his works are in a state of tetanus. In Nature, when one muscle contracts, the other relaxes.

So another conflict appears here between Michelangelo and his forebears: they worked from healthy living models while he

---

*Medici Madonna*, 1521-1531.
Marble, height: 226 cm.
New Sacristy of San Lorenzo, Florence.

*Pietà*, 1499. (p. 36)
Marble, height: 174 cm.
St Peter's Basilica, Vatican.

*Pietà* (detail), 1499. (p. 37)
Marble, height: 174 cm.
St Peter's Basilica, Vatican.

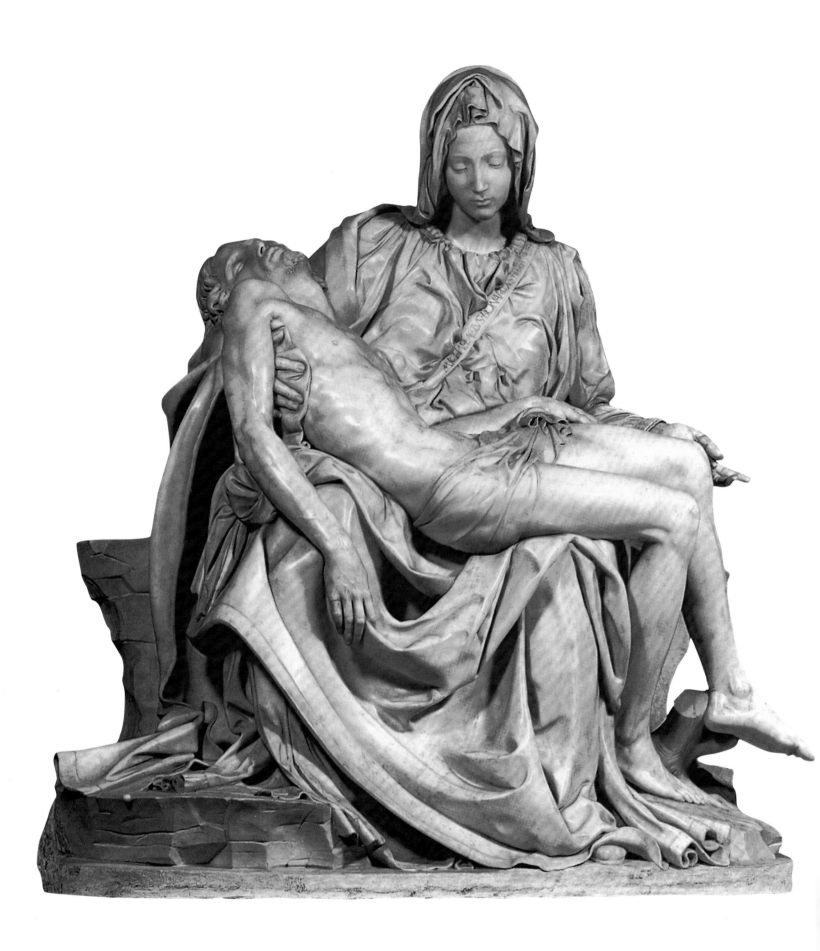

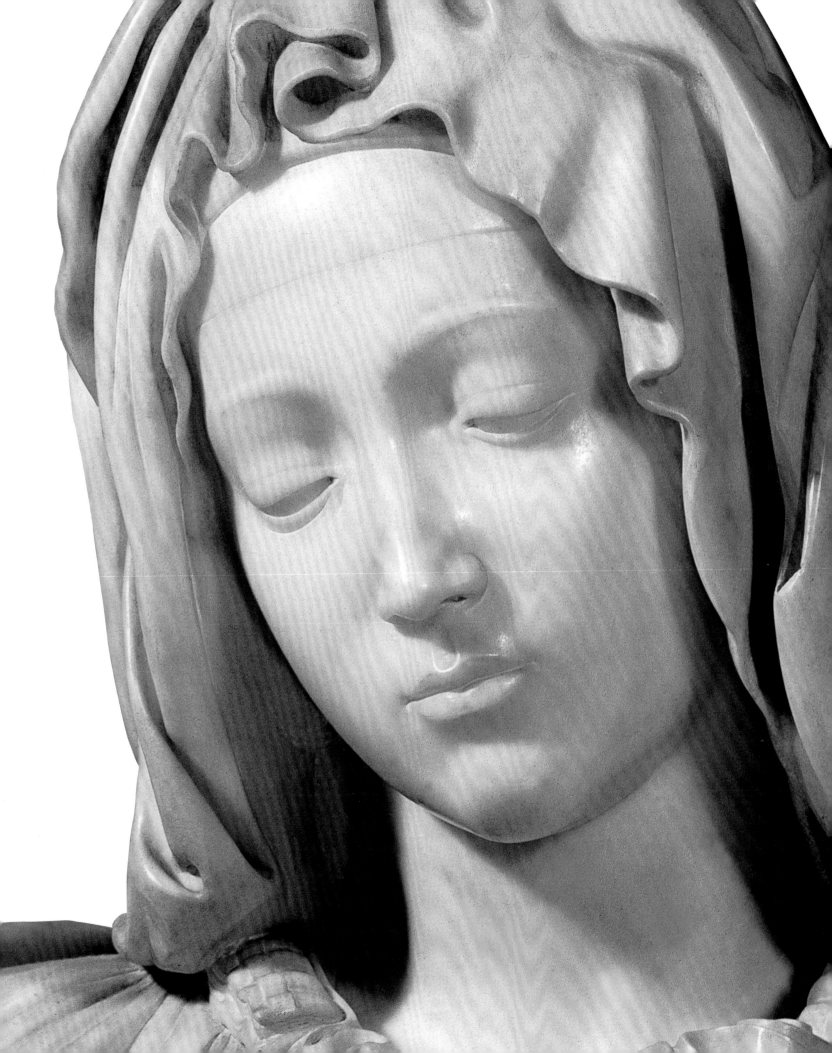

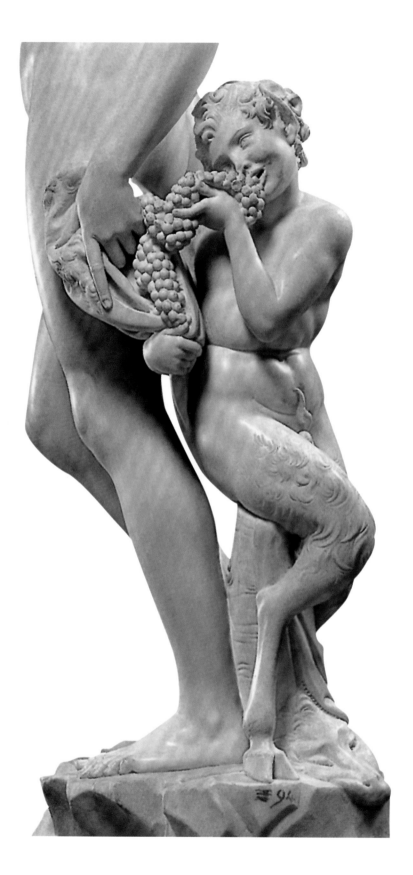

used cadavers. Ghirlandaio, the so-called 'master', neither instructed nor influenced the so-called 'student'. To date, we have only two Michelangelo drawings inspired by Ghirlandaio: one in the Louvre and one in the Albertina. Michelangelo's stay with the Medici powerfully sharpened his thinking and education. Living amidst the family's priceless collections, he developed an easy familiarity with the tiniest art secrets of Antiquity.

But if Antiquity so generously endowed the Renaissance master with ideas and themes, inspired him to worship form and stimulated his appetite for abstraction, Michelangelo's ideals unswervingly opposed those of Ancient Greece. For example, he would subordinate every element in a composition to a single overriding impression: not just the hands, arms, legs, eyes, and mouth that express the feelings and intentions of the soul, but also the torso and other somehow unconsciously expressive body parts. In short, we should underscore his habit of making the entire human form resonate with a single note, a note that expresses pathos, the strongest emotion. Does anything else clash more violently with the errant ways of the sculptors of Antiquity so concerned with pure and graceful curves before giving any thought to rendering the ripples of the soul?

We know luck led Michelangelo to Lorenzo de' Medici. Lorenzo developed a fondness for the youth and took him under his wing after Michelangelo immediately broke a tooth off his marble mask of a faun because Lorenzo had remarked that the face was too old to have all its teeth. Thus, the artist became a part of his patron's daily life in the Medici home on the Via Larga where he met Angelo Ambrogini, Marsilio Ficino, Pico della Mirandola, and other humanists of the Neo-Platonic School as well as a variety of poets, philosophers, and intellectuals. Lorenzo himself was a man of exceptional cultivation.

Michelangelo's first major work during his stay with the Medici was a low relief for what became the 'Casa Buonarroti' entitled *Battle of the Centaurs*.

---

*Bacchus* (detail), 1497.
Marble, height: 203 cm.
Museo del Bargello, Florence.

*Bacchus*, 1497. (opposite)
Marble, height: 203 cm.
Museo del Bargello, Florence.

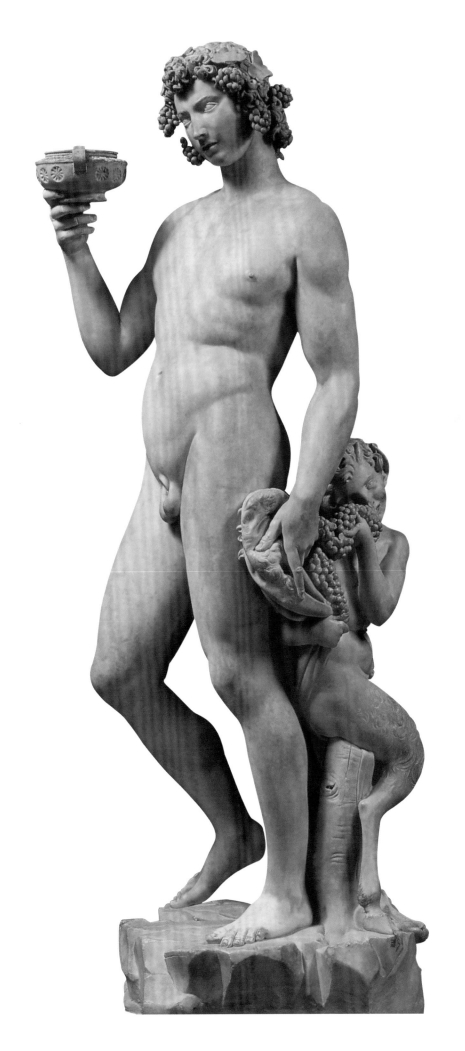

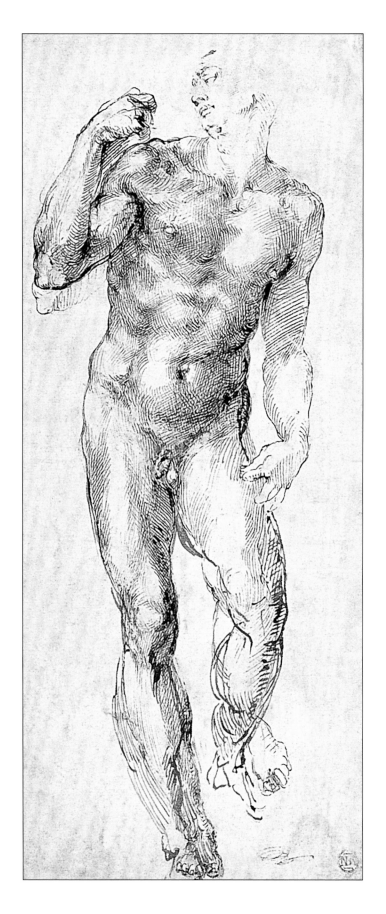

Michelangelo's full maturity as a sculptor was already obvious. His works not only demonstrate a mastery of anatomy that drove his rivals to despair, but go on to show a ferociously proud soul and even less imitable powers of dramatisation. Wholeheartedly swept up in ardent warfare, Michelangelo's combatants are true athletes and masters of every exercise performed in a palestra, with muscles bulging and chests thrust forward and defiant stares that resonate physical and moral strength, adding a note of gripping pathos to each of Michelangelo's works. Just as in the admirable *Slave* in the Louvre, which is perhaps the best example, his subjects not only brave their adversaries but the gods as well, and this is what makes them supremely eloquent representations of "being a free soul".

Lorenzo de' Medici's death in April 1492 interrupted this enviable lifestyle. The Medici's arrogant son Piero had no real taste for the arts and sciences that were his father's joy and glory. It appears he would have Michelangelo sculpt in snow or send him on errands for semi-precious stones. But the youth put his time to better use with his marble *Hercules* (long on display at the chateau in Fontainebleau until stolen in the 17th century) as well as with his wooden *Crucifix* (p. 29). The latter was executed as a gift to the priory of the Santo Spirito Convent in Florence for having hosted him there. Long missing, *Crucifix* was found, restored and set up in the sacristy of the Santo Spirito Church.

However, a storm was brewing that would bring down Medici rule. Cardiere, a singer in the Medici social circle, told Michelangelo of a vision, twice experienced, in which Lorenzo had appeared before him dressed only in a torn black shirt to ask him to tell his son Piero that he would soon be driven out of the city – upon which the young artist promptly fled to Bologna with a pair of friends. Given the extraordinary stress levels Michelangelo imposed on himself, these brusque depressions are not surprising. Nature, pushed to the limit, suddenly took its revenge. Likewise, he fled Rome in 1506 after imagining that Pope Julius II was going to have him killed. He went on to flee Florence just as suddenly during the siege of 1529, though only to return and stand tall among his fellow citizens once the initial panic had worn off.

In Bologna, Michelangelo netted a most flattering commission: the execution of several figures for the Arca (Shrine) di San Domenico in the church of the same name. This famous monument, started in the 13th century by Niccolo di Pisa and

continued in the 15th century by Niccolo da Bari (known as Niccolo dell' Arca), depicts the development of Tuscan sculpture from its beginning to its demise. Michelangelo's contributions were the statues of *St Petronius* and *St Proculus* (p. 26) as well as the statuette *Angel Holding a Candelabra* (p. 27). Until recently, the monument generated singular confusion over which sculptor did which work. However, there is no doubt about the statuette and close examination confirms material evidence from the archives: to carry a torch, this athletically-built child deploys the strength of Atlas carrying the Earth. This sombre-faced child with a gigantic torso, who looks like a miniature male adult, can only be the product of Michelangelo's chisel. Admirable in its own right for its representation of sharply focused vitality, the *Angel Holding a Candelabra* offends credibility. Why turn an angel into Hercules just to lift a torch? The angel's role and character call for suavity and Michelangelo's predecessor, Niccolo dell' Arca, fathomed the requirements for this subject very differently: his figure radiates inexpressible grace and charm. As for the *St Petronius*, he stands barefoot and capped in a mitre as he holds forth a scale model of the church; the figure is much alive and almost tortured, with disappointing drapery effects. It resembles Jacopo della Quercia's statue of the same saint, created for the façade of the San Petronio Church. Indeed, their busts show striking similarities in terms of looks, hairstyle, and hang of the cloak. Michelangelo only recovers his own style in the lower half of the statue, where the comparison is not to his advantage. For its part, *St Proculus* prefigures his *David* even though the saint is shorter, stockier, and more juvenile, with garments of lifelike pleating but an unpleasant look on his face, very unlike the one on his future masterpiece.

The most striking thing about the works of Michelangelo's youth, i.e. *Battle of the Centaurs*, the *Angel Holding a Candelabra*, and the *The Holy Family (Tondo Doni)*; is the overemphasised muscles of his heroes. Instead of being round and pudgy, even the child figures have arms that look able to handle the heaviest chores and roughest fist-fights – this rebel genius yearned for a more robust humanity replete with more powerful limbs and more muscular bodies. Moving moral messages worried him little at the time: the facial features are usually morose or impassive. Like the Ancient Greeks, he was sacrificing faces for torsos.

The only period where Michelangelo excelled at representing childhood was 1494 to 1504. Chubby fulsome faces and natural life-like baby smiles are evident in the Holy Infant of

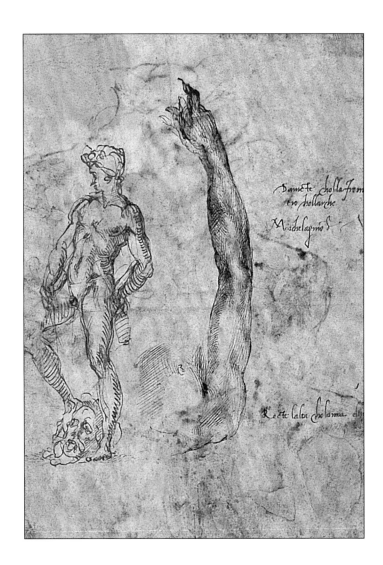

the *The Holy Family (Tondo Doni)*, the *Madonna* of *Bruges* and in one low-relief marble *Madonna* at the Bargello National Museum in Florence and another at Royal Academy of Arts in London. But before 1494 and after 1504, all the children look very athletic. And his recourse to compressed relief betrays a debt to Donatello.

Once back in Florence, Michelangelo did a small marble of *St John the Baptist* (known as *Giovannino* in Italy) for a

---

*Naked Man, Standing*, 1501. (opposite)
Pen and brown ink, 37 x 19.5 cm.
Musée du Louvre, Paris.

Study for *David* and left arm study. (above)
Quill and ink, 26.4 x 18.5 cm.
Musée du Louvre, Paris.

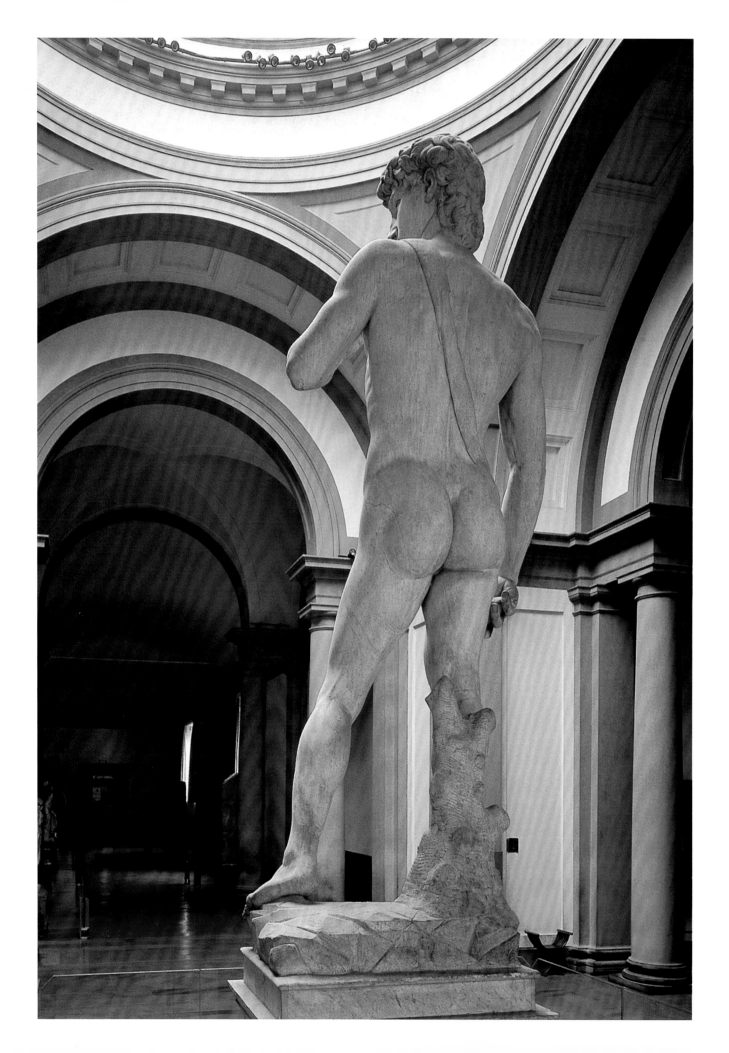

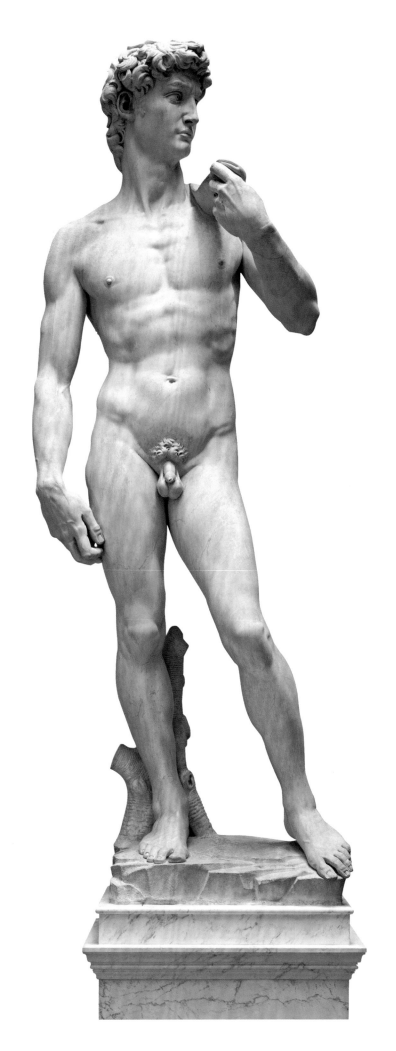

*David*, 1504.
Marble, height: 434 cm.
Galleria dell'Academia, Florence.

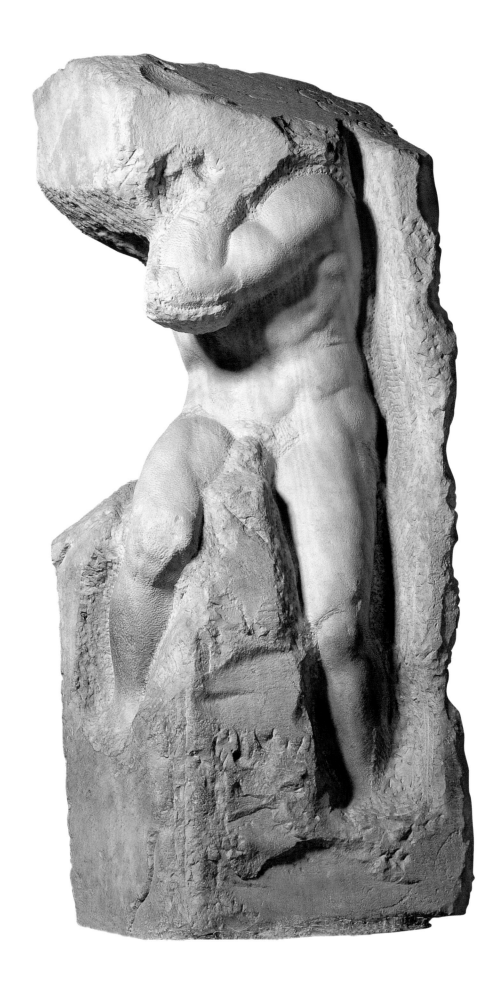

poorer Medici. This statue has been linked to another found in Pisa which now resides in a Berlin museum – it is a cold stilted piece of work and its attribution to Michelangelo is highly questionable. Returning to his home town Florence, Michelangelo entered his period of greatest serenity, or perhaps it should be called impassiveness.

At the foot of the pulpit from which Savonarola bellowed out his sinister warnings, Michelangelo went on from *St John the Baptist* to his *Sleeping Cupid* and *Kneeling Cupid* (Victoria and Albert Museum, London), *Bacchus* (p. 38, 39), *Death of Adonis* (p. xx, Bargello National Museum) and finally his *David* in marble, i.e. those works that stand apart in his oeuvre by their total absence of any vehemence, passion or pathos. This abrupt plunge into introspection was the product of his exposure to Classical art at its zenith. The importance of this series of works cannot be overemphasised: they prove that, before steeping himself in tragedy, there was a quiet, congenial Michelangelo somewhat moonstruck by the beauty of Antiquity.

To understand the massive volume of work Michelangelo put out in the few years between attending Ghirlandaio's workshop and completion of his *Bacchus, Cupid,* and *Adonis*, or to grasp his speedy, decisive, and almost miraculous emancipation of his art, we need only compare his works with those exiting the workshops of his most illustrious Tuscan peers at the time. Examination forces us to notice that, in comparison to the pure contours and fine relief of his works, theirs lack harmony, fullness, and free movement – in short, they have those 'charming flaws' that typify the Primitives.

On the other hand, Michelangelo demonstrates the most enviable ignorance of all the difficulties that stumped his predecessors. He hews marble as if kneading soft wax. He twists and turns human figures with playful ease, trying out the most contorted poses and always choosing the right one. Without such touching integrity and conviction throughout his works, one would think he enjoyed poking fun at obstacles.

---

*Slave, Named Atlas*, c. 1530. (opposite)
Marble, height: 277 cm.
Galleria dell'Accademia, Florence.

*St Matthew*, 1505-1506.
Marble, height: 271 cm.
Galleria dell'Accademia, Florence.

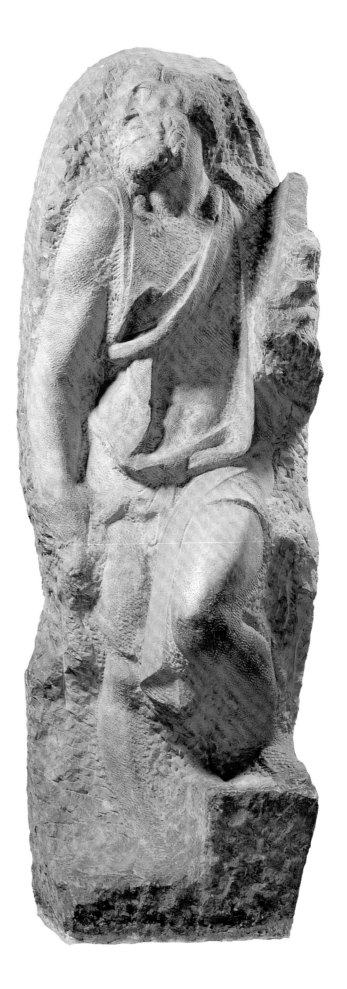

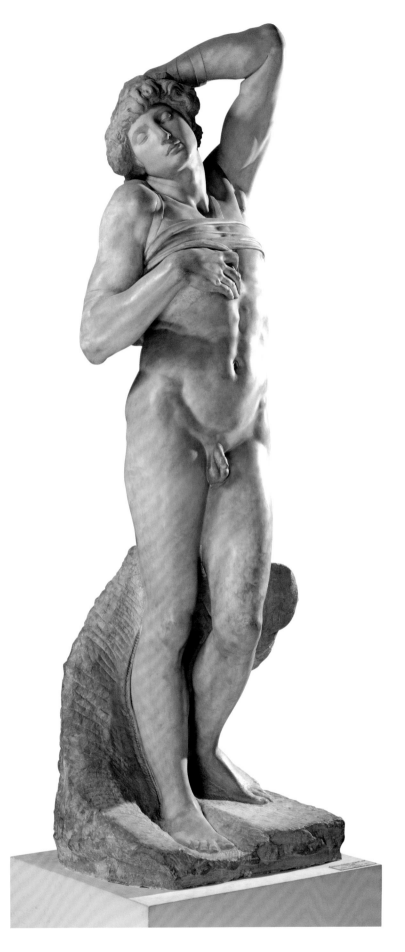

In short, if sculpture still had a long way to go before his time, Michelangelo raised it to the extreme limits of perfection and, to this day, no one can claim to have covered as much ground as he did.

A few years later, Michelangelo, roughed out two circular low reliefs, each called *Madonna with Child*, although this art form suited him only mildly. The first is at the Royal Academy of London and distinguished as the *Tondo Taddei* after Taddeo Taddei, a Florentine art lover and friend of Raphael's; the second is the *Pitti Tondo*, named after the commissioning Bartolomeo Pitti, and now at the Museo Nazionale, Bargello of Florence. In the Bargello medallion, the Virgin is seated on a block of stone (Michelangelo shunned all decorative trappings such as thrones and baldachins); with her left hand she holds a Child who is standing yet asleep on the book in her lap; she is huddled over (the foreshortening arguably lacks fullness) in a pose of perfect grace and freedom of movement as her gaze looks off to one side. The head of St John the Baptist appears behind her in the middle ground. The motif is simple yet richly powerful and charming – it reflects a youthful Michelangelo very sensitive to anything new and delightful.

The London low relief also shows an almost reclining Virgin who is tightly clasping the Child against her, as if to protect him from his young friend on the left and the scroll he is showing him: that boy would become St John the Baptist. This composition arguably flows more freely than the low relief in Florence.

The set of marbles called the *Madonna* of *Bruges* seems contemporary to the Bargello and Royal Academy medallions. Commissioned by the Moscheroni merchant family of Flanders, it went to Bruges and found a home in the Notre Dame Church, which it has never left. In passing, Dürer admired this monumental feat of such noble sentiment as the work of Michelangelo as early as 1521 but it only recovered this attribution in the 19th century.

His mysterious winged child, the life-sized *Sleeping Cupid*, dates to about the same time frame. This statue won such acclaim that it became the determining factor behind his move to Rome, where he arrived on 25 June 1496 at only 21 years old.

*The Dying Slave*, 1513-1515.
Marble, height: 228 cm.
Musée du Louvre, Paris.

If the marvels that graced the Eternal City made a deep impression on the young artist and left him enormously indebted to a metropolis that had nurtured so many geniuses; did he ever imagine that he would surpass any man in marking Rome with its trademark, the lion's claw, or that he would bestow her with the frescoes of the Sistine Chapel, *Moses* for the Palazzo dei Conservatori, and, lastly, the Dome of St Peter's Basilica? Michelangelo quickly established an unbreakable mystical bond with Rome, regardless of the ordeals his vocation would impose over almost three quarters of a century, and however much the tragedy of the tomb of Julius II would excruciate him. A city like Rome needed a man like Michelangelo, and when Destiny formulates her dictates so frankly, retreat or half-measures are not an option.

In 1498, Michelangelo started his *Pietà* for St Peter's Basilica (p. 36, 37), his most popular and pathos-charged work thus far. It resulted from a commission for a marble pieta from the French cardinal Jean de Bilhères de Lagraulas when the artist was 23. Financing came from Jacopo Galli, a prominent Roman, who proclaimed it as "the most beautiful work of marble that Rome will ever see". Completed in 1499, this majestic work took him two years. This early marble already proved his fine mastery of sculpting. The group of figures forms a delicately balanced pyramid: the Virgin dominates the vertical axis and Christ, the horizontal, with ample drapery to connect them. The Son's limp body surrenders to the Mother, who appears disturbingly adolescent – she arguably looks underage for motherhood yet that youthfulness underscores her Original Virginity.

Michelangelo realised a work of absolute perfection that mirrors Divinity in the beauty of Christ's body and of the Virgin's face. Yet the suffering is omnipresent: She is sad yet seems reconciled with her lot, even showing a certain tenderness before the outstretched body on her lap.

The *Pietà* of St Peter's is the only work Michelangelo ever signed. Did his vanity demand insurance against attribution to someone else? He alone could answer that. Because of its supreme perfection and harmony, this work typifies the Golden Age of the Italian Renaissance.

*The Rebellious Slave*, 1513-1515.
Marble, height: 209 cm.
Musée du Louvre, Paris.

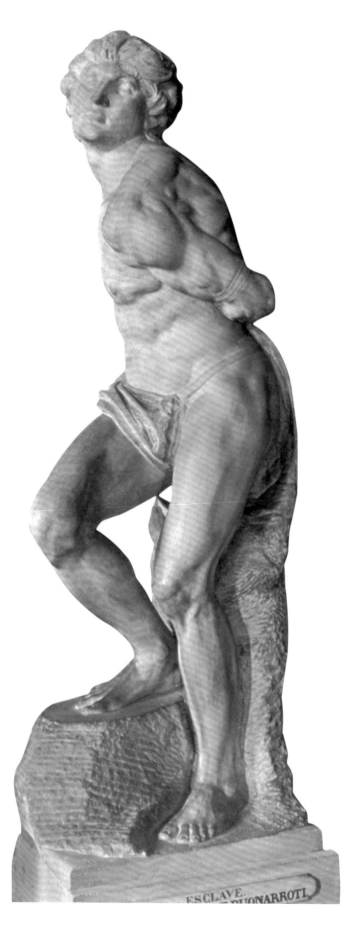

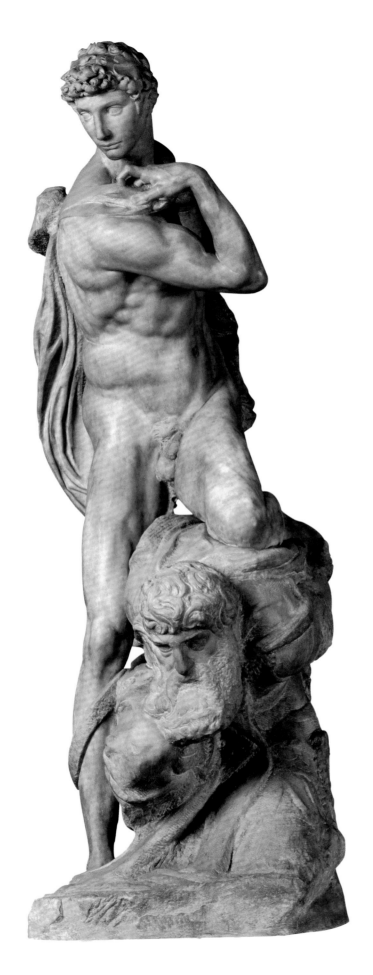

Coming at an otherwise trouble-free period of Michelangelo's life, the *Pietà* nonetheless heralded an inner torment; it was the first symptom of the ever deeper melancholy that would make him an artist of the highest order when it came to expressing human suffering.

Jacopo Galli went on to commission him for *Bacchus* and *Kneeling Cupid* while introducing him to the most powerful patrons. Now at the Bargello, *Bacchus* (p. 38, 39) shows a teetering figure whose left hand has a loose grip on a bunch of grapes that a satyr is about to steal as the right hand thrusts up a full cup of wine, as if in triumph over the viewer. This is an archetype straight out of Antiquity and unique to the artist's oeuvre. We now know the model for *Bacchus* was an ancient marble in the Uffizi Gallery. Need we add that Michelangelo 'appropriated' that work through the modifications he introduced, and that the word 'plagiarism' is taboo in his presence? The ancient statue shows Bacchus lowering his head towards the seated youth at his feet; Michelangelo raises the head, which instantly throws the subject into an entirely different light. And in comparison to the knee-kissing youth in the ancient statue, the little satyr sneaking a nibble at the grapes adds a lively note of spirituality into the equation. For a change, Michelangelo demonstrated the ability to ally humour, spirit, and charm with the world of the sublime. The juvenile figure radiates life and a good, healthy sense of fun, where fulsome masculine forms blend androgynously with feminine gracefulness to propel viewers back to the summits of Ancient Greek glory, yet the execution retains a highly personal and very modern touch.

The *Kneeling Cupid* with a drawn bow at the Victoria and Albert Museum gave Michelangelo the opportunity to try out a foreshortening for which he would develop a special fondness. The motif was as original as it was elegant and picturesque. He was ill-disposed to ignoring any facet of his arts without attacking and transforming them. This cupid is generally dated to the start of Michelangelo's stay in Rome.

*Victory*, 1532-1534.
Marble, height: 261 cm.
Palazzo Vecchio, Florence.

*Victory* (detail), 1532-1534. (opposite)
Marble, height: 261 cm.
Palazzo Vecchio, Florence.

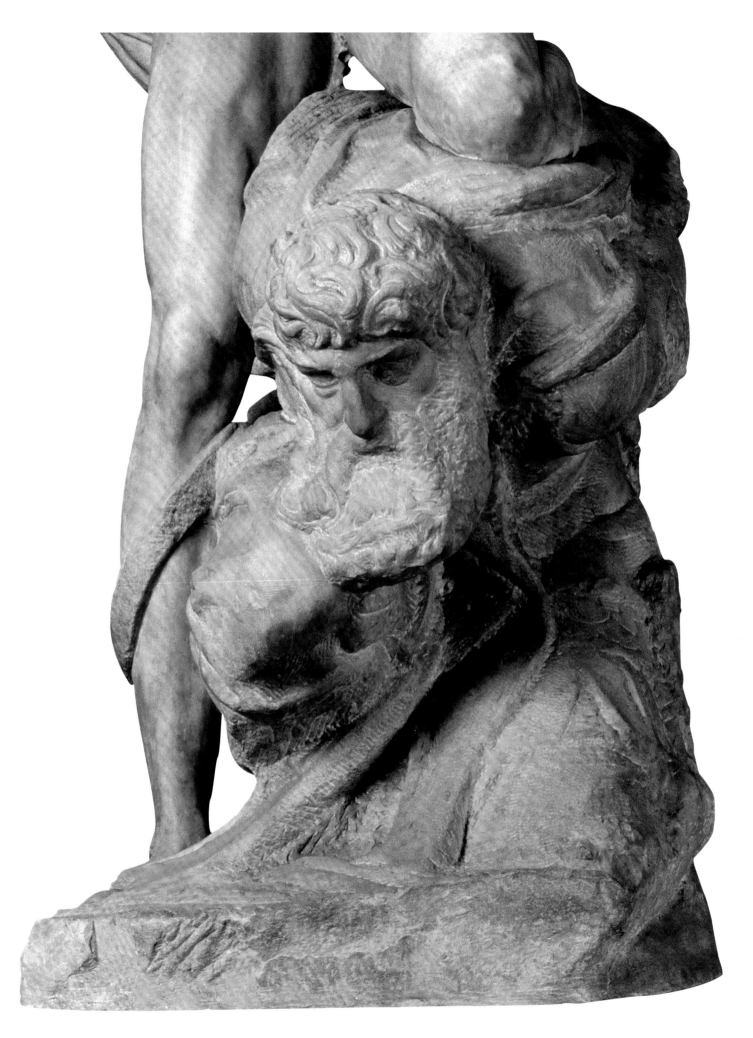

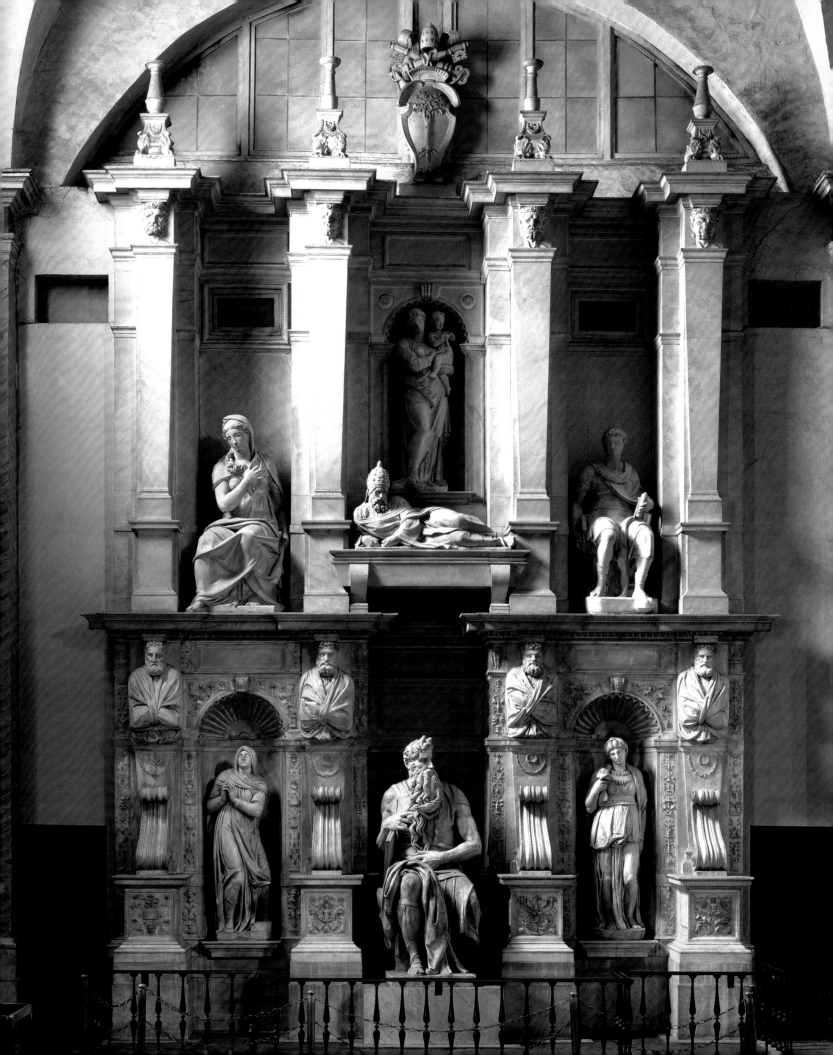

In the *Death of Adonis* at the Bargello, Michelangelo tried a different foreshortening, except that here the figure is reclining: one hand props up the head, with the other hanging across his chest down to the ground. The legs fold back over the boar, whose presence gives the work its true meaning. What 15th-century sculptor would dare have imagined a figure in a posture both knowledgeable and approachable?

Michelangelo's first stay in Rome covered 1496 to about 1501. The young master returned to Florence after friends had secured him a commission that promised more fame than his *Pietà*: the execution in marble of a *David*, the biggest statue Italy had seen since the fall of the Roman Empire.

Standing outside the Palazzo Vecchio in Florence until 1873, *David* (p. 20, 42, 43) is now at the Galleria dell' Accademia in Florence and took from 1501 to 1504 to complete. Its genesis is a story in itself. At first, the Cathedral of Florence promised Bartolomeo di Peitro 300 florins to rough-hew a 13.5-metre-tall statue of David onsite in Carrare and finish it in Florence. The cathedral took delivery and paid out but did not like the huge product. After Andrea Sansovino failed to secure a commission to rework the monolith, the task fell to Michelangelo on 16 August 1501 for six gold florins per month, plus a completion bonus of 400 pounds.

Fresh from Rome, Michelangelo set to work drawing heavily on his studies of *Castor* and *Pollux* in Monte Cavallo. Yet his *David* differs radically from either Greek work. He also started off with a serious mistake: forgetting that only adults make suitable models for bigger-than-life artworks, he selected an incompletely developed youth and his *David* has a puny look that clashes with its huge scaling. Had his model been at least adolescent, he could have fully powered the musculature to animate and support the colossus.

The *David* strikes a simple pose: given its size, any stronger action pose risked compromising balance, although Di Pietro's previous chiselling may have left Michelangelo little leeway to try. At all events, it was an extraordinary accomplishment to have extracted so noble and animated a figure out from such a disproportionately flat rectangular mass.

Supporting his body with the right leg and carrying the left leg forward, the almost divine young hero lets his right hand fall to thigh level as he flexes in the other to shoulder height. His face is bold yet thoughtful: he is defiantly awaiting his adversary and calmly sizing up his chances like a true Florentine as he plans an attack of questionable loyalty.

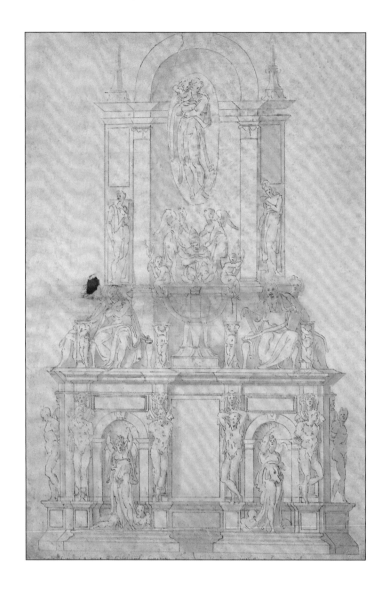

Florence sports two *Davids*: the first stands before the Palazzo Vecchio and the second, across the Arno River at Piazzale Michelangelo, where it was installed in 1875. The two masterpieces struck like lightning. Never before had the naturally sceptical Florentines reacted with such riotous enthusiasm.

Although free of financial woes or people problems, Michelangelo started to become gloomy and harshly critical,

*Project for the Tomb of Julius II.* (opposite)
Marble.
San Pietro in Vincoli, Rome.

**Giacomo Rochetti**, *Tomb of Pope Julius II*, painting after Michelangelo's project, 1513. (above)
Quill and ink, 52.5 x 39 cm. Staatliche Museum, Berlin.

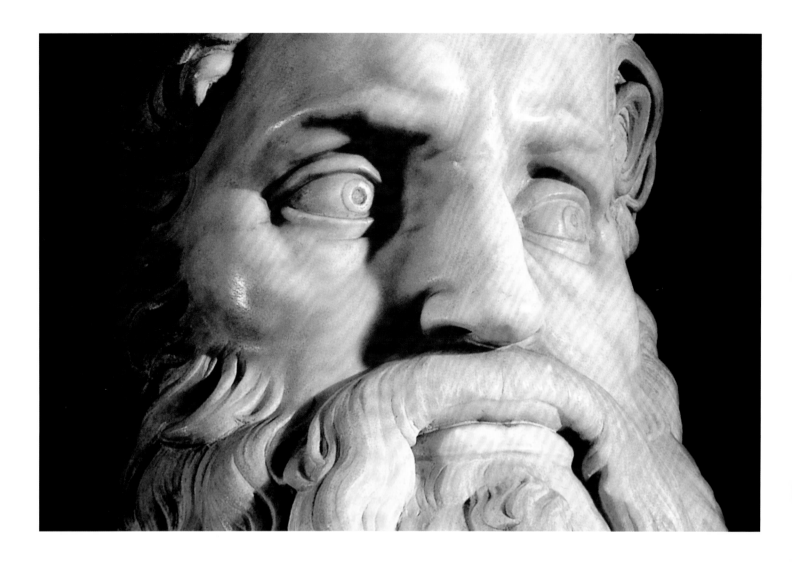

two traits that would trigger a string of difficulties and earn many enemies. He called Perugino a fool in a public tirade, and sarcastically rebuked Da Vinci for abandoning work on a bronze horse for Francesco Sforza, and more. But his fellow Florentines had oceans of indulgence for him and Piero di Tomasso Soderini, the chief justice of Florence, never missed a chance to send a new commission his way or give him extra publicity. As a result, Michelangelo amassed an impressive number of orders, including the bronze *David* for the marshal of

Gié in 1502 (which has long since disappeared) and the full set of *Twelve Apostles* for the Cathedral of Florence – of which he only ever completed *St Matthew* (p. 45).

It was around this time that Michelangelo produced some of his finest paintwork: the *The Holy Family (Tondo Doni)* (pp. 82, 84), *Battle of Cascina* (also called *War of Pisa*) cartoon, and perhaps the *Manchester Madonna* (p. 85).

The *Battle of Cascina* was delivered in August 1505, after Michelangelo's return to Rome. On 1 November 1503, Cardinal Giuliano della Rovere succeeded Pope Pius III. Nephew to Sixtus IV, Della Rovere became famous as Julius II. His pontificate raised high hopes among Italy's finest artists and Michelangelo was hardly the last to test his chances with so magnificent and devoted a patron of the arts. In Julius II, Michelangelo met as strong-willed a man as himself and someone with no taste for backtalk. The clash of minds stimulated the artist's genius and the despot went on to offer the artist the most splendid challenge any painter or sculptor could imagine.

*Moses* (detail), 1515.
Marble, height: 235 cm.
San Pietro in Vincoli, Rome.

*Moses*, 1515. (opposite)
Marble, height: 235 cm.
San Pietro in Vincoli, Rome.

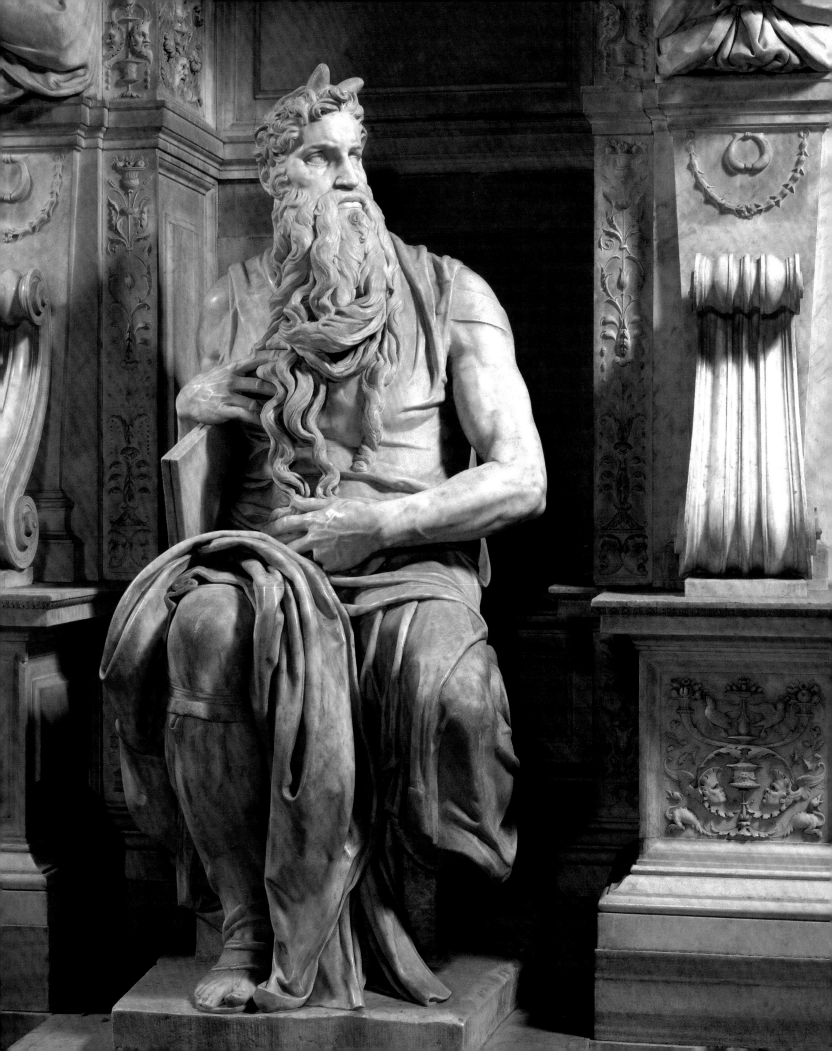

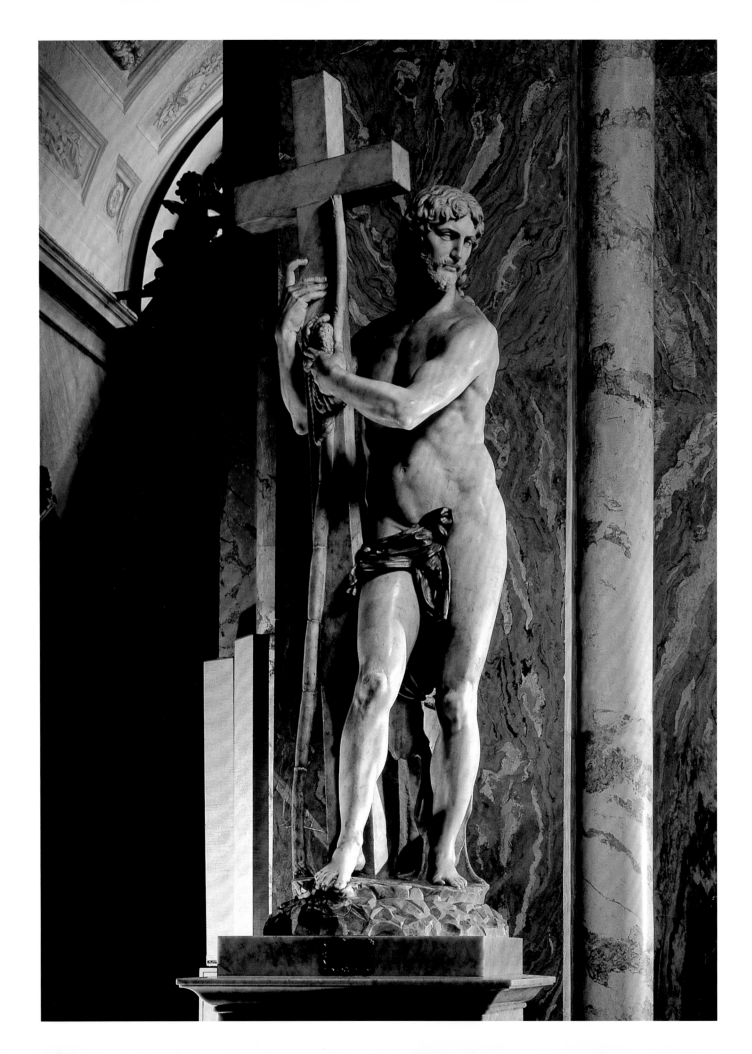

In art, the aged Pope and young sculptor understood each other and it is unclear who invested more in the relationship: the Pope who built a good deal of his glory on this initiative or the artist who benefitted from the chance to complete his finest masterpiece. The Pope did not always have the last word in this duel between two equally obstinate individuals: as he admitted himself at their reconciliatory meeting in Bologna: "Yes, instead of coming to us, you waited for us to come to you."

Michelangelo's variety of output up until then contained a serious flaw beyond his control. Though all of his works were masterpieces, they were also isolated items lacking any common principle or overall coherence to magnify their individual power and significance. Julius II soon gave him the chance to establish such unity for his oeuvre with a commission for his papal tomb.

The commission was apparently issued around April 1505 and the artist immediately set to work on it while finishing his cartoon for the *Battle of Cascina*. By December, he was at the quarries of Carrare, where he would spend extended periods at different points in his life. This was because he needed to choose each marble block personally and he saved on freight costs if the rough-hewing happened before shipment.

The story of the artist's dispute with the Pope, his flight to Florence and reconciliation in Bologna are too well known to repeat here. Suffice to say that the upshot was a commission for a bronze statue of the Pope destined for Bologna, and the result exceeded all expectations. It shows Julius II seated with a tiara on his head as one hand extends a blessing and the other holds the Keys of Paradise. When Michelangelo first suggested a book in one hand, the Pope shot back with: "What! A book? I'm no scholar – give me a sword!" Untrained in metal casting, Michelangelo suffered countless problems and delays. It was only fifteen months after his arrival in Bologna that the statue was finally installed and inaugurated on 21 February 1508. During the revolt of 1511, the statue was torn down and handed to the Duke of Ferrara, who turned it into a cannon christened 'La Giuliana' (derived from 'Giuliano', Italian for 'Julius'). But the duke kept the 600-pound head in his palace until its subsequent disappearance, thus completing the demise of the statue.

In the spring of 1508, Michelangelo was back in Rome, probably due to the pressure of having to complete the papal tomb, which never came to pass. Though started several years earlier, the mausoleum was never completed, though you might say it was finished off much later. Michelangelo called these vicissitudes the tragedy of his life and the spectre of that tomb haunted his imagination for over forty years.

In the original agreement between the Pope and artist around 1512, the mausoleum was to start with a central tomb inside a marble enclosure sporting one set of statues in niches and another before the pillars. The first set was to represent the *Victories* and *Vanquished Provinces* and the other, the *Liberal Arts*. A second level was to carry four even bigger statues.

When Julius II died in 1513, the heirs renegotiated and Michelangelo committed to a seven-year deadline for the tomb against a fee of 16,500 ducats, less the instalments already paid out. The monument was to be even more magnificent than the Pope had foreseen, for the original budget only reached 10,000 ducats. In 1516, further renegotiation obtained a nine-year deadline with an upgrade to thirty statues, plus the architectonic works and low reliefs. Once again, the artist returned to Carrare to supervise the quarrying. But Leo X already had other plans for Michelangelo's talents. Though untested in architecture, Michelangelo was commissioned for the façade of the San Lorenzo Church located in the Medici family parish. Citing commitments to the heirs of the last Pope, the artist tried to wheedle out of the deal but was forced to obey. Condivi says Michelangelo was in tears over abandoning a tomb that promised to be his supreme masterpiece. By 1532, he had received 8,000 ducats and further renegotiation extended the tomb deadline to nine years against only six personally-crafted statues, including the *Leah*, *Rachel*, and *Moses*. The tomb was still very incomplete in 1542 when the artist overcame his disdain for task-sharing and brought in outside help. Only after numerous setbacks could St Peter's Basilica finally host a bare-bones version of the tomb, which Michelangelo had originally estimated at 200 tons of marble.

The statues destined for the tomb now fall into four categories: the two *Slaves* at the Louvre; the four rough-hewn *Slaves* from the Boboli Garden moved to the Galleria dell' Accademia in 1908; the *Victory* in the Palazzo Vecchio; and the element now at St Peter's alongside the statues of *Moses*, *Leah* and *Rachel*.

---

*Christ Resurrected*, 1521.
Marble, height: 205 cm.
Basilica Santa Maria sopra Minerva, Rome.

Michelangelo started out by doing the *Rebellious Slave* (p. 47) and *Dying Slave* (p. 46) in 1512 and sketches at the University of Oxford show figures in chains, hands behind their backs and legs crossed in highly dramatised postures. The *Slaves* are now key attractions at the Louvre. However, they became irrelevant as the project evolved and the artist gave them to his friend Robert Strozzi in Rome before the works ended up in France. There, they turned up at the Château d'Ecouen, home of the Constable of Montmorency before reaching the French statesman Cardinal Richelieu in the following century.

There is lively debate over what both statues might mean. Almost taking dictation from Michelangelo, Condivi says that the prisoners are chained like the Liberal Arts; Painting, Sculpture, and Architecture are each flagged with the tools of their respective trades for instant identification. He adds, "They also express that, like Pope Julius, all Virtues are prisoners of Death and that never again shall they find anyone to promote and defend them as he did."

It is impossible to imagine any contrast more eloquent than that between the two *Slaves* at the Louvre. The first is an adolescent standing with his eyes shut as he clasps one arm against his chest while the other tries to prop up a tired head as though he has given up – exhausted, he has fallen back into the sweet unfettered sleep of youth with a faint smile across his lips that briefly lifts him beyond the cares and doubts of earthly existence. The older slave, however, is of different mettle: he is a fighter who knows his strength. Hands tied behind his back with one foot on the ground, he casts an ardent look at the heavens, both in protest and in a plea for help: Michelangelo invested his whole heart and soul into that look, along with his ferocious love of freedom and justice. We stand not before some symbolic figure, but before Prometheus himself – a Prometheus immovably chained to a rock by his unshakable will ready to defy the gods as long and as often as needed. It is an admirable example of the moral strength that lives on in humankind even after the body becomes helpless.

We could analyse forever the plastic beauty of the *Slaves*. The adolescent's deathly flesh, elegant reliefs, and suave

---

*River God*, c. 1524-1527.
Wood, clay, sand, animal skin, wool, vegetable and metallic fibers,
65 x 40 x 70 cm. Casa Buonarroti, Florence.

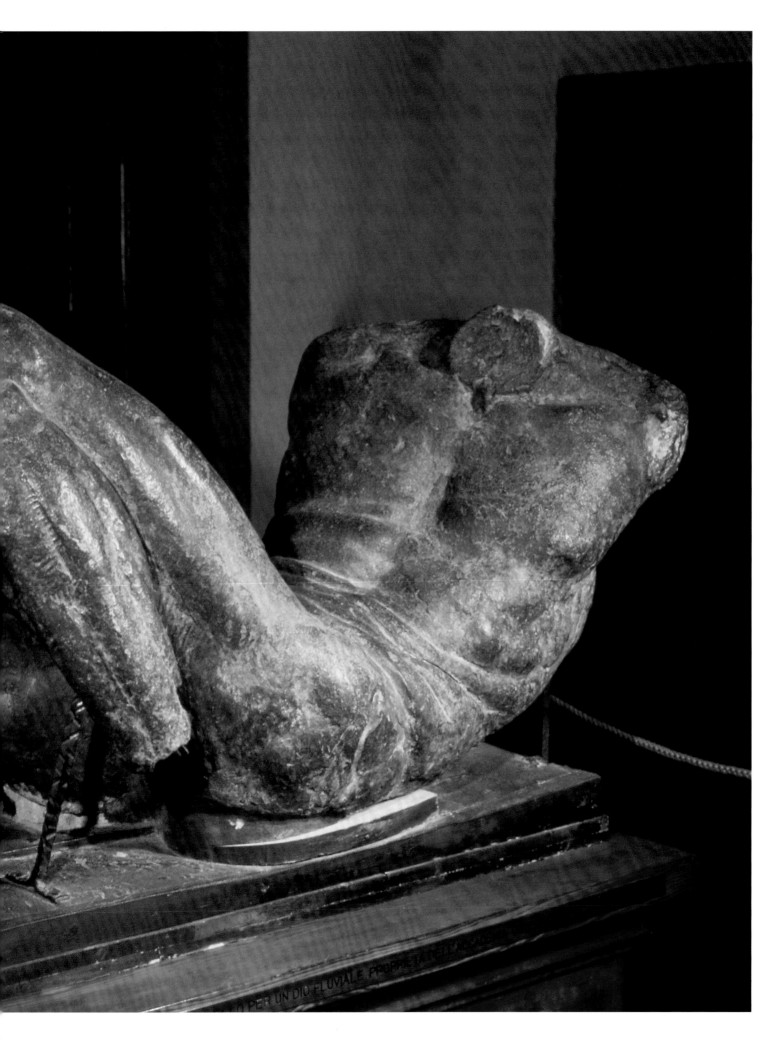

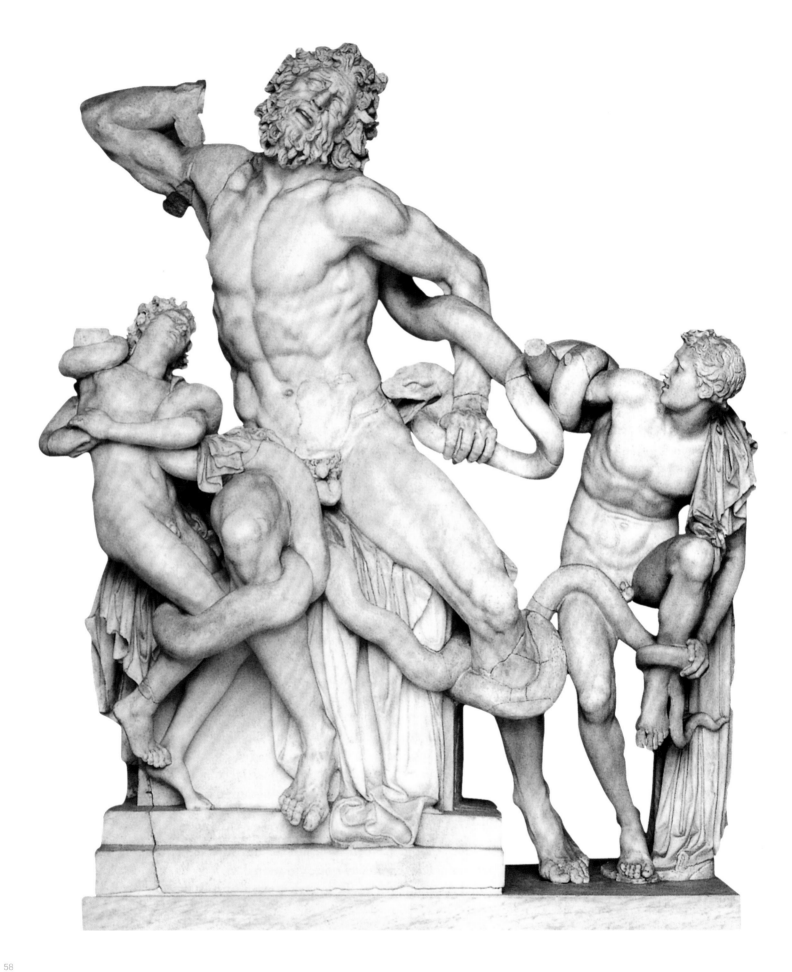

contours all command admiration, as does the consummate talent the artist applies to represent languor and a sort of surrender. The elderly slave's extreme grace finds counterpoint to the youth's prideful revolt – his body huddled into a compressed spring on the verge of releasing its tension. The limbs and muscles betray unusual vitality, yet the artist's quest for brute force does not undercut the elegance of the accompaniment.

Of his *Prisoner (Atlas)*, *Bearded Slave*, *Young Slave*, and *Awakening Giant* on display at the Accademia since transfer from the grotto of the Boboli Gardens, they are really only rough drafts that admirably reflect the trends of their times.

The pendant for the Louvre *Slaves* is Michelangelo's *Victory* (p. 48, 49) at the Palazzo Vecchio. In that work, the artist opposes pride and disdain in victor and vanquished. Entirely self-confident, the victorious adolescent lays one arm along the length of his body as he fetches a garment to his shoulder while pressing a knee to the neck of the prisoner at his feet, as if in warning that he remains alert to engage at the first hint of attack. Compared to Donatello's *St George*, you see a standoff between dignified low-key self-assurance and neurosis-driven heroism. Some observers rightly find the statue incomplete and link it to a drawing of a winged adolescent at the Casa Buonarroti: if you mentally reconstitute the statue from that drawing, you see that wings do round out the effect.

*Victory* is admirable for the almost excessive freedom of the pose: one leg stands upon the defeated opponent while an arm presses against the chest, the torso takes a violent, backwards twist to the left and the head turns right to present a profile, and suggests a longer, stronger right shoulder.

Having developed so many tricks of the trade, Michelangelo was heavily tempted to dazzle with any effects he could work into his pieces. If unable to resist such excess, at least he had enough genius not to flop. But what of lesser disciples who tried to mimic his feats without the trade secrets he kept to himself?

Of the six statues slated for the upper level of the *Tomb of Julius II*, only *Moses* was executed and survives to this day. Michelangelo started it between 1513 and 1516, when his overriding concern was grandiose figures of the Prophets for the Sistine Chapel, only to finish it in 1545. The style is identical to that dominating the frescoes: robust forms, intense expressions, and outlandish over-sizing.

Everyone must see his *Moses*! Seated on a base with a sleeveless tunic carelessly spread over his body and legs, clothed in the sort of pantaloon proper to barbarian prisoners, carved into arcs of triumph, the Prophet has his left hand on his lap, and his right around a book. His naked arms, explosive blood vessels, and powerful torso express superhuman strength while the implacable hardness of his face, thick hair set against a narrow skull, and long, unkempt beard proper to Eastern monarchs typify this lawmaker unswayed by any humane sense of pity. This is indeed the man entrusted with the words of Jehovah on Mount Sinai: his gaze remains set above the level of the mortal masses as it queries mysteries he alone has glimpsed. It has been argued that the statue represents Moses about to leap from his chair after learning that the Israelites were worshipping the Golden Calf – but if that were so, he would not be toying with his beard.

Beside *Moses,* in St Peter's stand *Leah* and *Rachel* to symbolise activity and contemplation. Inspiration for carving these two women came from Ch. XXVII of Dante's *Purgatory*:

> Whosoever asks my name shall know it is Leah and that I take everywhere my beautiful hands to make myself garlands. This I do to please myself in the mirror; my sister Rachel never turns away from hers but remains seated before it all day long. She is eager to look at her beautiful eyes, as I am to adorn myself with my hands. Her joy is contemplation and mine, action.

Michelangelo started these statues in 1542, late in his life. Where Leah looks enigmatic, Rachel clasps her hands to appear as graceful as Civitale's *Faith*. Having concentrated on expressing nothing but strength and passion thus far, Michelangelo eased up in old age and gave in to almost affected elegance.

Julius II chose to lie in St Peter's Basilica because he became cardinal there. Beyond the *Moses, Leah*, and *Rachel* just cited, the monument now set against the walls of the Basilica also includes Giacomo del Duca's insipidly styled *Hermes* statues, others of the *Prophet* and *Sibyl* by Raffele da Montelupo, and Maso Boscoli da Fiesole's truly grotesque Pope lying flat on his back.

---

*Laocoön and his Sons*, Hellenistic era.
Marble.
Vatican Museum, Rome.

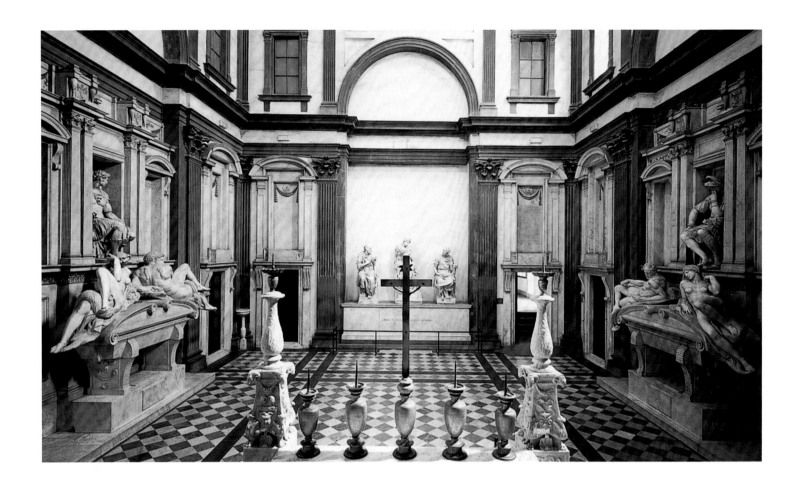

Inspecting the works of his disciples, Michelangelo could only conclude that he would have to be his own successor. Mediocre talents were quick to exaggerate and exasperate the elements of decadence he had injected into Italian art. Far removed from those of Giotto, Masaccio, or Raphael, Michelangelo's style throttled all feelings up to maximum intensity, leaving no room for works other than those of geniuses. Indeed, the sight of so much deplorable decadence must have appalled the man who had inspired it despite himself.

---

Interior of the Medici Chapel, 1520-1534. (above)
Basilica of San Lorenzo, Florence.

Study for the strengthening of the Porta al Prato d'Ognissanti, c. 1529-1530. (opposite)
Quill, watercolour, and red chalk, 41 x 57 cm.
Casa Buonarroti, Florence.

Interior of the Medici Chapel, 1520-1534. (pp. 62-63)
Basilica of San Lorenzo, Florence.

From 1508 to 1512, Michelangelo devoted himself exclusively to the vault frescoes of the Sistine Chapel, which we shall cover in the chapter on his painting.

During the pontificate of the violent and equally energetic Julius II, Michelangelo executed more masterpieces than new project designs. The opposite happened under Leo X, successor to Julius II: from 1513 to 1521, Michelangelo spent almost all of his time drafting all manner of projects, testing new ideas by trial and error, or starting sculptures he left unfinished. The root of the matter was that Leo X and Michelangelo were mutually incompatible; the latter was a morose misanthrope and the former, a true epicurean who loved even the spiciest pleasures. To reach Michelangelo's soul, you needed a minimum of shared aspirations and although Leo X could bond with Raphael and mine his talents brilliantly, he shied away from Michelangelo. Actually, he feared this stickler for justice who spoke so harshly of his benefactors, the Medici. In Sebastiano del Piombo in 1520, Leo X said as much himself: "Michelangelo is a terrible man, one cannot get along with him."

Under this pontificate, Michelangelo pursued work on the tomb of Julius II, took up the façade of San Lorenzo Church in

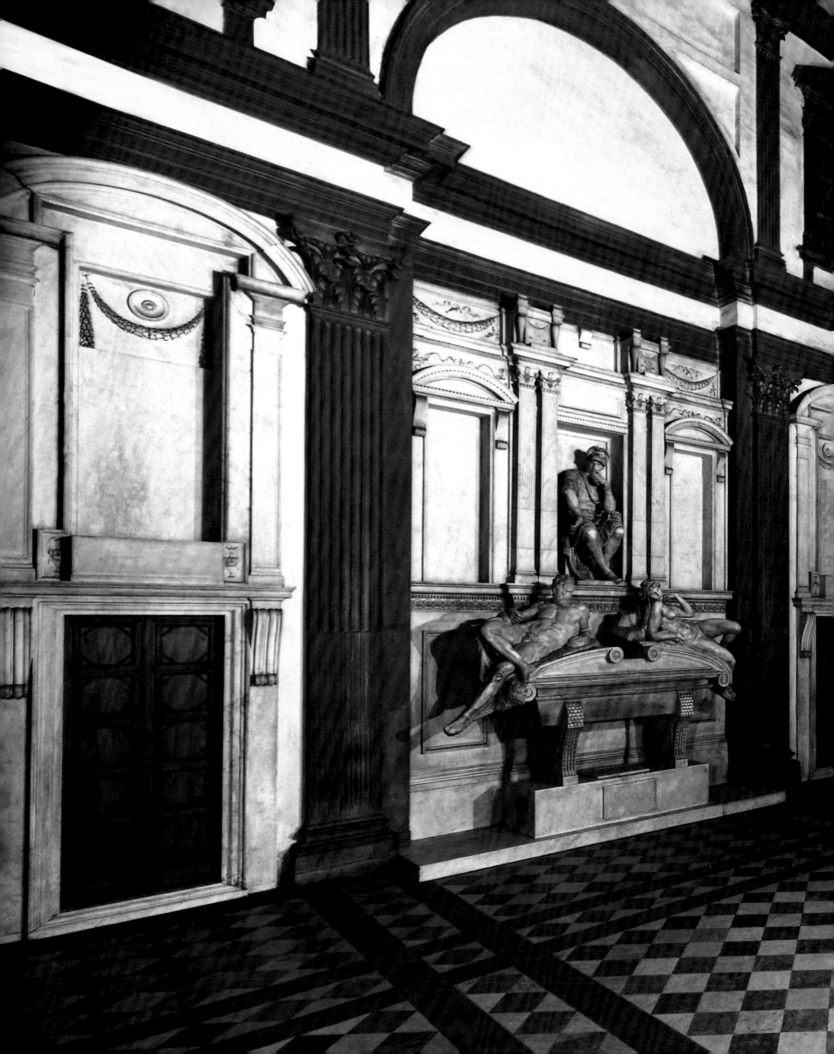

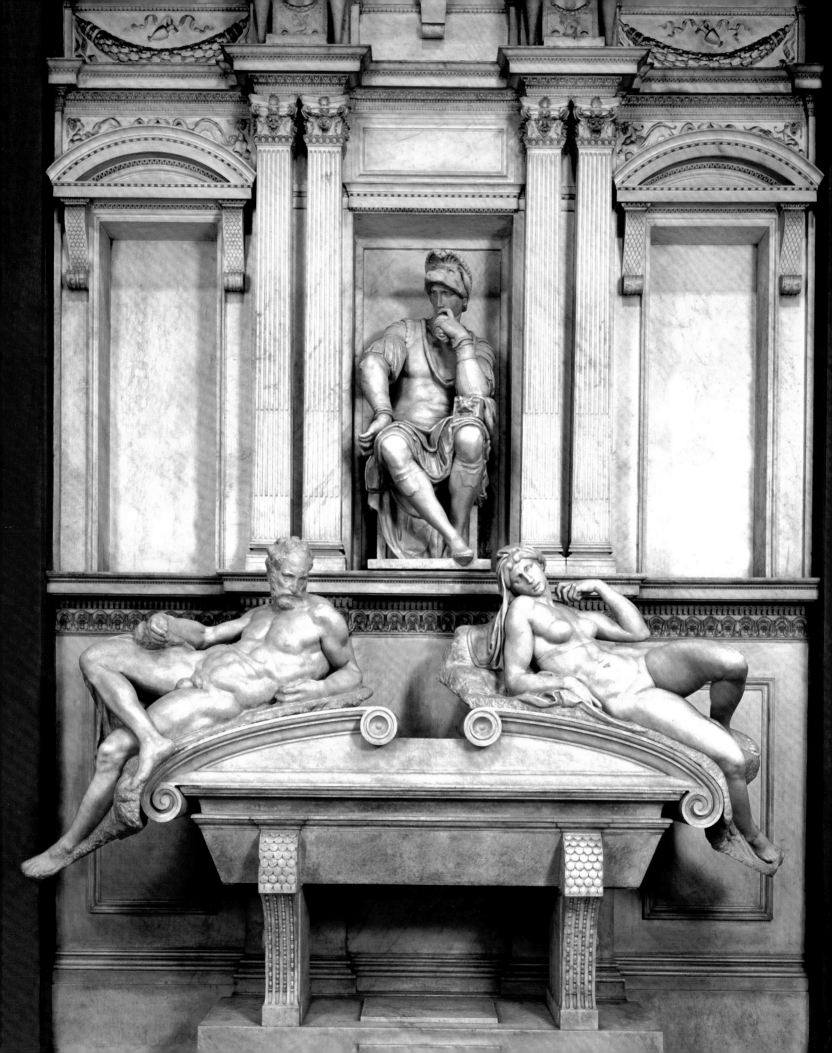

Florence, started the Medici tombs, and executed his *Christ Resurrected* (p. 54) statue for the Santa Maria sopra Minerva Church in Rome. As seen, the sculptor had entirely stopped painting and was already headed into architecture. Like Raphael, Michelangelo devoted his later life to architecture, a discipline more suited to the scientific and thinking skills of mature masters. It was cruel for Michelangelo to need to sit out the pontificate of Clement VII from 1523 to 1534 before his next commission for a painting.

Commissioned in 1514 and completed in 1521, the *Christ* statue in the Minerva Church was his only major work for Rome in that timeframe. His first try was a disappointment; the figure reeks with contrived elegance so foreign to the artist's combative personality: the head is undersized, the movement is unnatural, the pose looks stiff, and the torso is atrophied. At the time, Michelangelo had lost his grip on calm, harmonious forms and was obsessed with expressing passionate emotion. And once that mindset had come to the fore, his best option was to follow through rather than try to backpedal.

For almost twenty years, Michelangelo's sandbox became Florence, not Rome. Florence was livelier and fresher than the Eternal City but far less grandiose. However ill-advised it was of Leo X to move Michelangelo from working on the tomb of Julius II to the San Lorenzo façade (still unfinished despite a flurry of design proposals), Leo X deserves more credit from the artist and posterity for commissioning the tombs in San Lorenzo Church of his brother Giuliano and nephew Lorenzo. The challenge was enviable: he was to do the statues for the sanctuary as well as their architectonic structure.

Michelangelo first mused over the Medici Chapel in the San Lorenzo Church in 1519 after the death of Leo X's nephew, Lorenzo de' Medici (II), Duke of Urbino. The tomb of the Pope's brother, Giuliano, Duke of Nemours, was to follow. Then came the tombs of his father, Lorenzo de' Medici and of his second cousin, 'Founding Father' Cosimo I, all of which were embellished with a wealth of allegorical figures such as *Sky*, *Earth*, and *Rivers*. The rare and magnificent ensemble was truly a worthy complement to the famous mausoleum of Julius II. The original decoration was elaborate. A sketch at the Uffizi Gallery shows angels lifting funerary drapes, as do the statuettes of the Dome sacristy, but what a strong sense of movement in both! According to Vasari's *Vita di Tribolo*, Michelangelo wanted to flank Julius II with two statues; one tilting its head downwards under a crown of cypresses to mourn the loss of the young nobleman and thus symbolise the Earth; the second was to represent Heaven joyously welcoming his soul in its embrace.

As with Julius II, the Medici tombs suffered a string of modifications before reaching their current state. In May 1524, Clement VII thought of having his own tomb next to his uncle's. He foresaw a monument with one pair of sarcophagi twinning Cosimo I to Lorenzo de' Medeci and a second pair for Giuliano and the younger Lorenzo, plus separate monuments for each Pope. All thought of perpetuating the memory of Cosimo or the elder Lorenzo was shelved and only the remaining two were ever built.

San Lorenzo actually has three funerary chapels, all devoted to the Medici family: Brunelleschi's Old Sacristy that shelters the Donatello's and Verrocchio's tombs of Averardo, Cosimo I and his son Piero; the New Sacristy contains the tombs of dukes Giuliano and the younger Lorenzo; and the Chapel of the Princes, hold those of the Medici archdukes since Cosimo I.

The death of Leo X brought work to a halt. When the heirs of Julius II petitioned the new Pope with requests based on existing agreements, they found a friend in Adrian VI; Michelangelo had to return to the unfinished tomb of Julius II. Luckily, Cardinal Giulio de' Medici, now Pope Clement VII, fully understood and admired Michelangelo's genius. But in May 1527, a cruel twist of events again suspended all work. Emperor Charles V had sacked Rome when Florence revolted and shattered the Medici hold on power. As soon as the Pope and emperor had reached an understanding in September 1529, Florence came under siege. After heroic resistance, Florence surrendered on 12 August 1530, thus ending over three years of independence.

On 6 April 1529, long before siege was laid, Michelangelo found himself elected General Governor and Steward of Fortifications. With typical gusto, he set about learning military architecture on the job, demonstrating the same excellence he showed in art, notably visible in the fortifications to defend San Miniato Hill. And then suddenly he panicked, grabbed his 3,000 ducat bankroll and fled the city, just as he had done after his first contacts with Pope Julius II.

---

*Tomb of Lorenzo de Medici*, 1525-1527.
Marble, 630 x 420 cm.
New Sacristy, Medici Chapel, Basilica of San Lorenzo, Florence.

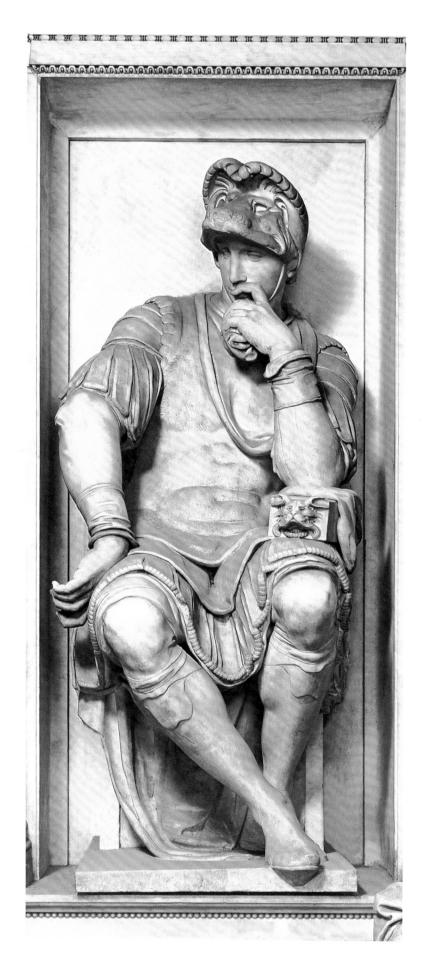

Feeling threatened anywhere near the rebel city, he ran off all the way to Venice where he contacted François I, who he knew was keen to secure his services. But the Florentine authorities had declared him a rebel along with twelve other citizens who had also deserted the city. However, they rescinded the decision and gave him a full pardon when he offered to return. Indeed, he did return and worked wholeheartedly for the upstart republic until its capitulation. Michelangelo was too dear to Clement VII for him to trifle over the artist's treasonous behaviour. He too forgave him, albeit on condition that he promptly resume the *Medici Tombs*.

He returned to those tombs with such a vengeance that his health suffered, causing friends to ask the Pope to ask him to lighten up. Knowing that the artist's depressed health was partly due to his inability to honour his commitment for Julius II's tomb, Clement VII forced Michelangelo to work only for the Vatican under pain of excommunication. Such an 'Act of God' sufficed to cool off many a hot-headed artist. Nonetheless, Michelangelo felt that there were duties to one's conscience which no earthly or heavenly power could annul. Thus, he went to Rome in the spring of 1532 to sign a renegotiated contract with the heirs of Julius II and only then worked exclusively on the *Medici Tombs* until the death of Clement VII in 1534.

This masterpiece took him from about 1519 to 1533. Yes, numerous other commissions interrupted him along the way. The ensemble was finished, or at least entirely rough-hewn before the siege of 1529, with the probable exception of his *Pensieroso*.

Armed with all of the above, let us turn to the chapel and its statues. The arrangement is minimalist: each of the two main walls contains three rectangular niches. There is a statue of a Medici in the central niche; the other two are empty. Below, a sarcophagus protrudes on a large projection, with its lid and helixes supporting a pair of male and female figures, semi-reclined back to back.

*Tomb of Lorenzo de Medici* (detail), 1525-1527.
Marble, 630 x 420 cm.
New Sacristy, Medici Chapel, San Lorenzo, Florence.

*Tomb of Lorenzo de Medici* (detail), 1525-1527. (opposite)
Marble, 630 x 420 cm.
New Sacristy, Medici Chapel, Basilica of San Lorenzo, Florence.

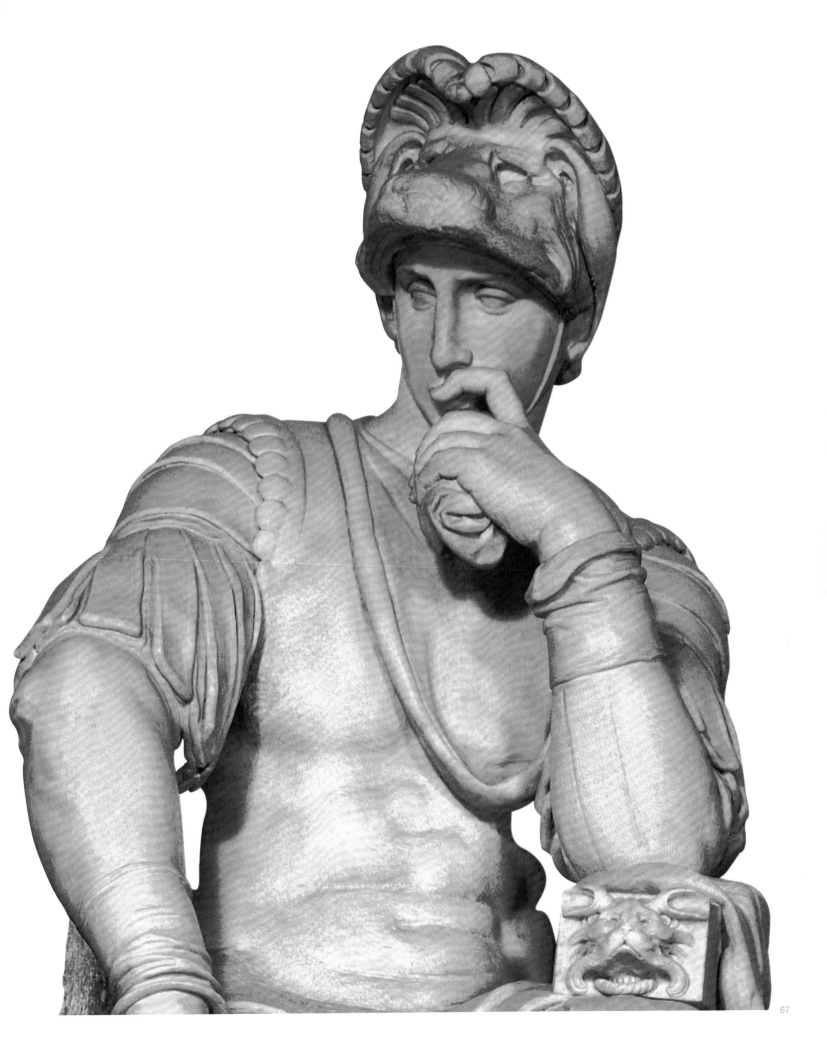

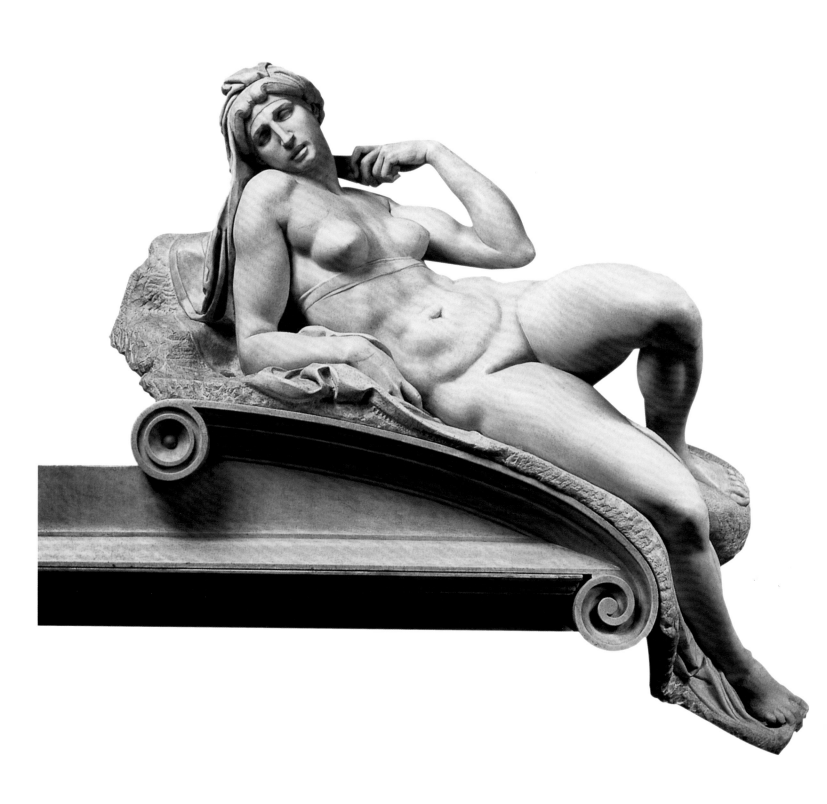

*Dawn*, detail of the tomb of Julius de Medici, 1525-1527.
Marble, length: 203 cm.
Medici Chapel, Basilica of San Lorenzo, Florence.

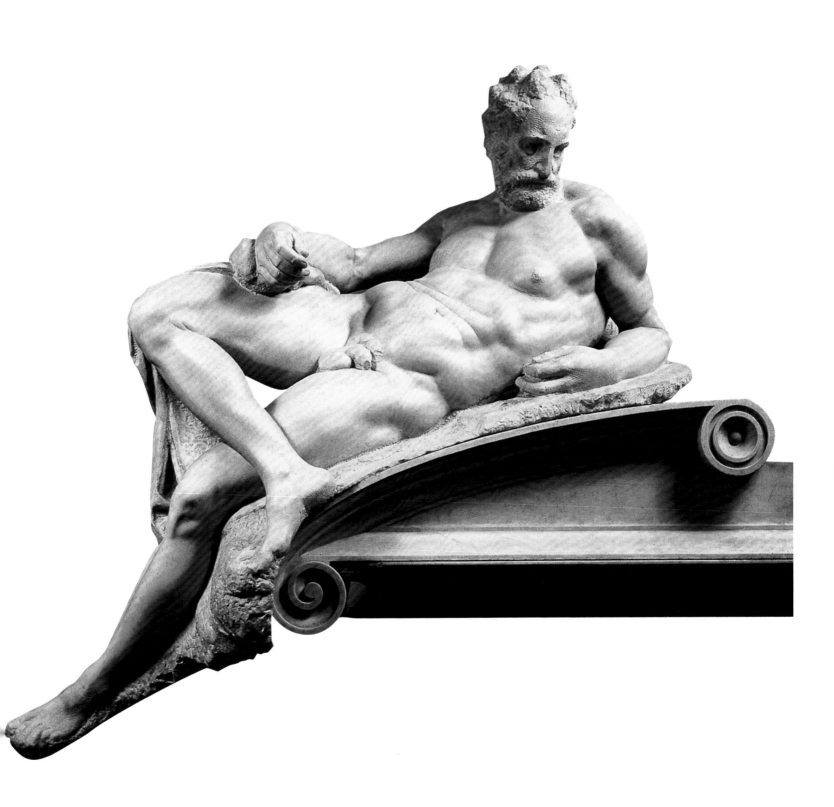

*Dusk*, detail of the tomb of Lorenzo de Medici, 1525-1527.
Marble, length: 195 cm.
Medici Chapel, San Lorenzo, Florence.

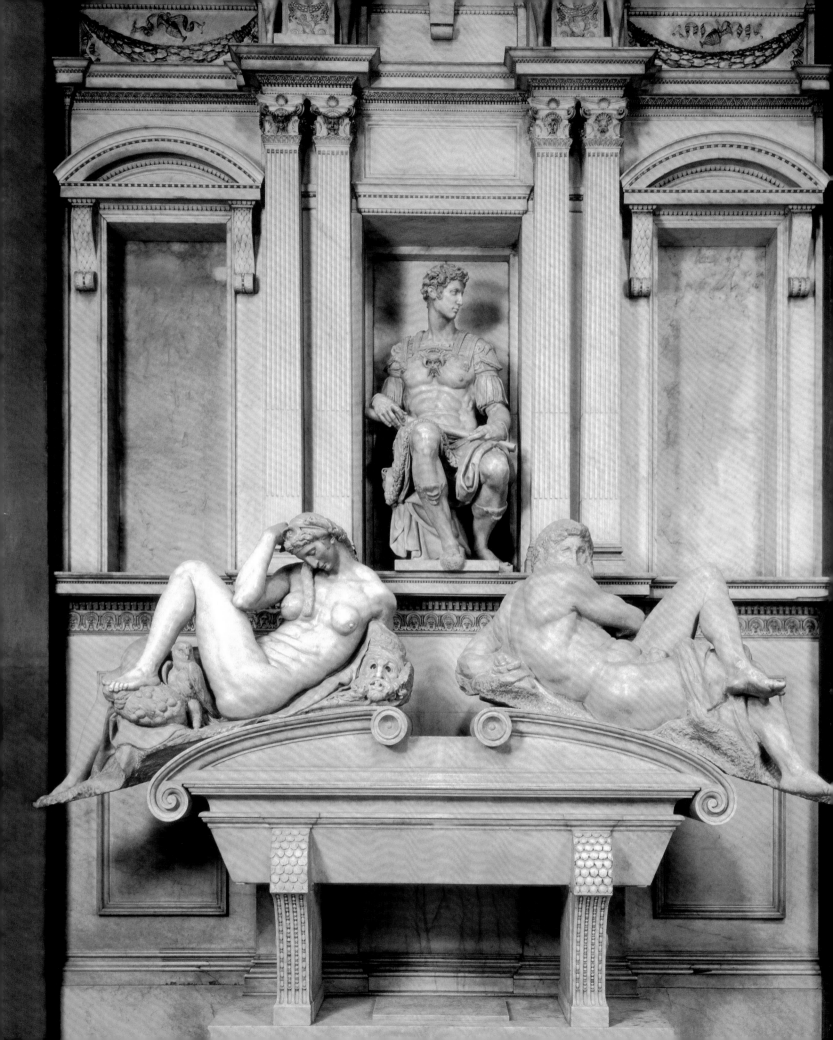

Finely tuned rhythm and proportions were not of leading concern to Michelangelo's fiery spirit, quick to lose patience with any form of discipline. The sarcophagi look too small for the colossuses they carry. But if they barely provide solid support, their inconvenient position obtains an effect all the more stunning. In a sketch still archived in Florence, Michelangelo had foreseen this objection: it shows a much longer lid scooped out in the middle so as to better support the figures. But the figures still upstage the sarcophagi and if the architectonic structure is to be sacrificed to statues and ornamental considerations, then the best option is, frankly, to become a full accomplice of the rule-breaking and total loss of credibility, as the artist did here.

The prodigal figures of the *Pensieroso, Day, Night, Dawn and Dusk* (*Twilight*) add up to a universe of heroic output that positions Michelangelo to rival with the greatest sculptors of Antiquity.

The easygoing freedom that Michelangelo obtains from his *Giuliano de' Medici,* without compromising the subject's aristocratic nature, shows that he had finally solved all his problems. Presented as a bareheaded Roman victor covered in ornate body armour, sporting naked legs tipped with laced boots and the commander's sceptre on his lap, the brother of Leo X is quietly looking off to the left; his pose is one of calm, self-confident triumph. If Giuliano de' Medici's uncovered head and frank facial expression are an eye-stopper without even facing the viewer, Lorenzo de' Medici, who pairs him off, seems absorbed in deep meditation. His face disappears into the shadows of his helmet through a light and shadow effect more proper to painting than statuary art. Chin on his left hand with the right hand carelessly dropped to his knees, the bust and legs seem overcome with a sort of grogginess: how admirably this reflects the intimate labour of introspection – what could he be thinking about? Overambitious projects suddenly brought to a halt? The vanity of all things human? The *Pensieroso* has evoked centuries of admiration.

More flagrantly than any other work, these two statues demonstrate Michelangelo's sovereign disdain for historical fact and accurate physiognomic portrayal. First, you can hardly recognise Giuliano or the younger Lorenzo. For example, a medallion shows Giuliano wore sideburns before growing a proper beard and his face had regular but unaccentuated features.

Michelangelo also flouts reality about their personalities, especially in the younger Lorenzo. This Medici was insatiably ambitious whereas the statue portrays an idealistic dreamer, right down to the half-folded fingers of his right hand indicating absorption in dynamic thought – a gesture also found in the *Jeremiah* at the Sistine Chapel.

The only concession that Michelangelo made to the mores of his era was to garb both men in clothing that approximates that of 16th-century Italy. He would have been deliciously tempted to represent them in the nude, as Canova was to do in his *Napoleon* statue at the Brera Museum in Milan, or to drape them in Roman togas. But fortunately he resisted these temptations. Dressed as Romans, *Giuliano de' Medici* and the *Pensieroso* would never have achieved such lasting general acclaim.

The real masterpieces are the four figures stretched out on the sarcophagi: *Day* (p. 72), *Night* (p. 75), *Dawn* (p. 68), and *Dusk* (p. 69), whose poses recall motifs straight out of Antiquity. Through these grandiose personifications that no modern work can remotely even suggest, Michelangelo achieves a degree of power and eloquence that induce the spectator to rise above the human species and its lowly preoccupations. Even Antiquity has no work that boasts style of such pride.

More physically, these superhuman creations exude pure strength and power. The facial expressions show indifference to worldly disputes unfolding before their gaze. These specimens of the race of giants have the strength to overcome any resistance along with quiet disdain for petty misdeeds that cannot touch them. They look as if they can strike us down with a turn of the head and a stare.

In a memo at the Casa Buonarroti archives, Michelangelo describes the reasonably subtle meaning of the four allegorical figures he was then working on:

> *Sky* and *Earth*, *Day* and *Night* speak to say: In our speedy movement, we have led Duke Julius to his death. That he would seek revenge is only justice. His vengeance is that, now that we have killed

---

*Tomb of Lorenzo de Medici*, 1525-1527.
Marble, 630 x 420 cm.
New Sacristy, Medici Chapel, San Lorenzo, Florence.

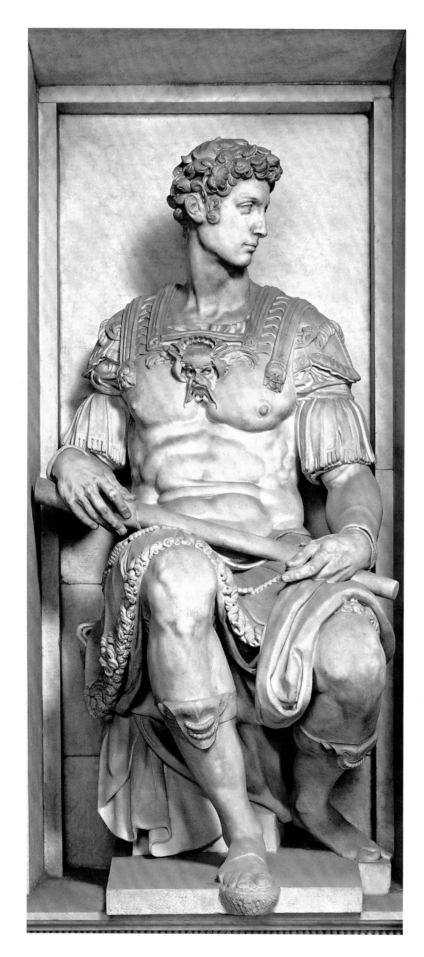

him, he has abducted our light, and his shut eyes shut ours, such that we no longer shine upon the Earth. What might he have done to us had he remained alive?

*Sky* and *Earth* were never executed while *Day* and *Night* would take on a different meaning despite the artist's intention. But after all, isn't genius about constantly, often subconsciously, mirroring the moods of humanity as a whole, through works that stimulate the widest possible variety of interpretations because of the wealth of facets that each artwork presents? Michelangelo's eye seems to have probed the depths where thought and form laboriously emerge from chaos. He has glimpsed the mysteries of the titanic struggles that characterise the start of religions. The figures in San Lorenzo belong to a dynasty of giants who preceded the gods of Mount Olympus.

Nonchalantly inclined with one arm on his magnificent torso and the other so offhandedly slapped across his chest, *Day* is looking over across his shoulder with one leg folded royally over the other. He looks somewhat annoyed at being roused from sleep. The fulsome torso shows admirable vigour while the figure as a whole radiates the haughty disdain proper to the mighty. It recalls Dante's quip: "Like the lion at rest."

*Night* is deep in sleep with her favourite bird, the owl, at hand. They respectively personify ignorance and disdain. Like him, she belongs to the race of Titans: her muscled limbs have no feminine grace, a grace the master so rarely depicted. Her powerful thighs seem built to carry colossuses.

As for the tough lines of a face numbed by sleep, all expression of any feeling whatsoever is entirely lacking – only some vague hint of latent life subsists. Still, the resting image terrifies us into responding with a mysterious shudder: it is a dark sort of sleep and the awakening will prove indeed unpleasant. Visitors spontaneously fall into meditation before it and speak softly despite themselves.

*Julius de Medici, Duke of Nemours*, detail of the tomb of Julius de Medici, 1525-1527.
Marble. Medici Chapel, Basilica of San Lorenzo, Florence.

*Julius de Medici, Duke of Nemours*, detail of the tomb of Julius de Medici, 1525-1527.
Marble. Medici Chapel, Basilica of San Lorenzo, Florence.

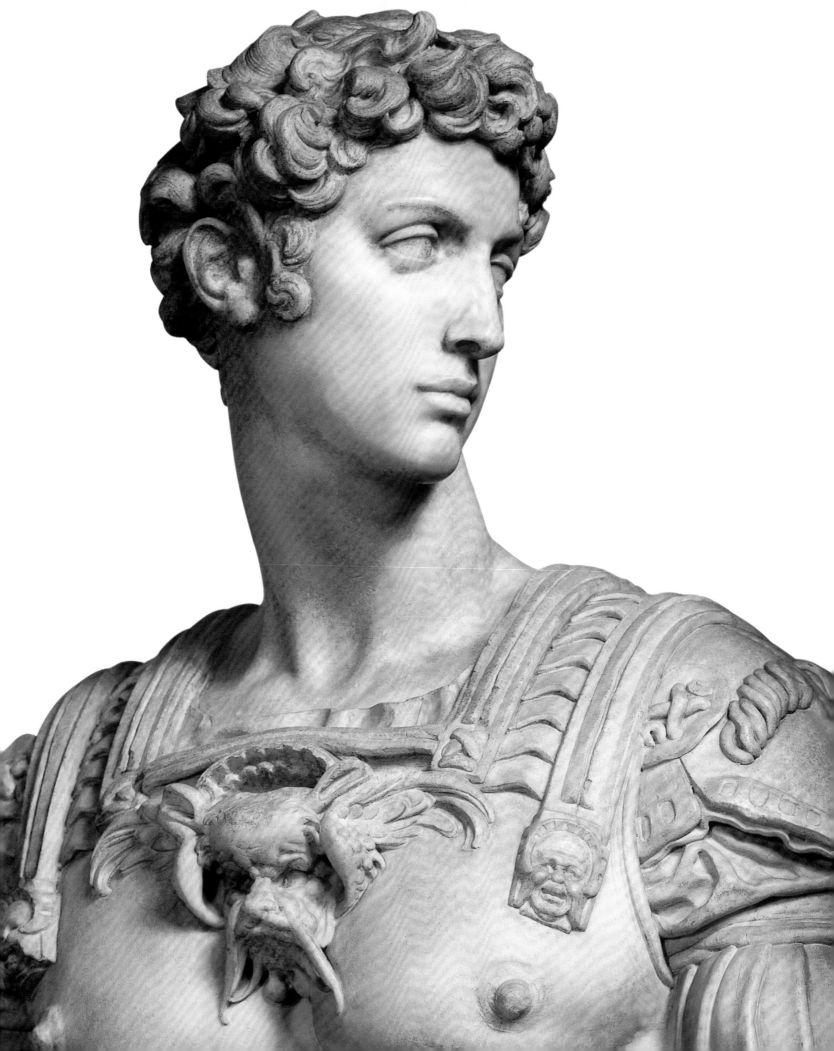

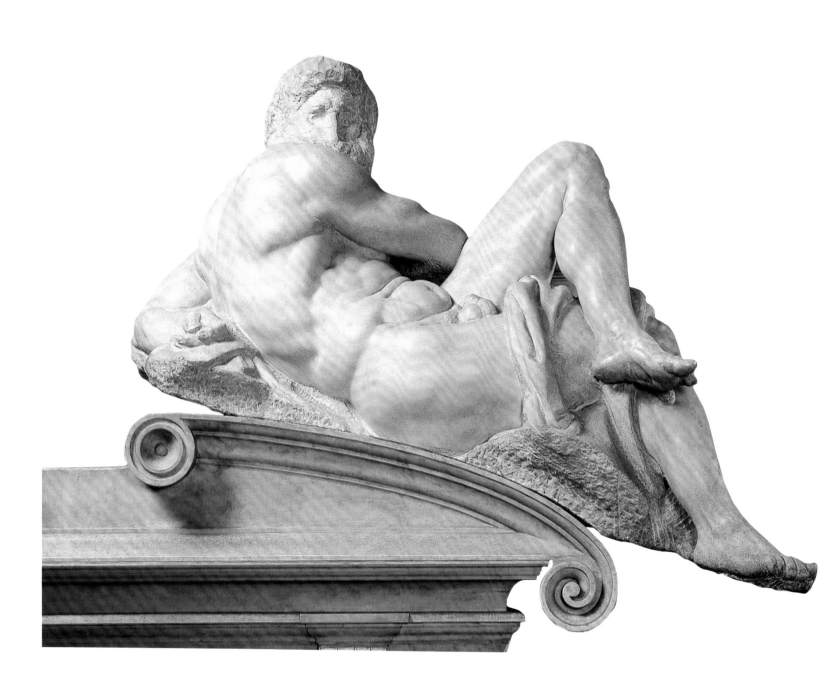

*Day*, detail of the tomb of Julius de Medici, 1525-1527.
Marble, length: 185 cm.
Medici Chapel, Basilica of San Lorenzo, Florence.

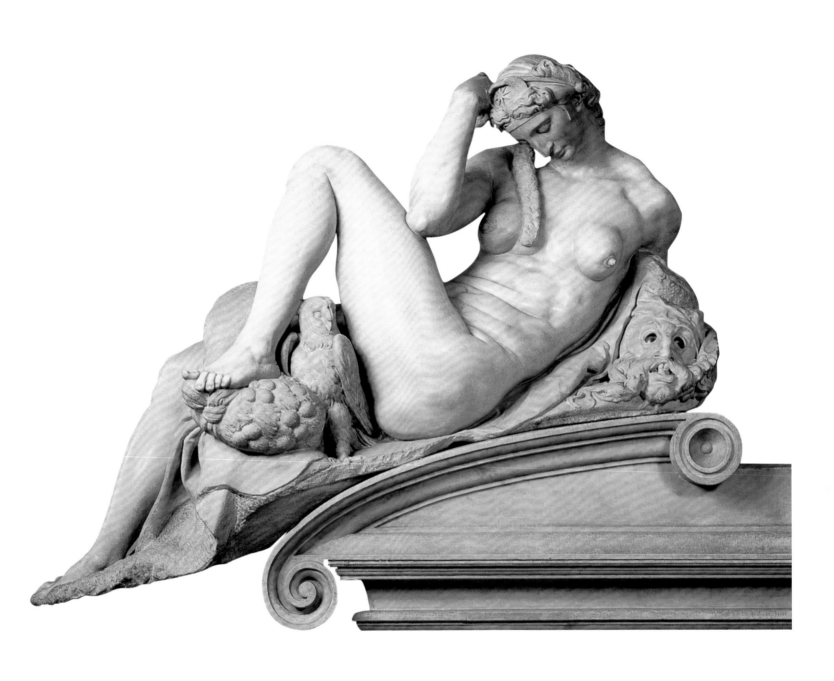

*Night*, detail of the tomb of Julius de Medici, 1525-1527.
Marble, length: 194 cm.
Medici Chapel, San Lorenzo, Florence.

We should all know Giovambattista Strozzi's inscription for the *Night* (where the word 'Angel' alludes to Michelangelo):

> The Night that here you see plunged deep into soft sleep,
> An Angel carved her out of marble,
> If you believe that not, awaken her and she shall tell you.

To which Michelangelo replied ever so immortally:

> 'Tis sweet to sleep and sweeter still to be of marble.
> So long as shame and peril may survive,
> To see nothing, feel nothing, is my great joy.
> So wake me not. For pity's sake, speak softly.

Though this repartee happened twelve years after completion of the statue, it nevertheless expresses Michelangelo's mood when he was working on this masterpiece.

The contrast of *Day* and *Night* to *Dusk* and *Dawn* is handled masterfully: *Day* turns its back on the viewer while *Dusk* presents us an inimitably firm yet supple full-chested torso as it casts an indifferent gaze on the pygmies scurrying beneath it. This is not the philosopher Titus Lucretius Carus on his rock contemplating the storm unfurling below (as Raphael chose to depict his philosophers in his *School of Athens*). It is Saturn or some other primitive Olympian god with a ravaged brow, unkempt beard and taut face – a Saturn weighed down by age yet still vigorous, whose life experience and immortal nature lead him to look down on mortals with deepest contempt. His nonchalant air intimidates as much as neighbouring *Day*'s turned back.

*Dawn* is fresher and less misanthropic. Reclined like her companions but in a less indifferent pose with the head and left arm lifted, *Dawn* is starting to awaken. It is that special moment when reality creeps back in and dissipates nightmares and morbid visions, the shadows of the night and the beasts of darkness. *Dawn* adds a note of reassuring freshness to this dark dreamscape: whatever the sorrows of the moment, there is still hope for Florence, she says. She dangles the promise, if not the guarantee, of a brighter future. The *Medici Madonna* (p. 34) in the Medici Chapel was part of the original project; there is mention of a marble block for a seated Madonna in a contract dated 1521. It was half-finished when Michelangelo realised he had made an arithmetic error that precluded full extension of the right arm, so he settled for roughing out that arm before abandoning the work. Lorenzo and his brother Giuliano lie in the New Sacristy beneath this Virgin and Child in a simple marble sarcophagus. They were moved there from Brunelleschi's Old Sacristy in 1559. Michelangelo's original design never saw daylight; thus the tomb of these two great Medici goes almost unnoticed beside the monuments to the two others of far lower stature.

To conclude our review of Michelangelo's sculptural works, we should mention a handful of statues from his final years. The siege of Florence oddly inspired the artist's two most mismatched works in terms of his preoccupations at the time. The first is *Leda and the Swan*, one of his rare paintings at the time, that was commissioned by the Duke of Ferrara, sold to King François I and now at the Royal Academy – though it may only be a copy. The second, *Apollo Taking up a Quiver* is at the Bargello National Museum, a statue destined for Baccio Valori in return for personal favours after the siege. It is a bold free-flowing work akin to the *Rebellious Slave* at the Louvre.

In 1540, Michelangelo started the *Brutus* bust now at the Bargello. Its completion later fell to Tiberio Calcagni. It was a statement of the artist's passion for freedom after a career in the service of despots. Superbly alive and dynamic, the head is supposedly copied from an ancient engraved stone: if it does not depict Brutus, it at least shows a man of great pride and courage.

Towards the end of his long career, Michelangelo returned to, and developed, the theme of the *Pietà*, something he had treated with so much pathos for St Peter's: this time it was the *Florentine Pietà* (p. 78) in marble. Its figures include a man on his feet with a hood over his head in a self-portrait probably representing Joseph of Aramaia, the Virgin, and Mary Magdalene who are supporting Christ's body. If Christ is surrendering to the arms that hold him, he is in a state of total collapse and however natural the posture, there is nothing noble about it. The general effect is one of dull, impersonal pain that remains latent instead of bursting out with the sort of frank, focused power that was the artist's baseline for art.

In this marble, it is plain that Michelangelo was as inept at group compositions as he was at low reliefs. Not only did he fail to build them into a coherent whole, he didn't even scale them down properly. Most saliently, Mary Magdalene's head is far too small. Nor was the artist happy with the result: after the rough-hewing, he abandoned it only to end up smashing it to

pieces. Only later did his friends manage to persuade him to authorise its repair, a task entrusted to Calcagni.

Michelangelo was almost 80 when he sculpted the *Florentine Pietà*, earmarked for his own tomb in Rome though he finally opted for burial in Florence. Along the way, the statue was sold off, hauled to San Lorenzo Chapel and finally shifted across town to the Duomo Museum. It has been on display there since 1981. There is also the *Rondanini Pietà* (right) at the Castello Sforzesco that he started in 1599. This last pieta could pass for the gist of Michelangelo's legacy. The refined forms develop around a strong vertical axis. The Holy Virgin and Son of God are entirely caught up in the maelstrom of death's torment. The work is typical of his penchant for the unfinished – Michelangelo was working on it only days before death interrupted him.

Though Clement VII proved a weak powerbroker and vacillating patron of the arts, his insight into Michelangelo was sharp. After commissioning the *Medici Tombs* and Laurentian Library, he entrusted him with the *Last Judgment* for the Sistine Chapel, thereby mobilising all three skill sets of the artist – sculpture, architecture, and painting.

Michelangelo was assigned completion of decorations for the opposing walls at the extremities of the structure. However, the walls already hosted Pietro Perugino's *Assumption of the Virgin with Saints*, *Nativity*, and *Finding of Moses*. Moreover, it meant sacrificing two of Michelangelo's own lunettes. For this commission, Michelangelo chose a *Fall of the Rebellious Angels* for one wall and a *Last Judgment* (p. 132) for the other. The theme of rebellious angels kept coming back at him for the way they synchronise with the revolt of the titans against the gods of Mount Olympus. *Fall of the Rebellious Angels* went unfinished, too. A shoddy painting of the Trinità Monti in Rome broadly reproduced its general features until it also vanished. Clement VII only lived to see preparatory drawings; he died in September 1534 before paintwork had begun in earnest.

By the time of Clement's death, Michelangelo had outgrown the patronage of the Medici clan, to whom he owed so much but hated intensely, as he basically saw them as the oppressors of his homeland. However tempting Cosimo's offers

*Pietà Rondanini*, 1552-1564.
Marble, height: 195 cm.
Castello Sforzesco, Milan.

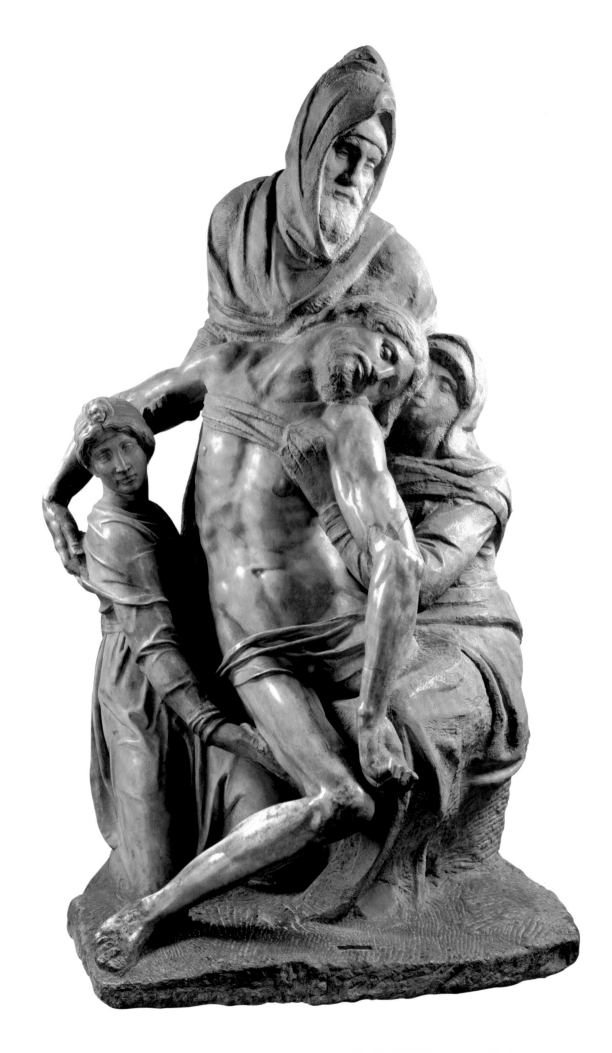

would have been, he stubbornly refused to return to Florence; Rome was to remain his domicile of choice for the last thirty years of his life, ending in 1564. Because of the infinite wealth at their disposal and high moral stakes they were bound to safeguard, only the Popes could offer Michelangelo commissions worthy of his genius.

The advent of Pope Paul III would benefit Michelangelo. At this point in his career, the artist was already a living god. No other artist had ever tallied so many tokens of esteem from the rich and powerful: he had become an immortal in his own right. The new Pope outdid his predecessors. Michelangelo protested in vain at the new Pope's offers, citing commitments to Julius' heirs. The Pope's retort: "Where is the contract so I can tear it up? How can it be that I have been yearning to busy you for thirty years and now that I am Pope, I should not be able to satisfy my wish?!" Flanked by a stunning array of cardinals, Paul III dropped in on the artist's workshop to admire his sketch for the *Last Judgment* and statues for the tomb of Julius II. According to deft courtesan Cardinal Sigismund Gonzaga, "The *Moses* was more than enough all by itself to forever honour the mausoleum."

Hardly content to preside merely over completion of the *Last Judgment*, Paul III wanted Michelangelo to do a painting of his own papal inspiration and in his own honour. He had already commissioned Antonio da Sangallo to build a structure inside the Vatican that was christened the Pauline Chapel, after himself of course. Perino del Vaga was to decorate the vault, with Michelangelo reserving the walls for himself.

As subjects, Michelangelo chose the *Conversion of St Paul* and *Crucifixion of St Peter*. He began the frescoes in 1542 and finished them in 1550 at the age of 75. But Michelangelo devoted the final years of his life to architecture.

After this review of Michelangelo's main output, it is worth examining the personal aspirations of this generous, if quick-tempered, artist and to say a few words about him as a thinker and poet. First, let us touch upon Michelangelo's personal appearance. He was short, stocky, and well-muscled like many a hard worker. His bony head expressed conviction and stubbornness, after adjustment of his nose by Torrigiani's fist, giving him the striking look of a lion.

His austerity was extreme: on the job he would usually just munch on bread as he continued working. As he told his biographer Condivi: "Though rich, I've always lived like a pauper." He found sleep painful and slept as sparingly as he ate. Whenever he took a break, he got migraines. Even in his

peak years, he went to bed in his clothes without even taking off his shoes. Condivi says that he wore his boots for so long at a stretch that the artist's skin stuck to the inside when he tried to remove them.

Michelangelo's utter disdain for socialising and other worldly pleasures freed him to invest his enormous energy in work and it was not enough to wrest up the secrets of each of his arts, he moved on into literature where he made a success of that as well.

When Da Vinci abandoned the paintbrush for the quill, he focused on physics and natural science, with all their philosophical and moral implications but for Michelangelo, the objective was poetry and there, instead of giving free play to his imagination, he also chose focus: he needed obstacles to conquer. Thus, he turned to the sonnet for its complicated mechanism and sovereign concision.

Despite his gloomy sense of sarcasm, Michelangelo enjoyed a wealth of loyal friends. He was good to his friends and companions, especially his servant Urbino. And then there was the pure and noble love that made his name inseparable from that of Vittoria Colonna.

Michelangelo's closing years chilled his ardour and thereby stilted his imagination. Did he sense some feeling of inferiority? At all events, Vasari once heard him say during a bout of melancholy that the artist knew more as a youth than now in old age.

His health had visibly been in decline for some time by the end of a working day that fell on Saturday, 12 February 1564. He may have been sculpting the *Rondanini Pietà*. The next day, his servant Anotonio del Francese had to remind him that it was Sunday when the artist said he wanted to go to his workshop. On Monday, he was taken ill and fell into deep sleep, such that on Tuesday, "He wanted to go horse riding to beat the illness, just as he usually did each evening in good weather, but the season's chill and the weakness in his legs and head stopped him. He then returned to sit by the fire where he remains more gladly than in bed." Despite medical attention and nursing from friends, he died on Friday, 18 February after three days in bed. He was sixteen or seventeen days short of his 89th birthday. San Lorenzo in Florence was chosen for the funeral.

*Pietà*, c. 1550.
Marble, height: 226 cm.
Museo dell'Opera del Duomo, Florence.

Today the Santa Croce Church boasts a superb mausoleum that commemorates Michelangelo with allegorical figures of *Painting, Sculpture*, and *Architecture* designed by Vasari and executed by Giovanni dell' Opera, Cioli, and Lorenzi. His tomb stands among those of fellow Tuscan immortals Dante, Galileo, and Machiavelli.

Having examined his masterpieces, we can pass on to the main features of Michelangelo's genius.

His first stunning gift was universal appeal. He also commanded encyclopaedic knowledge to succeed across so broad a range of works as the *Pietà*, Sistine Chapel frescoes, tomb of Julius II, *Medici Tombs* and the superhuman task of the cupola of St Peter's Basilica. If Da Vinci and Raphael possessed equally diverse skill sets, they remained dwarfs by the standards of Michelangelo's achievements in architecture and sculpture.

Destiny placed Raphael and Michelangelo as beacons of vitality at the close of an era: one died before attaining full expression of his genius and at the height of his glory, while the other went after technical problems with a vengeance, and the unsurpassed vitality of his works has travelled the centuries intact. It was surely painful for the old, but entirely lucid Michelangelo to watch his successors take his techniques to mutilating extremes.

Before his time, art was progressing with steady but deliberate restraint and skirting the knottier technical problems, probably due to the inexperience of the Primitives, or even out of innate reticence. In short, that art was scrupulous, discreet, and wary. At heart, the issue was the sublime audacity of the Sistine frescoes, *Slaves, Moses*, and *Medici Tombs*, which left his fellow artists with nothing to solve and everything to clone.

But let us stress his triumphs rather than their inevitable consequences. What peerless masterpieces! Michelangelo emancipated sculpture, painting, and architecture, endowing absolute freedom of movement to a wide range of warm emotions and deep pathos: majesty, pride, melancholy, terror, love, and justice. He raised them to maximum intensity or encapsulated them in works none had previously imagined and none has since equalled. Such is his legacy to the Renaissance.

**Raphael**, *School of Athens*, 1508-1511.
Fresco, width: 770 cm.
Stanza della Segnatura, Vatican City.

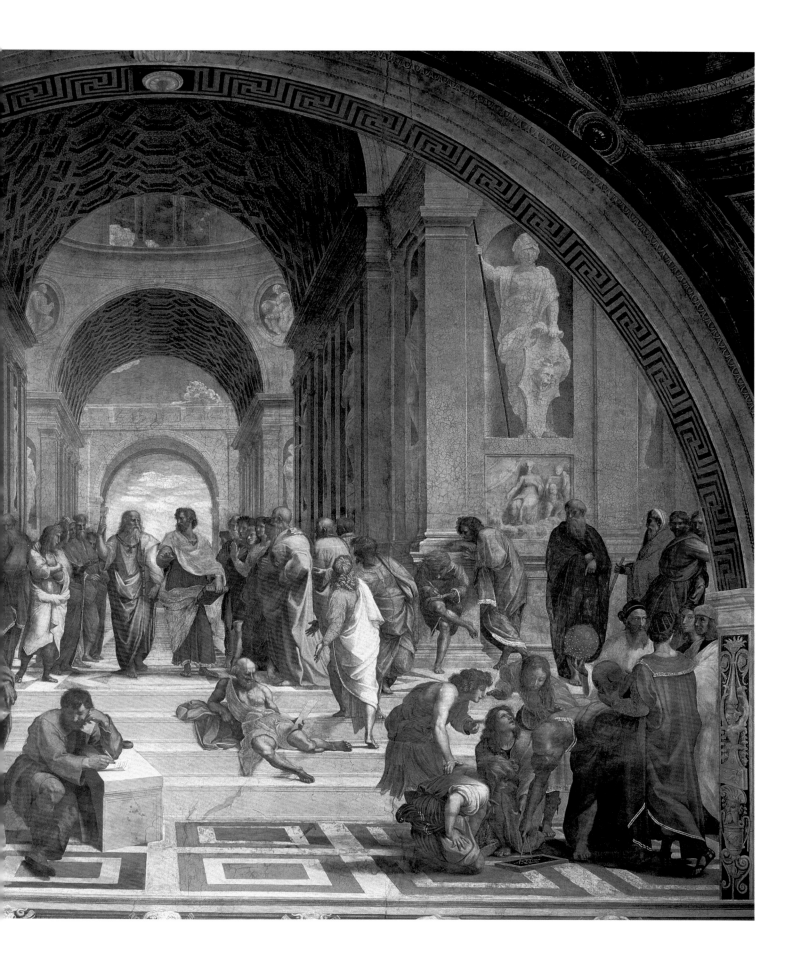

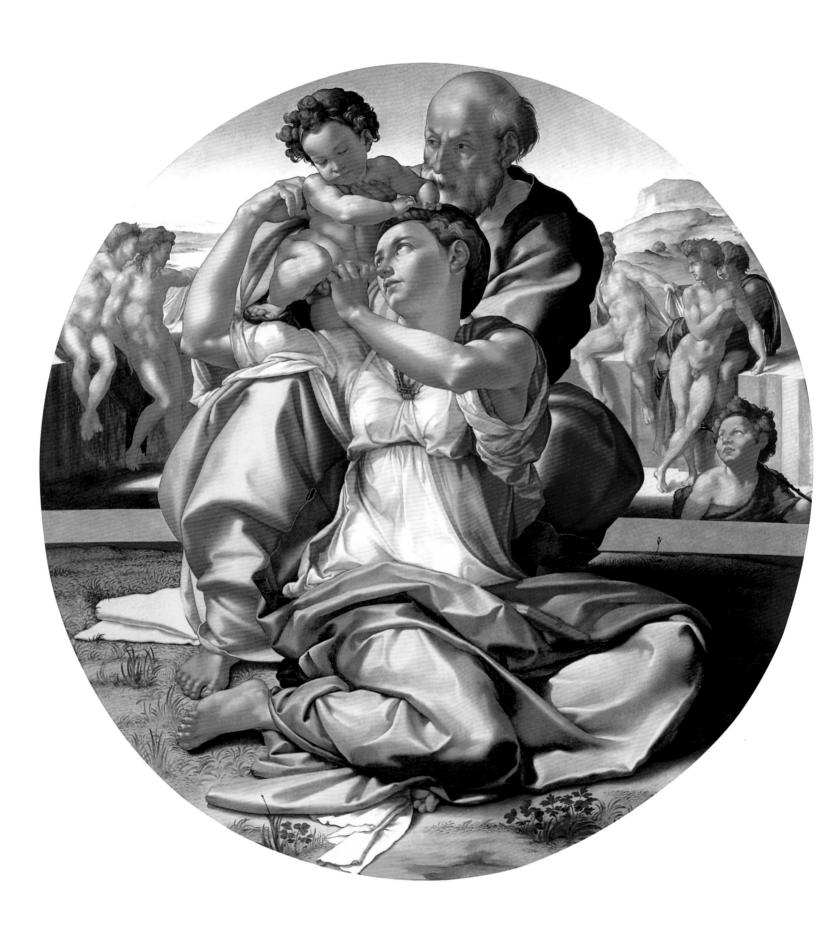

# THE PAINTER AND THE DRAFTSMAN

## Late Renaissance Painting And Drawing

Except for Michelangelo, there is no first-rate sculptor of the same calibre as painters such as Correggio, Luini, Sodoma, Titian, and Veronese. In art, the supremacy of painting stems from the absence of any surviving works from Antiquity, hence the need for ongoing innovation. But as soon as a breakthrough happens, an entire herd of second-rate talents inevitably clones it instead of pushing on to creatively research the next one.

Although entire generations of artists could thrive on the serenity of models laid down by self-composed masters. such as Raphael, without boring their audiences, imitation of Michelangelo's *terribilità* (the violence of his style) inescapably grew to intolerable proportions. As Stendhal notes in *Histoire de la Peinture en Italie*: "Painting drives home the maxim that force is the first prerequisite for all virtue."

In raising his art forms to extraordinary heights, Michelangelo doomed his disciples to impotence. Exaggeration of facial expressions and all else leaves no leeway for burnout and mediocrity. Pathos is black or white: your product is sublime *or* abominable. Abuse of power has a price and you do not set up examples lightly without compromising the destiny of future generations. The Florentine School learned that lesson the hard way: Michelangelo's death dissolved it and if his presence propelled it towards its peak, he largely set the stage for its decline.

The artists of the Italian Renaissance brought painting into regular informal contact with aristocratic society, the elite for whom it was intended. It could thus flexibly respond to market demand in its clientele in countless little ways. Never before had painting diversified so extensively. Never before had it penetrated into the family lives of its client base. Scientific advances were boosting productivity almost exponentially. It had taken two years for Mantegna to paint a few square feet in one church, and four years for Ghirlandaio and all his assistants to decorate the choir of Santa Maria Novella Church, a far larger enterprise.

Suddenly, it only took weeks to populate hundreds of square metres, i.e. Paolo Veronese's *Marriage at Cana* fits about 150 life-sized figures into 66 square metres. Soon, monumental oils and frescoes were all over the walls of the Vatican, Palazzo Vecchio in Florence, Palazzo Te in Mantova, and the Palazzo Ducale of Venice. Vasari reports that even peasants covered their walls in fresco.

The new painters distinguished themselves primarily through layout. Although Raphael grasped layout to perfection, his later works incorporate isolated groups that make for overall incoherence. These disjointed figures and their lack of unity became even more glaring because the Roman School was losing its grip on colour and only skilful use of colour could offset these failings.

Layout begins with the art of arranging groups of figures. Michelangelo's invariably abrupt lines show that he knew less about composition than most hacks. Primarily gifted for

---

*The Holy Family* (*Tondo Donì*), 1505-1506.
Circular wooden panel painted with tempera (watered down), diameter: 120 cm. Galleria degli Uffizi, Florence.

*The Holy Family* (*Tondo Donì*) (detail), 1505-1506. (p. 84)
Circular wooden panel painted with tempera (watered down), diameter: 120 cm. Galleria degli Uffizi, Florence.

*The Virgin and Child with St John and Angels* (*The Manchester Madonna*), c. 1497. (p. 85)
Egg tempera on wood, 104.5 x 77 cm. The National Gallery, London.

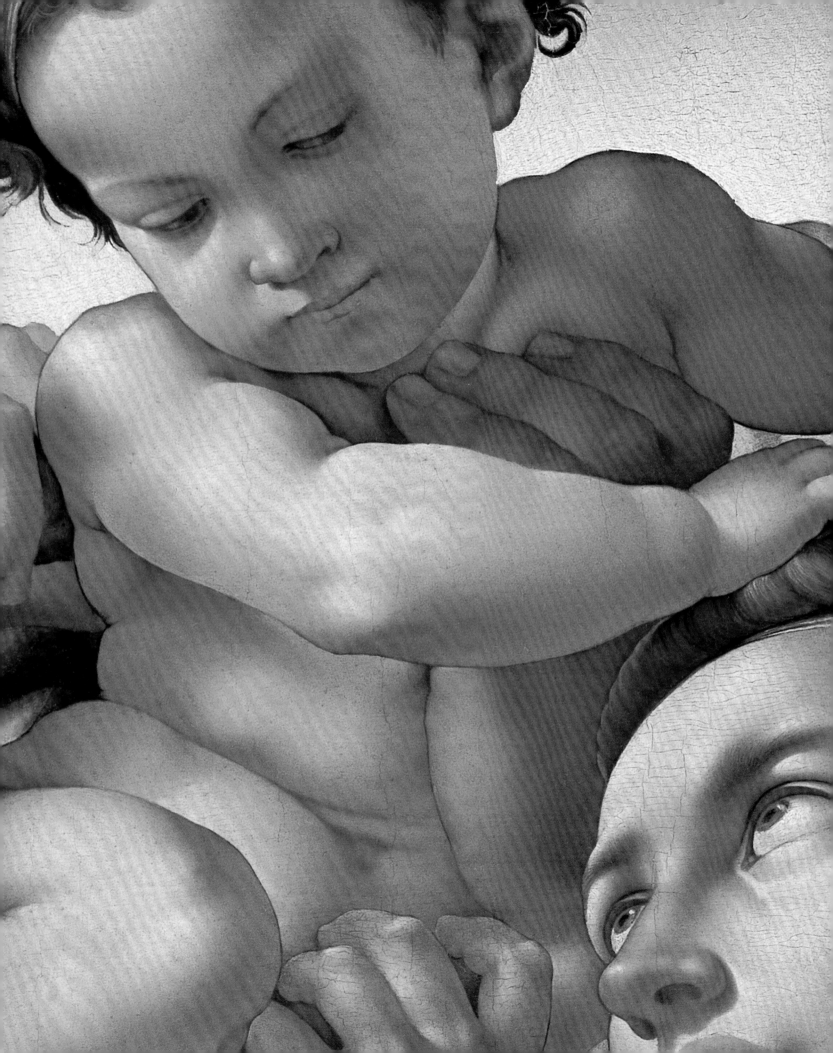

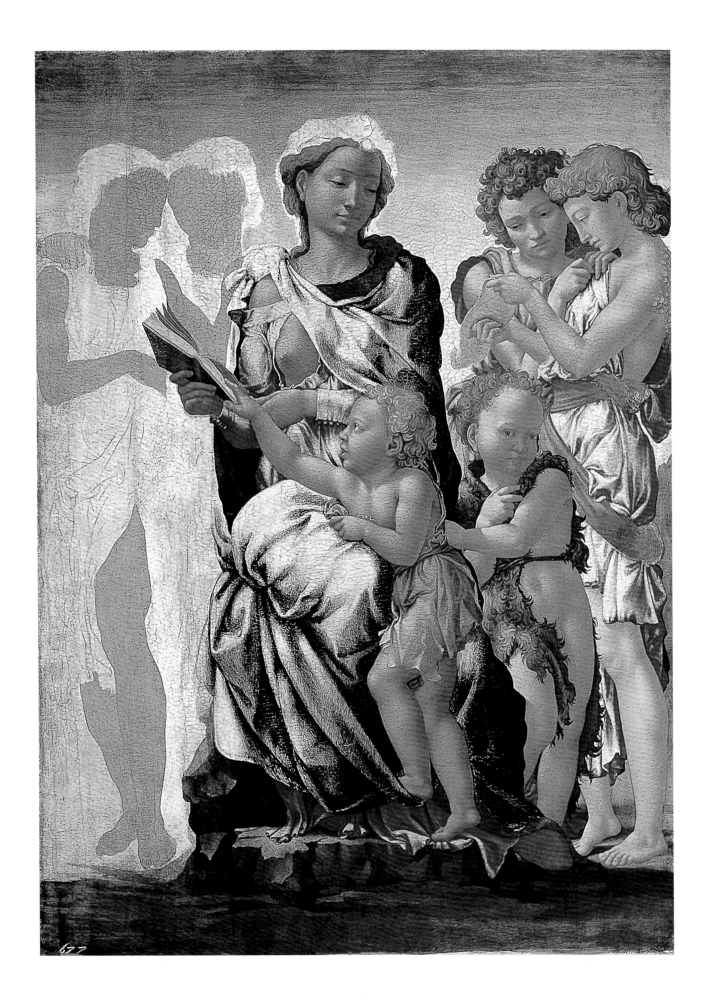

Archers Shooting at a Herm, c. 1530. (above)
Red chalk, 21.9 x 32.3 cm.
Royal Library, Windsor.

**Leonardo da Vinci**, Study for *The Battle of Anghiari*, 1504-1505.
(opposite)
Galleria dell'Academia, Venice.

**Antonio da Sangallo**, *The Battle of Cascina* (adapted from **Michelangelo**),
c. 1542. (pp. 88-89)
Oil on panel.
Private collection, Norfolk.

*Nude* study for *The Battle of Cascina*, c. 1504-1505. (p. 90)
Quill, 40.8 x 28.4 cm.
Casa Buonarroti, Florence.

*Standing Man Seen from the Back, Holding a Stick* (detail), c. 1504. (p. 91)
Black pencil, 28.2 x 20.3 cm.
Musée du Louvre, Paris.

statuary art in three dimensions with a fine understanding of the human body freed from all constraints, Michelangelo did only three low reliefs: *Battle of the Centaurs*, and two versions of the *Madonna and Child*, one at the Bargello and one at the Royal Academy.

Although he applied painting techniques to sculpture, he remained a sculptor when he took up the brush; instead of using gestures, poses, perspective, and lighting to connect figures to each other, he merely highlighted each individually. Thus, decorative effect is absent, especially in his easel paintings and *Last Judgment* (p. 132). His incompetence at layout explains his total failure to arrange twenty or thirty figures into any harmonious whole. To hide this failing, he would simply put everyone in the foreground. *The Deluge* (*The Flood*, p. 116-117) is one of the rare works in which he tried to represent several episodes in the same frame and it was unsuccessful, as we can see.

So what happened when he had to juggle 200 or 300 figures, as happened in his *Last Judgment*? The answer is easy to guess. Taken as a whole, the fresco in the Sistine Chapel is a disjointed series of groups (some of which are beautifully executed). The groups of figures do not even balance each other out.

They are unevenly distributed across the immense wall – squeezed in up near the ceiling and widely spaced elsewhere. Bodies cluster up in some places, leaving huge voids elsewhere. The result is suffocating, unsettling and discordant. Earlier painters sought to structure their paintings because they knew that mere agglutination of figures would destroy clarity and harmony.

One standard trick of the trade was to wrap Christ in an egg- or almond-shaped halo to isolate him from the crowd and capture viewer focus at the centre of the composition; other devices to establish structure were to separate heaven and earth with a rainbow, to form choir groups for symmetrical arrangement of angels, and to line up apostles in rows of thrones.

Unlike them, Michelangelo kept breaking up the symmetry so essential to decorative art. His quest for life and thrust made him hate smooth lines, carefully arranged groups, and anything that seemed premeditated. The powerful abstract thinking he demonstrated in his *Genesis* frescoes or *Medici Tombs* seemed to make him the ideal artist to give the *Last Judgment* all the spirituality and simplicity that often escaped the Primitives.

But he sinned unforgivably by deserting his majestic heights to come down into the arena and attack a throng of motifs unworthy of his brush. Instead of summarising the different acts of the Final Judgment with a handful of grandiose key figures, he opted for a cast of hundreds that dissipates interest among countless little episodes. These bog down the composition without enriching it or adding any much-needed variety because, of all the emotions there were to express, all he really transmitted was terror.

These mistakes are even more flagrant in his imitators, especially Bronzino, Salviati, and other Late Renaissance Florentines.

Florentines were notable for cacophonies of figures and gestures because their contours are too detailed, unlike the Venetians who proposed real groups held together by tailoring colour brightness to the needs of the particular context.

Layout and composition apply to ceiling art, too. Ceilings can scare off the most adventurous artists but their difficulties fascinate a handful. Correggio was one such master with a taste for new technical problems who, in his frescoes for the Dome of Parma, wanted to show off how well he could put figures against a ceiling and create illusion with highly daring foreshortenings. He succeeded.

Only Michelangelo's frescoes at the Sistine Chapel show such natural poses of majestic self-confidence and freedom of movement. Actually, it is often dislocation rather than movement. Paolo Veronese enjoyed such strokes of genius even more than Correggio and handled them like child's play.

Considering colour, the very essence of painting, we find a series of equally important innovations. Only a handful of painters retained the confident brushstrokes of the past, with candid and substantial but luminous tones. Then, painting was also about upsetting nuances and thinning them out, if not making them more transparent. It is as if viewers had undergone a change of perception.

For portrait painting, the Late Renaissance was a rollercoaster ride. In a matter of decades, we move from the 15th-century profile portraits of Pisanello, Piero della Francesca, and Botticelli to Da Vinci's full-face, half-length portraits. From there we have the full-length portraits that Raphael filled with various accessories to round out depiction of the subject. Family portraits were another innovation. Then came equestrian, allegorical, and genre portraits where human subjects do not pose obediently before the painter but go on about their business and the viewer becomes a voyeur.

While some painters carried on the Primitive tradition, others did not. Michelangelo hated working from live models. Portrait work is about setting aside personal

---

Interior view of the Sistine Chapel, Vatican, 1508-1541. (opposite)

Vault of the Sistine Chapel after restoration. (pp. 94-95)
Vatican.

*God Separating the Earth from the Water*, seventh panel of the vault, 1508-1512. (pp. 96-97)
Fresco.
Sistine Chapel, Vatican.

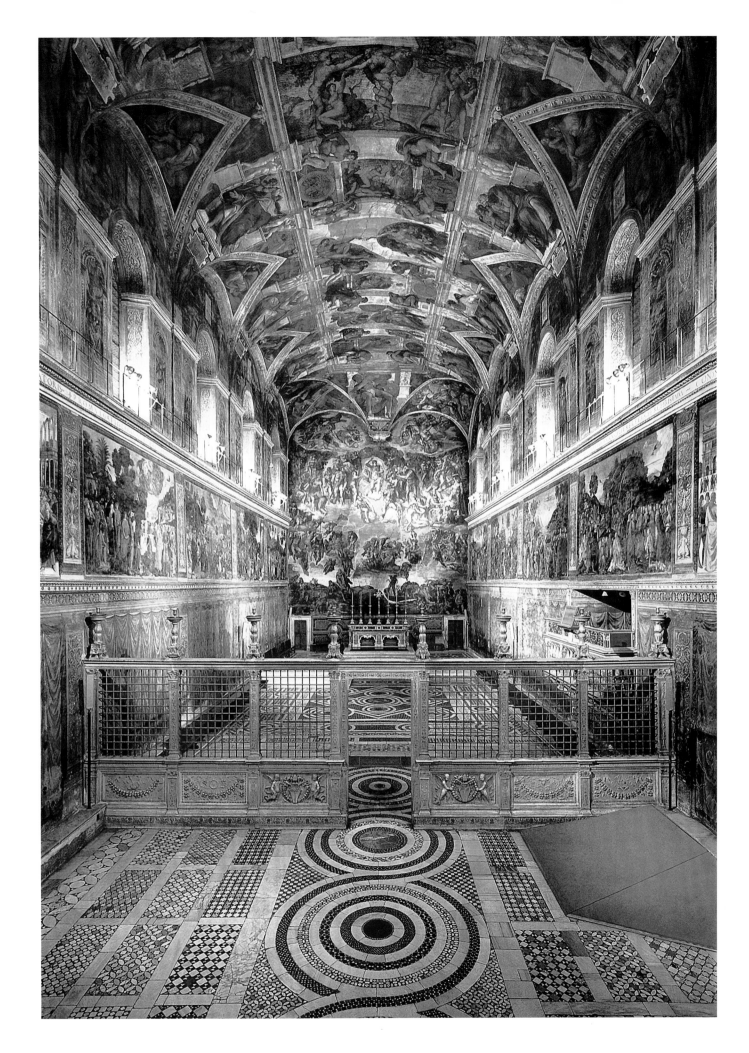

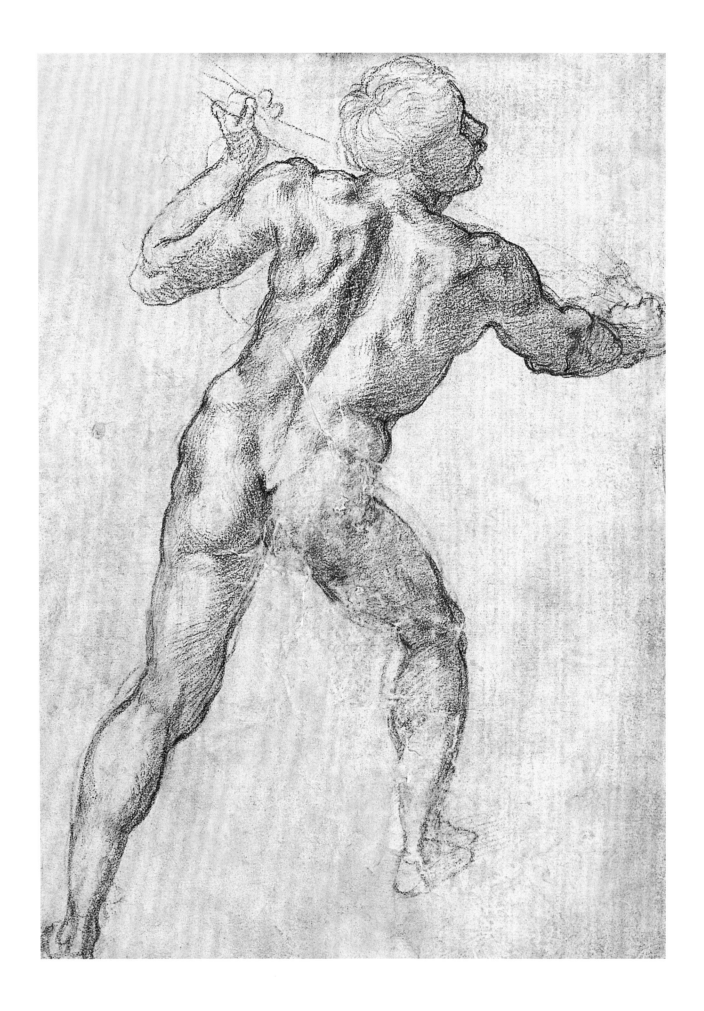

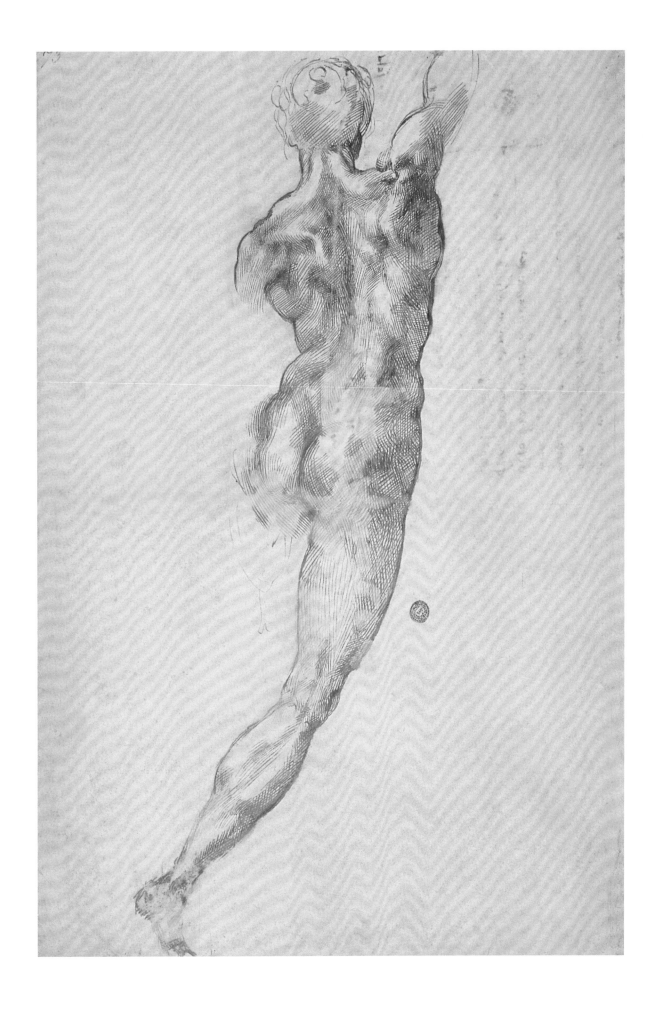

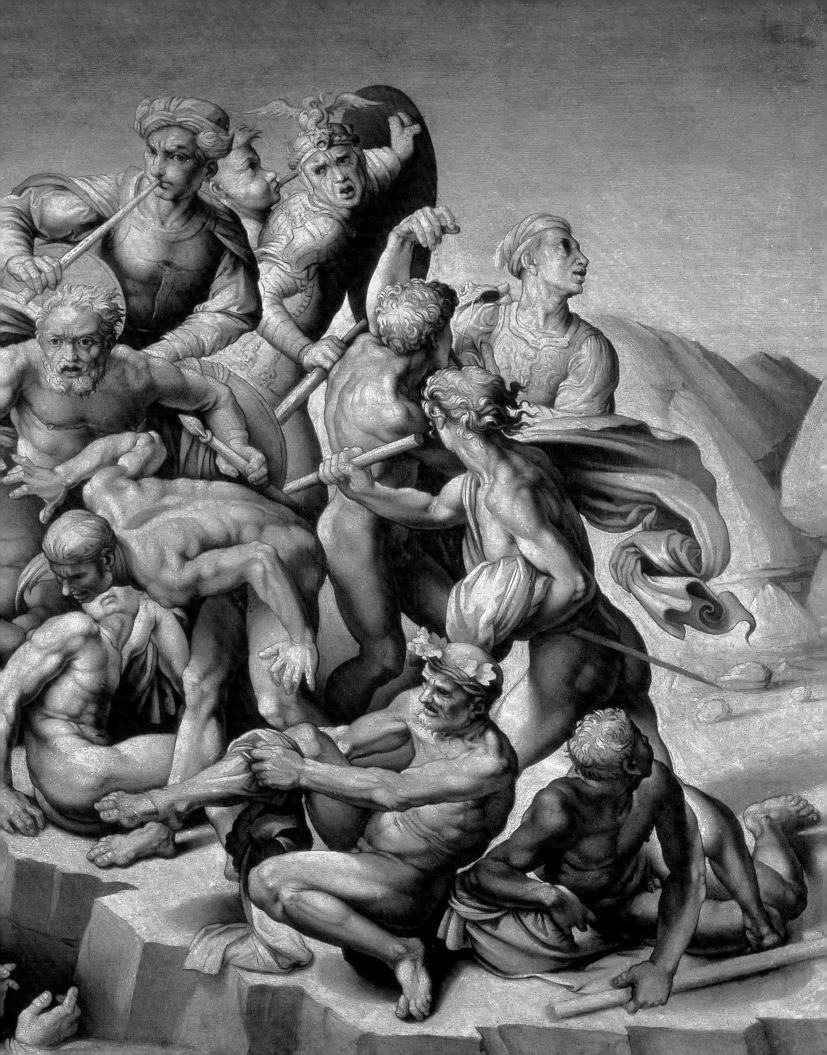

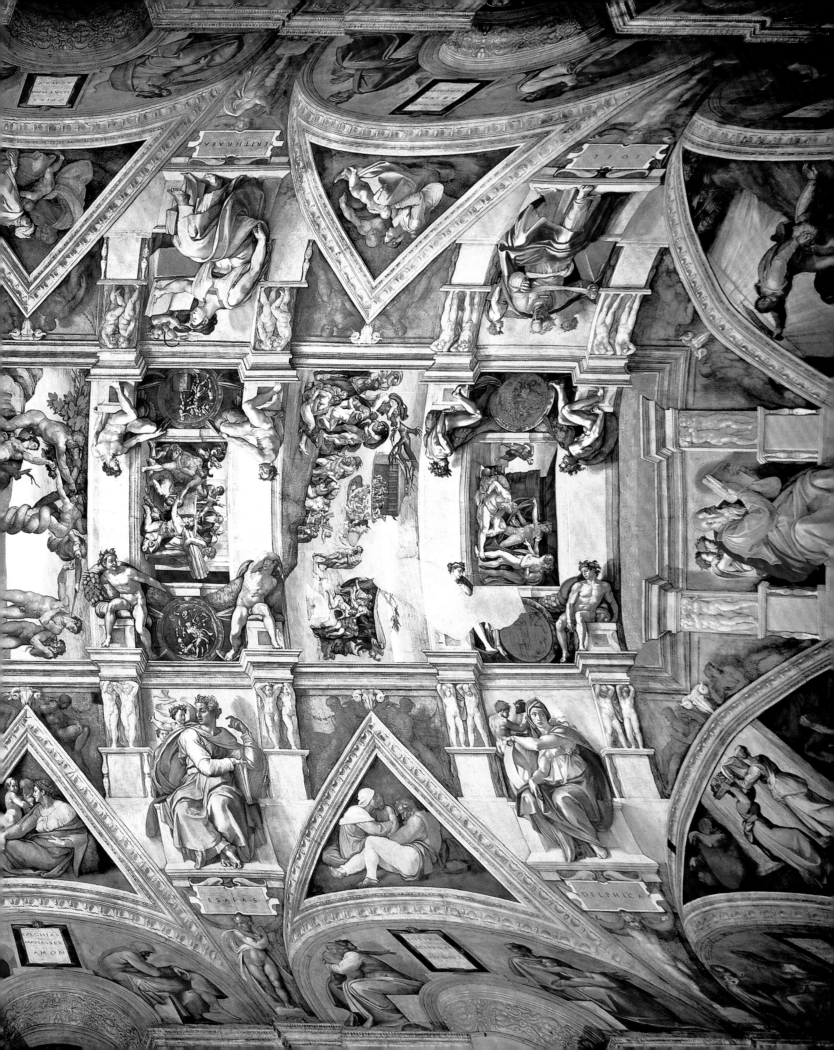

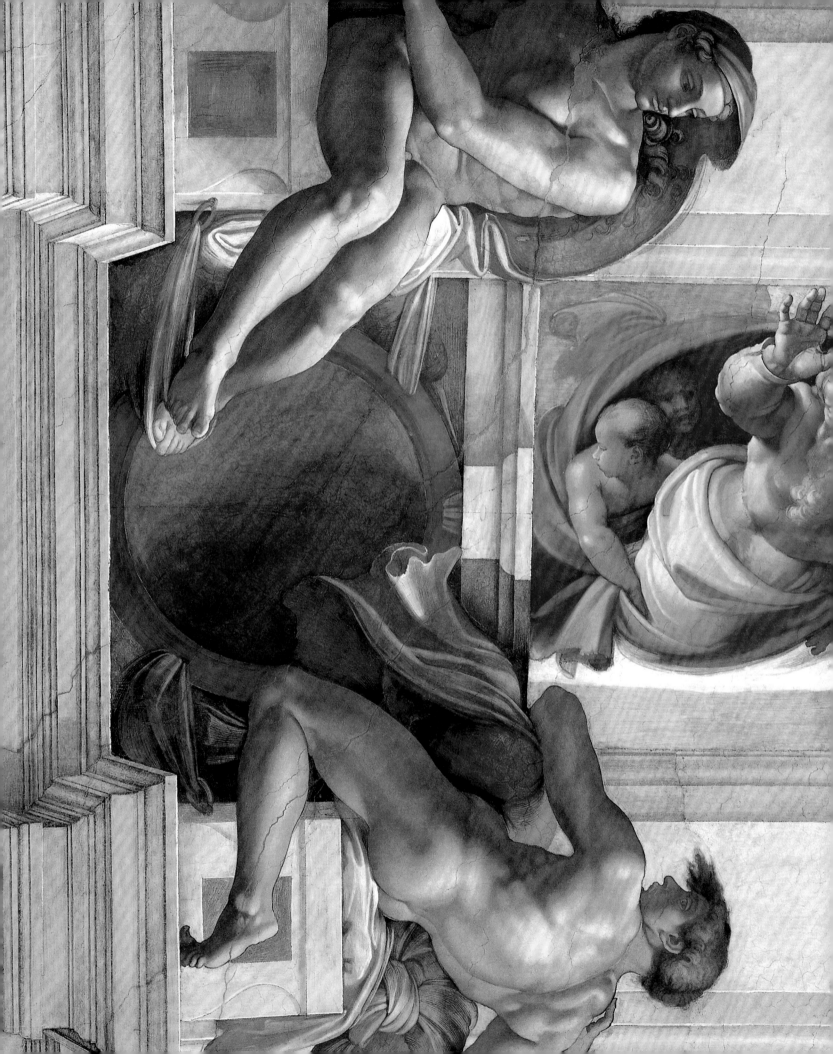

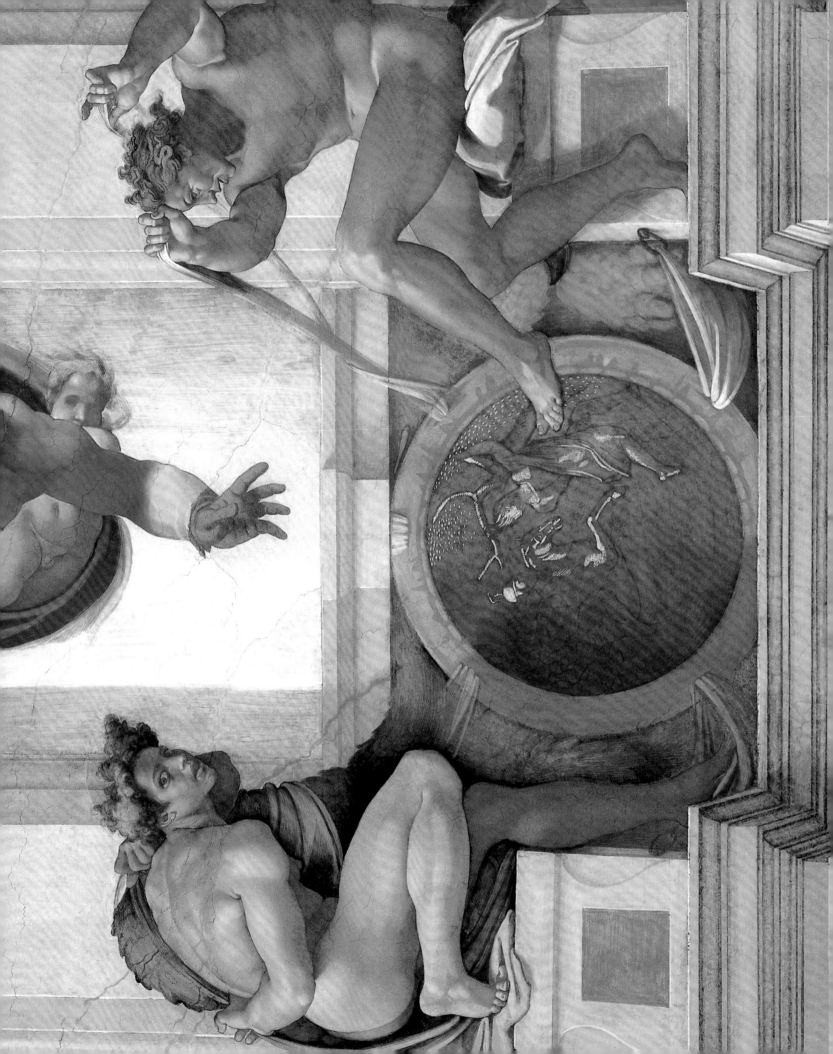

creativity and reproducing a predetermined model. It was understandably difficult for the haughty, fixed mindset of Michelangelo's genius to operate inside such a box after having depicted gods and titans completed from pure imagination.

Regarding landscape painting, the reproduction of more or less picturesque scenery formed a major part of historical and even portrait art in the early 15th century. But if the Primitives had the sincerity and precision vital to landscape art, they did not have the equally necessary layout skills or freedom of style. Looking at the countryside near Rome, Perugino tried to group and simplify. The odd Florentine artist did take up landscapes but most remained entirely absorbed in figures.

Indeed, their output soon looked stale; they would have had trouble excelling in a genre that requires more inspiration than hard thinking. More than anyone, Michelangelo disdained painting scenery, trees and buildings, thereby depriving himself of incalculable resources – imagine the setting he could have given to *The Flood* by adding gushing waters and dark ominous skies!

Man had at last freed himself from background and reconquered his almighty powers as master of creation and there was no question of trivialisation with useless accessories. Any countryside needed to support figures was reduced to a minimum: Michelangelo's idea of scenery for Adam and Eve is one green knoll and a leafless tree trunk.

It is heartbreaking to think of the exquisite detail now suddenly banned – the flowers Primitives put on their lawns and birds tucked into niches now disappeared from Italian art. But without these mutilations, would Michelangelo have immortalised his talents as definitively? Would he have managed to replace the romance of the 15th century with the grandiose tragedy of the origins of the world?

---

*The Creation of the Stars and the Planets*, eigth panel of the vault, 1508-1512. (opposite)
Fresco.
Sistine Chapel, Vatican.

*The Creation of Adam*, sixth panel of the vault, 1508-1512. (pp. 100-101)
Fresco.
Sistine Chapel, Vatican.

In a final word on landscape painting, the Ferrara School flourished in an area the Roman and Florentine schools chose to neglect. It was the Venetians who earned landscape painting its rightful place, transforming it into a platform for depicting major historical events. Venetian landscapes are brightly lit and eloquent; these artists knew how to arrange groups, provoke unexpected contrasts, and inject impetuous movement into sea waves.

Almost entirely ignored by the Florentine and Roman artists of the time, the art of blending figures into landscapes would reach its peak with Titian.

Oil and fresco were the two preferences of Late Renaissance artists. Hardly any master of the period was not equally comfortable with either medium. But with the exception of Veronese, most Venetians preferred oil, and Michelangelo, fresco. The Pope hesitated over which medium to choose for *The Last Judgment*. Fra Sebastiano del Piombo persuaded him to select oil; Michelangelo was forced to obey but revolted and stopped work. Begged, pressured, and cornered, Michelangelo insisted on fresco, saying oils were for girls, idlers and the likes of Sebastiano. He then had all of Sebastiano's preparatory work removed and they never spoke to each other again.

Drawing soon adjusted to developments in painting. Heads and faces became empty and atrophied as this previously interesting medium started spiralling into decadence.

Dominated by improvisation, most drawing was preparatory work for paintings and sculptures because of the difficulties inherent to both, but what content survives from these fast playful pens? Firm strength transpires only in the sketches of Michelangelo and a few other Florentines, Giulio Pippi (known as Giulio Romano), Giovanni Battista di Iacopo (also called Rosso Fiorentino) and Andrea del Sarto. Forms were less abrupt and sunken with a touch of chubbiness. Stress was on the total picture rather than detail.

The choice of medium fluctuated similarly. Silver tip disappeared and ink drawings were disappearing while India ink washes, sepia, and red and black chalk became the rage. Media were mixed in an infinite variety of compositions, with the addition of bistre and other tints. Previously rare, three-pencil drawings began coming into vogue.

Michelangelo's sketchwork deserves individual study because he saw drawing as an end it itself, capable of constituting a distinctive body of art in its own right; he did

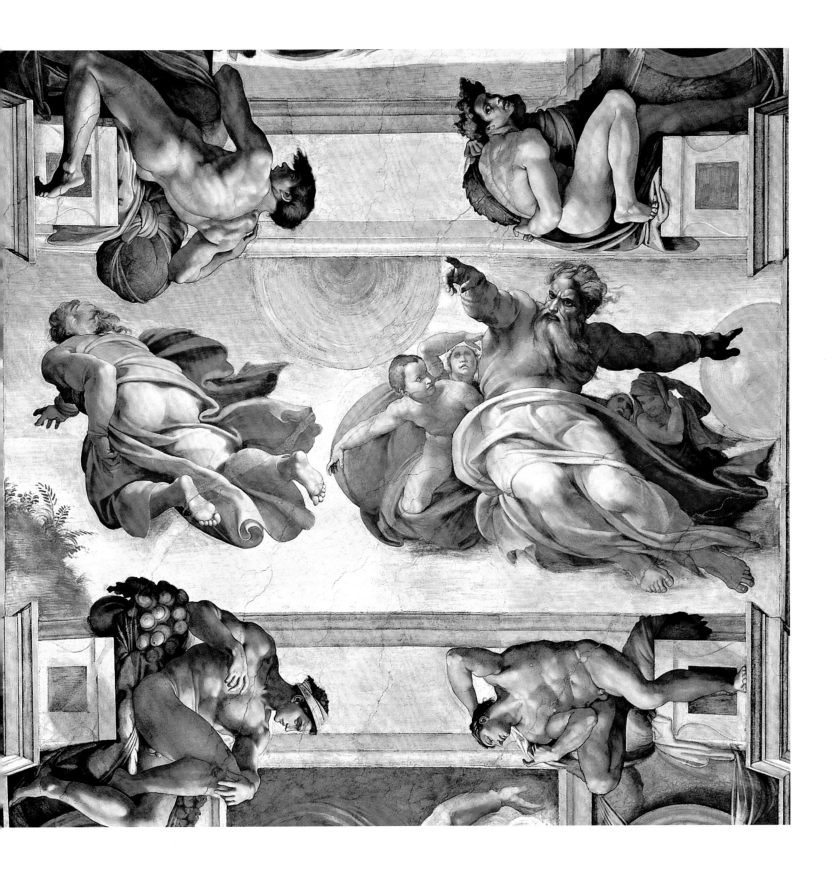

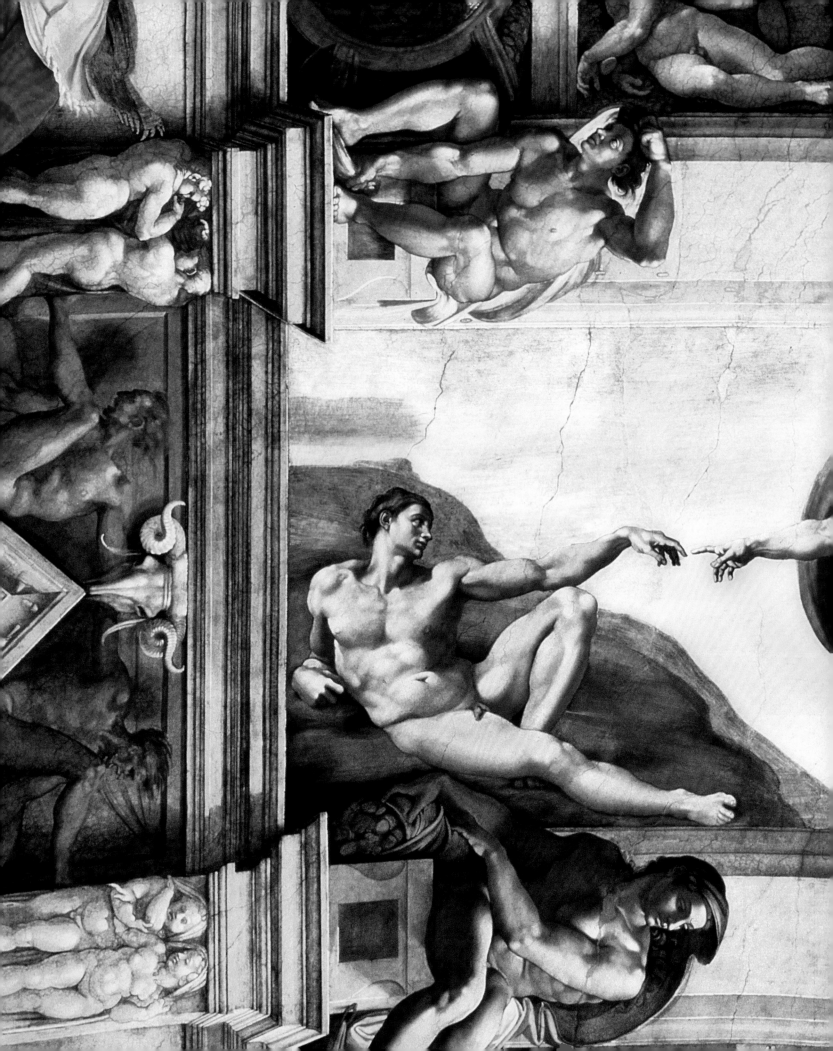

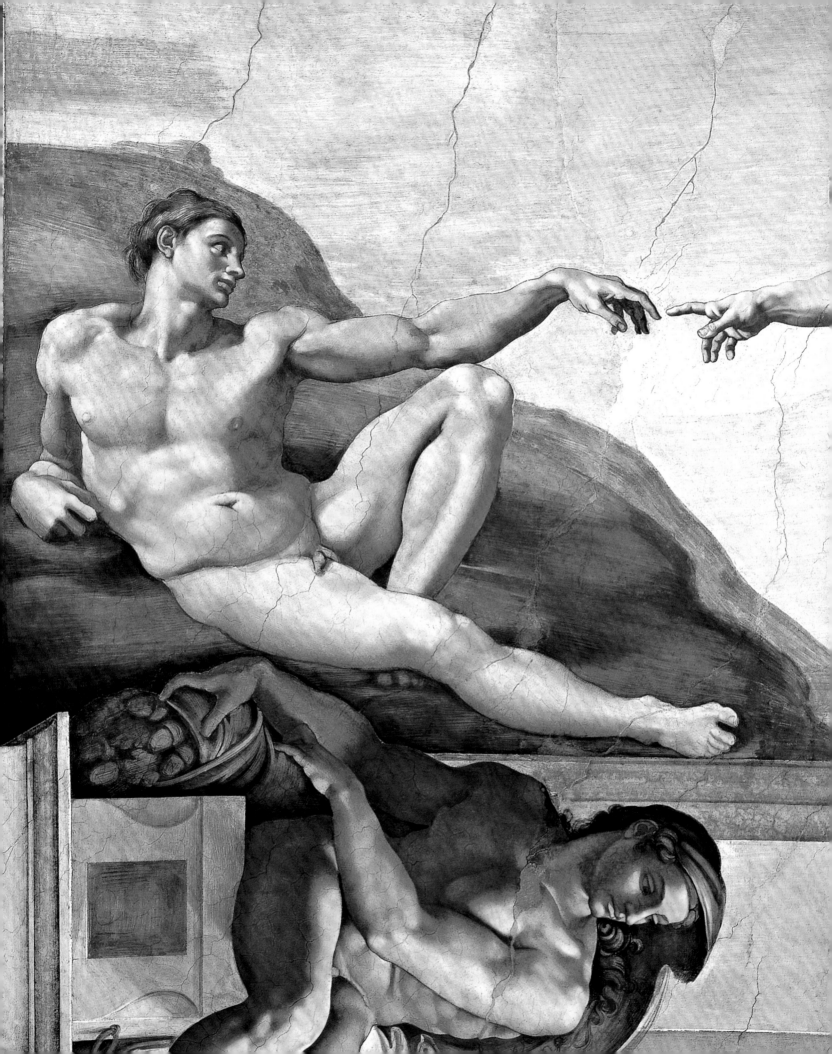

not just see charcoal and red chalk as a process step between conception of a subject and its production in paint or stone.

His three favourite media were ink, charcoal and black chalk but, though dear to Primitivists, silver tip obtains scant relief effect and there is no evidence he ever used it. He would have found washes and watercolours too time-consuming and unsuited to his concise, sober style.

The largest collections of Michelangelo drawings are in the Albertina, British Museum, Louvre, Oxford University, Galleria degli Uffizi, and the House of Windsor Collection. His head portraits are admirably rich in melancholy or pride and span a wide range of strong emotions. The renderings are so bold and powerful that it becomes difficult to visualise fear, pride, and sadness in features other than those sketched by Michelangelo's hand.

Freed of concern for contours, Michelangelo sketched in proud, brutal, and almost barbaric strokes: all of his conviction and haughtiness is present, he sacrifices detail to overall composition, and analysis for synthesis. While Raphael spent long years feeling his way, Michelangelo asserted his sublime obstinacy at full strength right from the start.

Yet his terribly expressive drawings have a jerky feel; they conquer the viewer's eye but fail to charm or to comfort, as happens with the pure smooth drawings of Raphael and Da Vinci that radiate harmony and loving treatment. Michelangelo patently worked under pressure to reach his goal and finish as quickly as possible, economising each stroke like a craftsman doling out a precious raw material. He wanted to be able to make his statement in a single stroke and somehow managed to do so; none condensed so much energy and movement in figures requiring so little time to complete.

Excessive and despotic in all things, and torturing the expression of emotion to the extremes of pathos while restricting their expression to the most limited means, Michelangelo performed feats of genius in drawing as much as in frescos and stone.

Some of his lesser-known drawings are on display at San Lorenzo Church since their discovery in the 1970s. They cover the walls of a crypt adjoining the New Sacristy, where the artist had gone into hiding after returning from exile in 1530: still much in danger, he used the downtime to draw all over the walls that sheltered him.

## The Oeuvre

With some instruction and trade secrets from Ghirlandaio, then considered the finest painter in Florence, Michelangelo would occasionally trade the chisel for the paintbrush.

There were basic differences of style between the two painters. Ghirlandaio sought out faces, dress, furniture, and ornaments that were picturesque, unlike the grandiloquent style and idealised figures in simple garments suggestive of Antiquity that are found in the works of Michelangelo and Da Vinci, regardless of differences between the latter two.

Michelangelo liked to concentrate a universe of sensations into a single subject; Ghirlandaio needed a bigger cast and eye-catching stage props to impress his viewers. But the latter's figures lacked substance in comparison to the fullness and exceptional relief that Michelangelo was giving his figures from the very outset. Despite Ghirlandaio's own knowledge of Antiquity, his style remained poorer and mannered next to that of his student.

For example, the nude in his *Baptism of Christ* is shockingly paltry. And what a chasm separates his *Evangelists* from Michelangelo's *Prophets*! Competently executed, Ghirlandaio's figures look suitably grave with well-articulated drapery, but crumble under the pressure of the gigantic creations of the Sistine Chapel. The *Last Judgment* in Santa Maria Novella suggests an equally fearful comparison. The group has an array of charms: warm distinctive colour, the elegance of the Florentines attending St John's, birth and more.

The youthful Michelangelo would continue to paint in the interval between his admission to Ghirlandaio's shop in 1488 and his second trip to Rome. His first painting may well have been the *Entombment* discovered some thirty years ago and acquired by the National Portrait Gallery of London. Like most of his paintwork, this one also lacks grace and harmony but the figures have such bearing. They exude such savage grandeur! Typically for the period, the rendering of physical strength takes

---

*The Creation of Adam*, sixth panel of the vault, (detail). 1508-1512. (opposite)
Fresco. Sistine Chapel, Vatican.

precedence over that of moral pain. Christ's body is a chunk of rare might, worthy of comparison with the *Pietà* (p. 36, 37) at St Peter's Basilica.

Additionally, the *Manchester Madonna* (p. 85) at the National Gallery depicts the Virgin teaching the Child how to read while the young St John the Baptist and four adult-sized angels look on. It nicely blends pride with love and tenderness. That said, the authenticity of *Entombment* and *Manchester Madonna* is disputed.

Michelangelo's most important painting is *The Holy Family* (*Doni Tondo*) (p. 82, 84), the pride and joy of the Uffizi Gallery. It was Michelangelo's first serious attempt at composition in a painting. Moreover, inscribing all the figures in a circle was a challenge in itself.

At the time, Fra Bartolomeo and Raphael were tackling the same problems which Michelangelo faced, until the first two solved them brilliantly. Michelangelo's groupings failed because he ignored or rejected the rules of aerial perspective and pictorial effect. Thus he did not properly map down his fore-, middle-, and backgrounds or impose any architectonic clarity to the painting.

However, he succeeded through his mastery of drawing, which stands out sharply in the foreshortening of the three main figures, their free-flowing movement and complex poses as well as their austere gravity and originality. So foreign to Raphael's loving treatment of the idyllic, it is a harsh grandiose moment in history, full of forebodings.

In 1504, Michelangelo received a most enviable commission to paint the *Battle of Cascina* for the Palazzo Vecchio, where it would stand opposite Da Vinci's *Battle of Anghiari*. Payment receipts dating from 30 October 1504 until 30 August 1505 imply he started work a few months after Da Vinci, at which time he handed over the cartoon he had made in a hospital ward at Sant' Onofrio where the Florentine State was housing him.

---

*The Creation of Adam*, sixth panel of the vault (detail), 1508-1512. (opposite)
Fresco. Sistine Chapel, Vatican.

*The Creation of Eve*, fifth panel of the vault, 1508-1512. (pp. 106-107)
Fresco.
Sistine Chapel, Vatican.

A few words on the subject of the painting: the memory of the battle of Cascina, waged by the Pisan army on the Florentines, was highly popular in Florence and thus made a suitably glorifying subject. On a Sunday morning in July 1364, a 15,000-strong Florentine army just couldn't help breaking ranks for a swim in the Arno and long naps in the shade. Leading the Pisan forces, Sir John Hawkwood (an Englishman otherwise known as Giovanni Acuto) noticed the vulnerability and advanced his men, who finally shouted the war cries that alerted the Florentines of the assault.

The few guards on duty desperately returned fire until their comrades could reinforce their positions. The defenders then managed to outflank the Pisans, routing them back to their own camp but leaving 2,000 men to fall prisoner, not counting numerous dead and wounded.

A dearth of preparatory drawings makes it hard to reconstitute the metamorphosis this painting went through. The Albertina in Vienna has the largest collection of them and they show major discrepancies with the final work but they may well best reflect the artist's initial intentions. Michelangelo reversed several figures between the sketches and cartoon: a man stepping out of the water stands to the left in the sketch but to the right in the cartoon; he faces us in the sketch only to turn his back on us in the cartoon.

We should note here that the *Bathers* is only a fragment of the *Cascina* composition because Vasari clearly mentions 'infinite' horsemen engaging the enemy. For its part, Oxford University has a number of sketches of cavalry that very likely belong to the cartoon. Those drawings show much richer background than that found in earlier engravings. Another study for three *Cascina* figures is at the Albertina.

In the Accademia dell' Arte in Venice, a further drawing profiles a naked figure blowing a clarion at the extreme right and another, also naked, turning away beside him. One drawing at the Louvre shows a kneeling figure with right arm outstretched and another clad in body armour. We know of four more figures from Daniele da Volterra's drawing at the Uffizi and of combatants in the background forest from an engraving, Raimondi Marcantonio's *Climbers*.

Michelangelo chose to represent that moment in the battle when the off-duty soldiers first hear the clarion. They are scurrying to their trousers and weapons or moving out towards forward positions. As in Da Vinci's *Last Supper*,

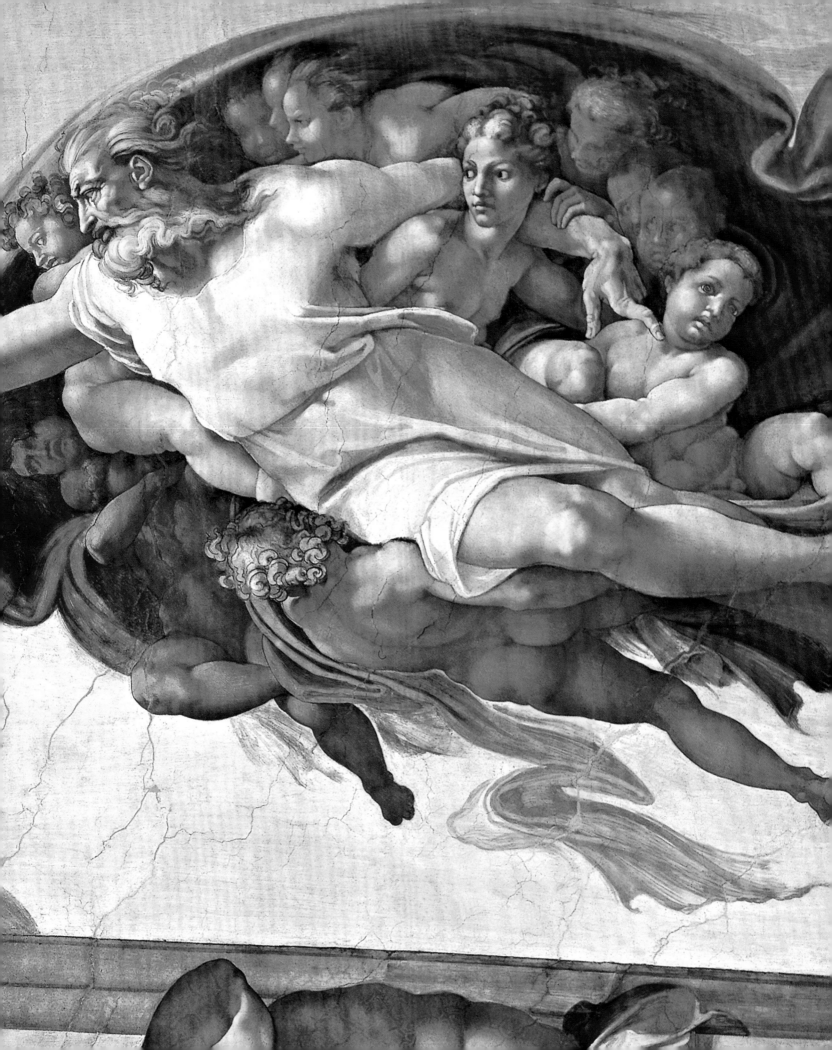

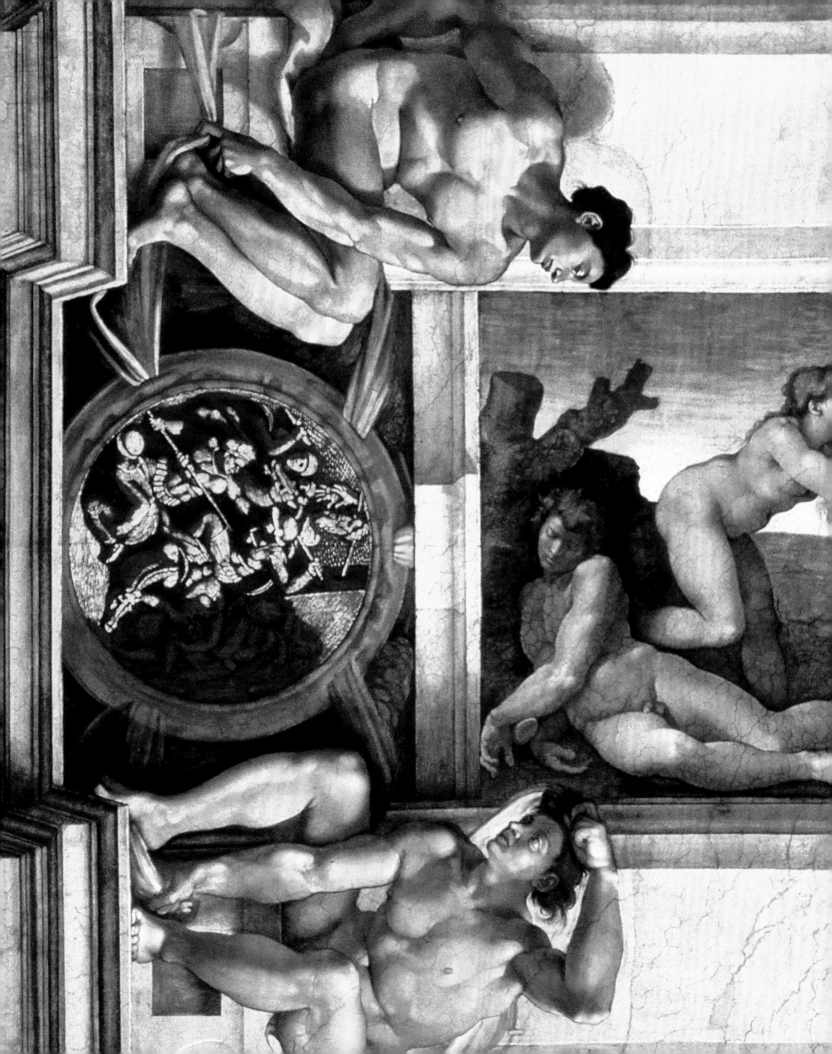

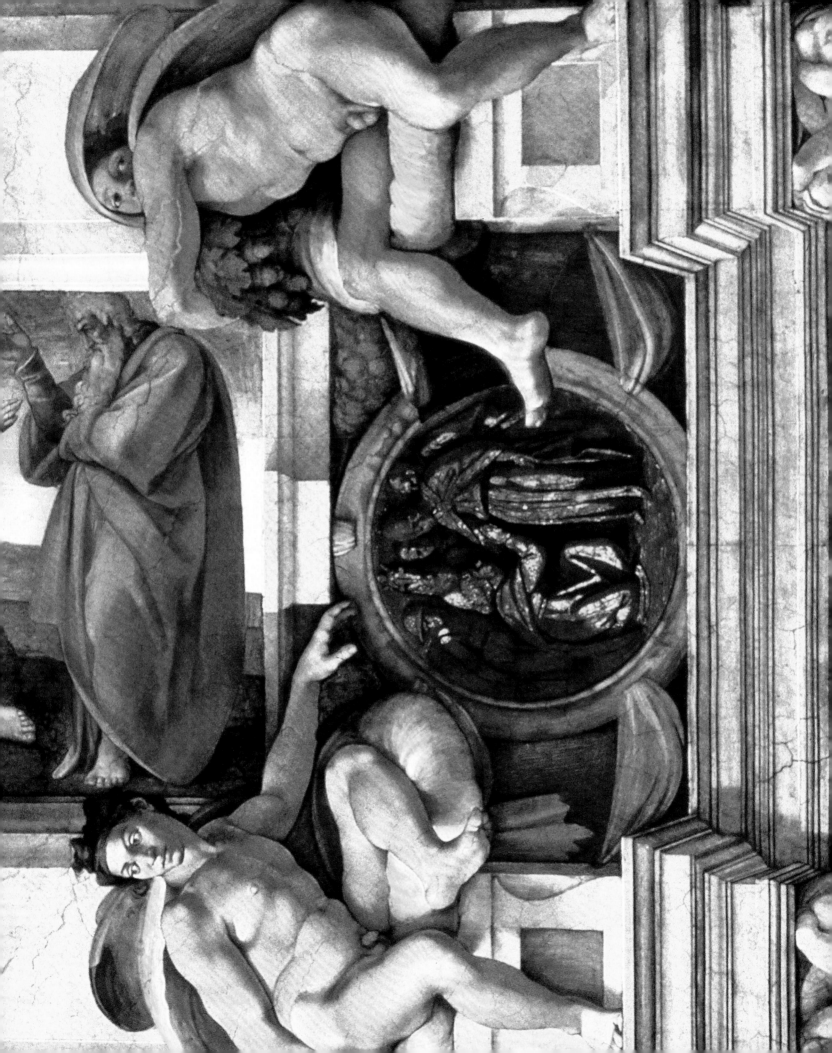

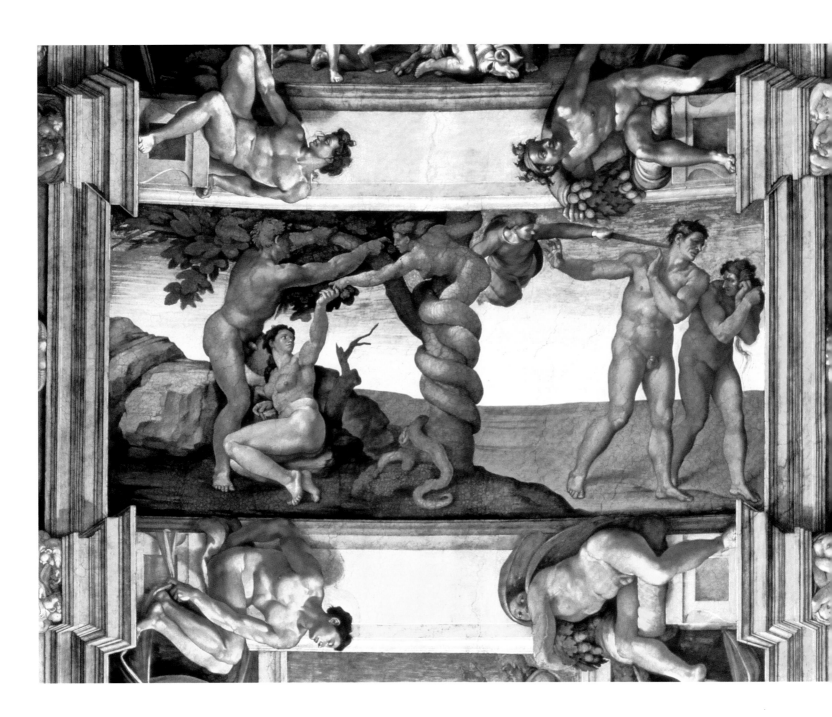

Michelangelo's cartoon electrifies viewers by depicting the powerful kinetic effect of the call to arms or a spoken word. However, the figures are impersonal: these combat-tested troops know only aggressive fighting spirit and physical effort, both rendered with incomparable vigour and mastery. Nothing matches the vitality of their movement, the pride in their poses, or the boldness of the foreshortenings. The spirit of the war god fills their powerful limbs.

Already clad in body armour, one soldier is hastily fastening his footwear as another dons his pourpoint [padding for under armour]; others are still wading or climbing up the riverbank as one drowning comrade raises an arm to call for help. Then there is also an old man crowned in ivy, clumsily trying to get one leg into a pair of wet breeches as the clarion storms right into the centre of the group and the frightened old man clasps his pike.

Elsewhere, a fully geared soldier joyfully throws himself at his attackers. The only false note is one soldier, nonchalantly turning around and wondering what all the fuss is about — standing so close to the others, he must have heard the clarion exactly when they did and his attitude brings the whole painting to a sudden halt. Did Michelangelo just stumble on a natural picturesque pose and elect to keep it despite the subversive impact on dramatic effect and credibility?

Better than anything else, the *Cascina* cartoon illustrates the antagonism between 16th-century art and Primitivism. The Primitives were primarily conscientious observers who, because of scruples and lack of relevant skills, did not fictionalise their subjects but represented action as faithfully as possible. Although they would not try to capture the thousand struggles of a battlefield in a single work, they would aim for accurate detailed renderings of battle dress, body armour, and even the facial features of principal combatants. They would have offered the sort of free-for-all found in Piero della Francesca and Paolo Ucello.

Michelangelo rashly and fortunately did not stoop to such calculations. His impulsiveness could not process such earthy renderings. Historical fact and credibility meant nothing to him. He had the confidence of knowing that, once the composition was completed, the power of the resulting visualisation would mesmerise viewers into perceiving it through whatever forms his imagination had selected. A master of Michelangelo's stature is best understood in terms of personal convictions; having convinced himself that something happened his way, it convinced everyone to see it that way too.

Beneath it all, he depicts a melee at the palestra between over-muscled ancient warriors fighting in the nude. It is hardly a battle out of the Middle Ages or Renaissance when body armour was standard combat kit — an observation worth adding to the list of reasons for the strong influence of Antiquity on Michelangelo. Up until that time, only Signorelli's *Last Judgment* at Orvieto Cathedral assembled so many nudes in one painting.

Michelangelo's contemporaries were most struck by the bold confidence of the poses, as seen in the soldier turning to buckle up his body armour, the one joyously hurling himself at the enemy, or yet another figure kneeling to reach out to a comrade in a pose that recalls the wrestlers of Antiquity in the Florence Tribunal (from a work only discovered in Rome in 1583, but the artist may have copied it from a replica). What masterful foreshortenings! What command of impulsive, semi-subconscious gestures that sweep through the human body!

The cartoon was ready around March 1505 but for unknown reasons, execution never happened. Da Vinci abandoned his commission as well. Though Julius II had convened him to Rome, Michelangelo had ample time to work on *The Battle of Cascina* during a seven-month stay in Florence spanning from at least April until November 1506. Desperate to recover from the embarrassment of the two walkouts, the Florentine State tried to justify its choice of both outstanding artists by holding an exhibition of their cartoons in 1506 — and people visited from all over to see it!

Among those who scrutinised Michelangelo's cartoon, termed 'cutting edge art' by Vasari, were Baccio Bandinelli, Benvenuto Cellini, Franciabigio, Ridolfo Ghirlandaio, Granaccio, Lorenzetto, Maturino, Jacopo da Pontormo, Raphael, Rosso, Aristotele da Sangallo, Jacopo Sansovino, Andrea del Sarto, Tribolo, and Perino del Vaga.

---

*The Original Sin and Expulsion from Paradise*, fourth panel of the vault, 1508-1512.
Fresco.
Sistine Chapel, Vatican.

Henceforward, the prime goal of artists became to capture poses of equal pride and freedom of movement. Beauty, charm, and grace were relegated to the backburner: art was made to project power and terror.

The figure that most affected the artist's contemporaries was the seated old soldier in a crown of ivy, struggling helplessly to slip dry leather footwear over wet feet. His contorted face expresses extreme effort and frustration. Not without comic intent, this motif is the only trace of Primitive influence.

Further, it is not entirely Michelangelo's as Masolino used it in a fresco at Castiglione d'Olona. Michelangelo's warrior buckling his belt from behind gives off a torso effect that distinctly recalls the pose of a man drying himself from behind off to the right in Masolino's fresco. But what transfiguration from the latter figure to the former!

If careless about the intellectual property rights of others, Michelangelo was quick to defend his own and, as soon as the exhibition closed, he squirreled the cartoon far away from anyone's sight – only to become the first victim of his mistrustfulness.

Vasari notes that during the counterrevolution that reinstated the Medici in 1512, fellow sculptor and arch-enemy Bandinelli managed to access the cartoon and tore it to shreds. But elsewhere, Vasari says destruction happened much later at the Medici home during Duke Giuliano's illness. The surviving fragments only increase dismay over the loss.

From 1508 to 1512, Michelangelo devoted himself entirely to a relatively coherent major project that he finished down to the last details: the frescoes of the Sistine Chapel, named after Pope Sixtus IV who had commissioned it. The chapel interior is 40 metres long, 13 metres wide and 20 metres tall; therein all Popes have been elected ever since.

---

*The Original Sin and Expulsion from Paradise*, fourth panel of the vault, detail, 1508-1512. (opposite)
Fresco.
Sistine Chapel, Vatican.

*The Original Sin and Expulsion from Paradise*, fourth panel of the vault, detail, 1508-1512. (pp. 112-113)
Fresco.
Sistine Chapel, Vatican.

Until recently, it was held that the artist's enemies connived to secure this commission for Michelangelo because they were persuaded it would prove his downfall. However, documents released for the centennial of the Sistine Chapel prove that the original project dates back to 1506, that it was Sangallo's idea, and Sangallo is a known friend of Michelangelo's.

Moreover, it was normal for Florentines to lobby for each other against rivals from competing art colonies established in Rome, except that Bramante fought against Michelangelo's candidacy. As Michelet writes:

> The obscure and lonely dome under which (Michelangelo) spent at least five years (1507-1512), was his Cavern of Carmel and he lived there like Elias. He painted lying on a bed suspended from the ceiling with his head cocked backwards. His only companions were the Prophets and Savonarola's sermons.

Initially, the lunettes were to accommodate the twelve prophets, with ornamental motifs for the rest of the ceiling. Or at least execution started out that way. But Michelangelo soon realised it would diminish the stature of the prophets so he returned to the Pope with a proposal of far higher symbolic impact and many more figures. Ever fascinated by the colossal, Julius II was delighted.

Michelangelo started work on 10 May 1508 and had finished the vault by the autumn of 1510. In October 1512, the lunettes and pendentives were completed and the Chapel was ready for general admission. This enormous worksite had taken one man only four short years: a unique achievement in the annals of modern art.

Michelangelo's stamina and powers of concentration were prodigal here. He banned visitors and locked himself up inside the chapel; even his paymaster, the Pope, was unwelcome. Execution ran into numerous problems but Michelangelo's vitality and determination were prepared for any obstacle.

First, Bramante's mistake on the scaffolding meant it had to be dismantled and replaced with one of Michelangelo's own design. Then there was a shortage of assistants: untrained in fresco, Michelangelo called in help from Florence: his friend Granacci along with Giuliano Bugiardini, Jacopo di Sandro,

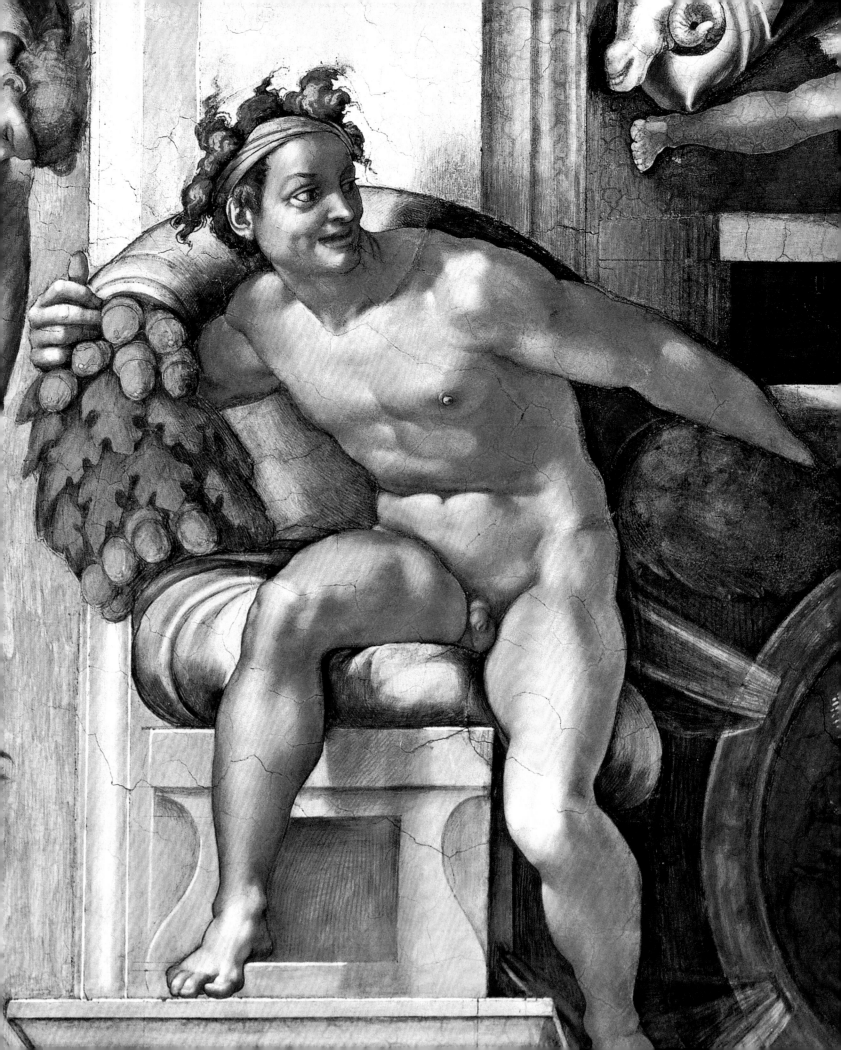

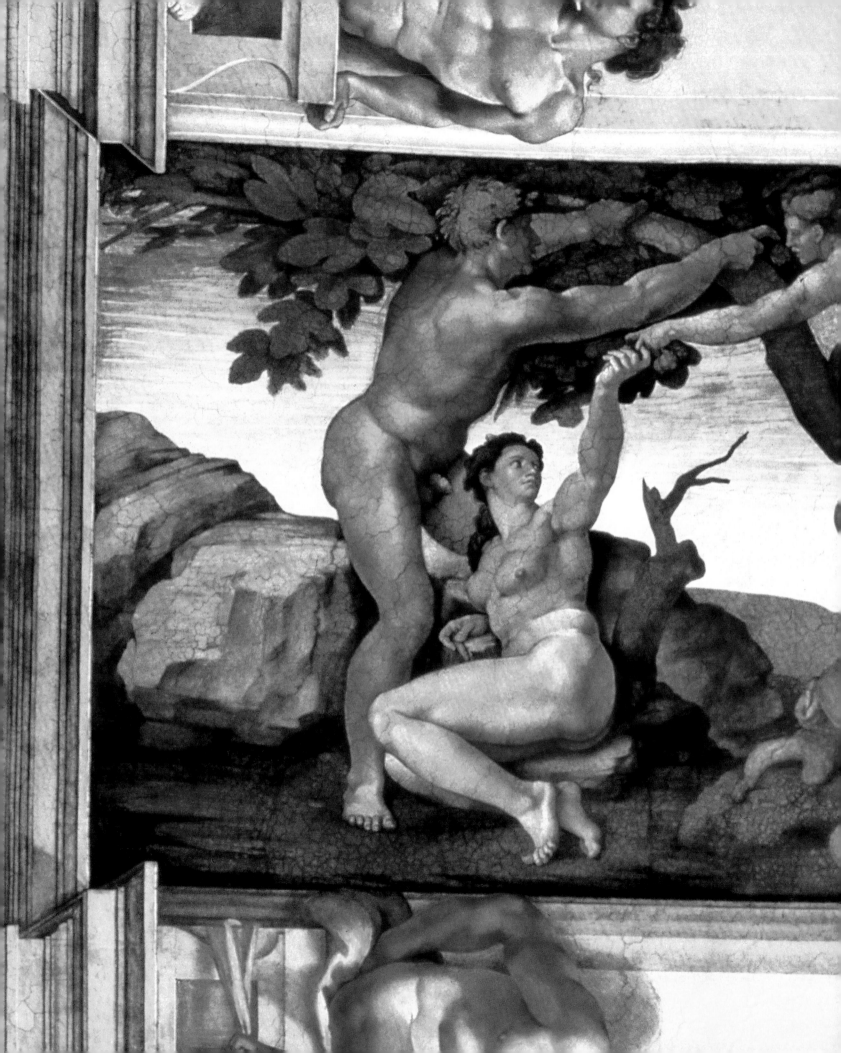

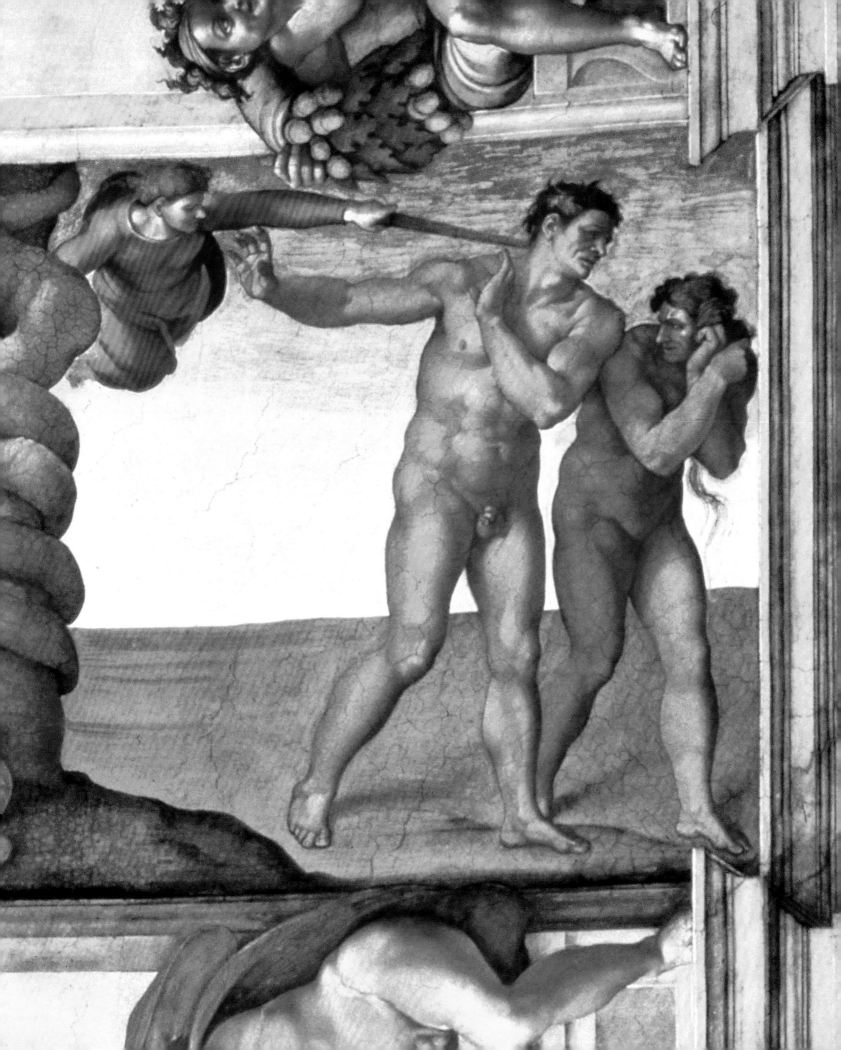

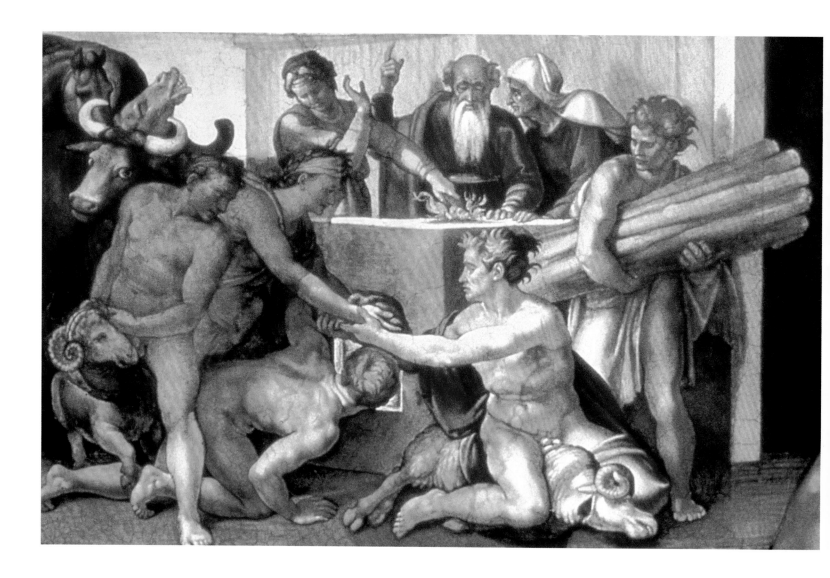

Indaco the Elder, Agnolo di Dominion, and Aristotle. But dissatisfied with their studies, he effaced all their work, locked up the chapel, and never spoke to them again. They must have been mortified all the way back to Florence.

Eventually, Julius II encountered financial difficulty, which resulted in irregular funding for worksite materials. At the outset, Michelangelo suffered several bouts of depression. In a letter dated 27 January, 1509, he writes:

> I remain deeply troubled because I have not received any payment from this Pope for a year;

*The Sacrifice of Noah*, third panel of the vault, 1508-1512.
Fresco.
Sistine Chapel, Vatican.

I ask him for nothing because I feel that work is not progressing enough to deserve remuneration. This is because of the difficulty of the work and then fresco is hardly my profession. I am therefore wasting my time. God help me!

How sublime his modesty in a moment of desperation! Completing such an enormous task in only four years is what he calls "wasting his time"!

When Julius II became impatient, Michelangelo had to take down the scaffolding before completion of the ceiling work and the Pope deplored the total absence of gold he felt needed to enhance the overall effect. To which Michelangelo rebuked: "The figures I painted were poor and their saintly simplicity hated worldly wealth."

Did the Pope's entourage grasp the genius of Michelangelo's creation? French historian Jules Michelet notes:

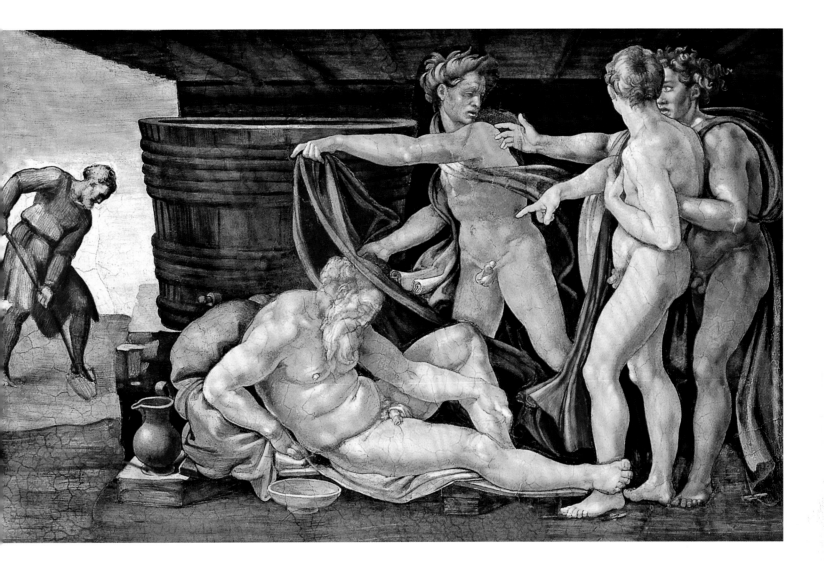

On the dangerous day the door finally opened and the Pope entered with his grand retinue; Michelangelo could see that his work remained for them a shut book, that in seeing they saw nothing. Ill-intentioned and as mute as a vast enigma yet not daring to speak ill of these giants under their withering gaze, they all remained silent.

Working alone and mixing all his colours himself, Michelangelo finished the last half of the chapel in twenty months. The Pope's impatience caused him to complain that he lacked the time to complete it to his own satisfaction.

When Julius II asked him about completion one day, Michelangelo said, "When I'm satisfied with the result." To which the Pope retorted: "And we, too, should like to be equally satisfied – promptly so. Otherwise I shall have you thrown off your scaffolds."

Panic-stricken, and with good reason to fear the Pope's ire, Michelangelo immediately ordered dismantlement of the scaffolding. The entire chapel was thrown open to public view on All Saints' Day, and the Pope celebrated mass there the same day before a vast audience, according to Vasari.

Contemplating the Sistine ceiling, it is tempting to conclude that, like Moses, Michelangelo had climbed his

*The Drunkenness of Noah*, first panel of the vault, 1508-1512. (above)
Fresco.
Sistine Chapel, Vatican.

*The Deluge (The Flood)*, second panel of the archway, 1508-1512. (pp. 116-117)
Fresco. Sistine Chapel, Vatican.

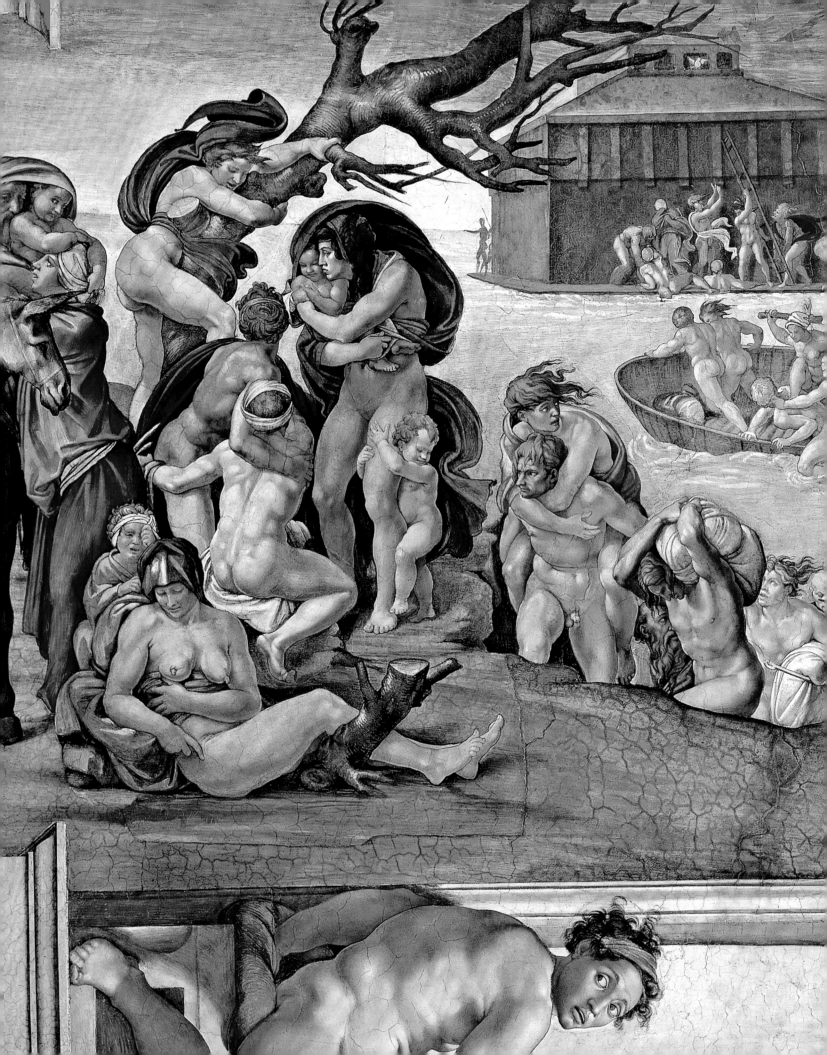

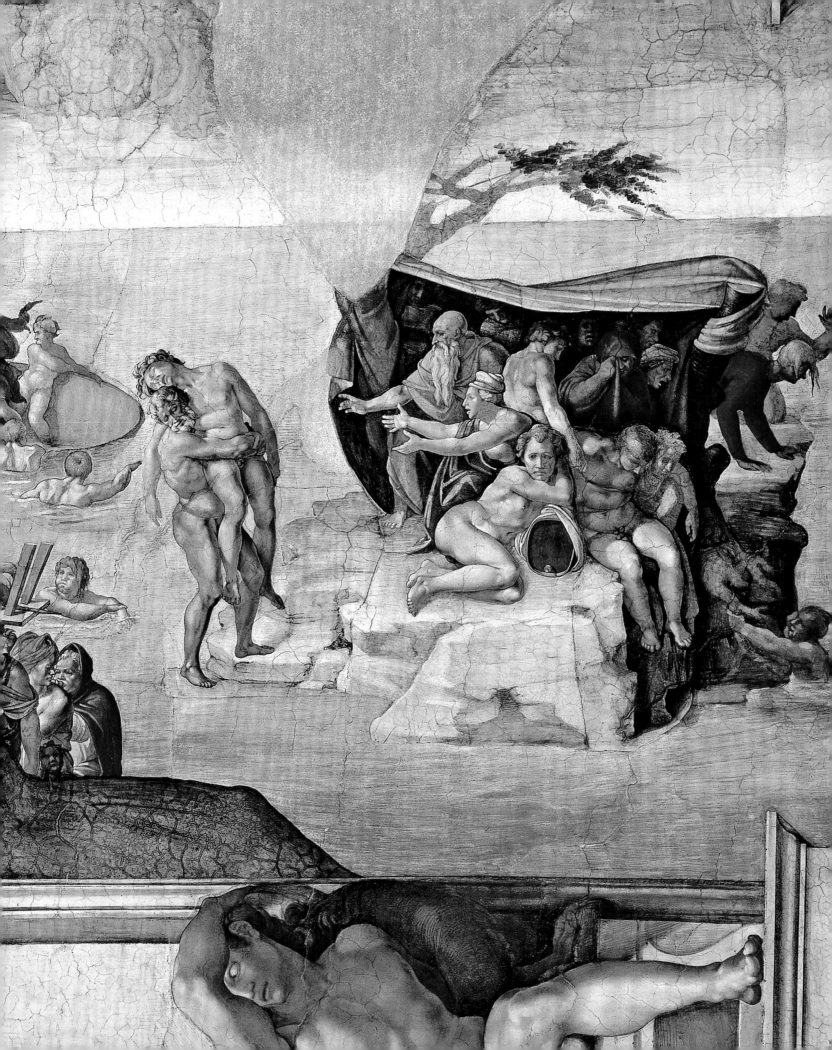

*The Brazen Serpent*, 1511.
Fresco.
Sistine Chapel, Vatican.

*The Punishment of Haman* (detail), 1511.
Fresco.
Sistine Chapel, Vatican.

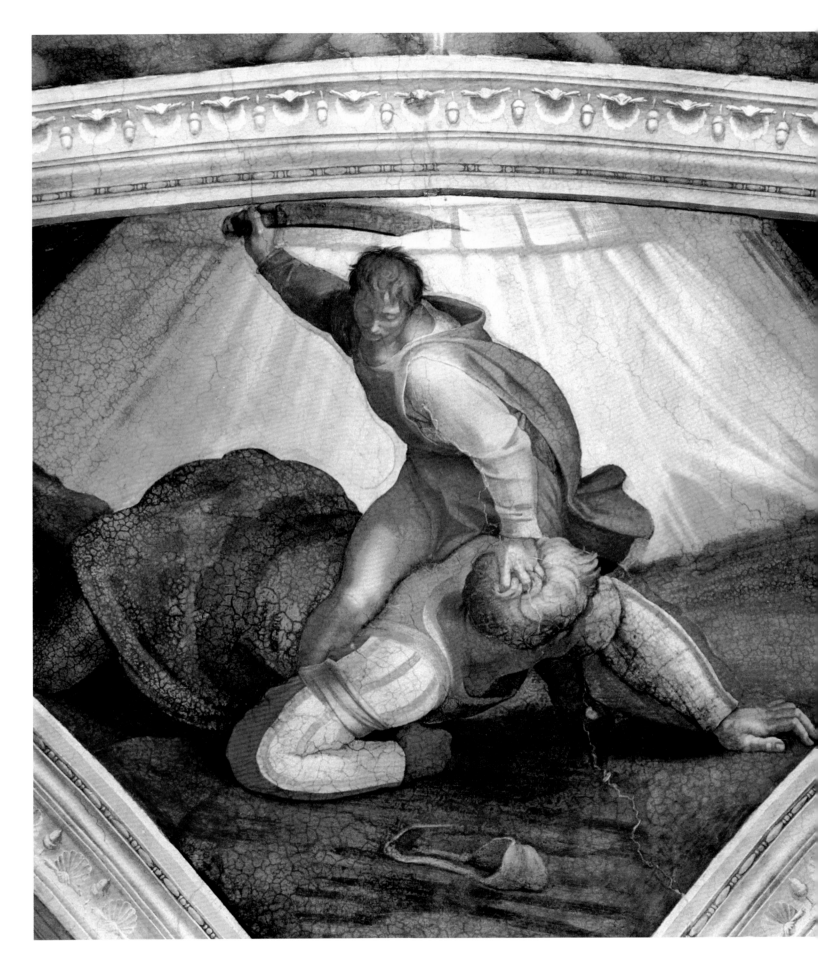

SALMON

BOOZ

OBETH

own Mount Sinai here and spoken to Jehovah. Like the Lawmaker, he too was exempt from sentiment; both were oracles of a severe implacable God whose Word is not open to appeal. Before that Word, humanity can only tremble and comply. If the poetry of Christianity perhaps touts the image of suffering too strongly, it also consistently tempers it with that of tenderness.

In contrast, Michelangelo's Sistine frescoes project an image of inexorable fatality where God is one of Nature's forces, like the *fatum* of Antiquity – not a just and benevolent divinity that presides over the origins of the universe, the creation of our forebears, and their trials during the Great Flood.

To render the feelings of resignation, leniency, and serenity that form the basis of Christ's teachings, a better choice would have been someone tender and elegiac such as Raphael, or

perhaps even Da Vinci. A sombre-minded *enfant terrible* such as Michelangelo characterises the angry God of the Old Testament, the Jehovah of the Israelites.

But then, suddenly, Michelangelo changes his mind and takes issue with this God who has inflicted so much misery on humanity and lauds the upstarts, the *Rebellious*

---

*David and Goliath*, pendentive angle of the vault, 1508-1512. (opposite)
Fresco.
Sistine Chapel, Vatican.

*Salma, Boaz, and Obed*, 1508-1512. (above)
Fresco after restoration.
Sistine Chapel, Vatican. Lunettes above the window.

Angels, Prometheus, and the superhuman figures portrayed in Day and Dusk, descendants of the Titans of Antiquity. Clearly, the artist's own inner conflicts transpire in his independence from Christian iconography and need to appropriate it for his own purposes by deleting many attributes the faithful had consecrated through their worship.

The ceiling paintings each match one of six windows on either side of the chapel. Taken as a whole, they break down into five orders of architecture, with caryatids, consoles, and figures seated on pedestals.

Each order contains paintings of its own that serve as framings for the nine compartments (four large; five small) which accommodate the following representations: God Separating Light from Darkness, Primordial Creation, God Separating Earth from Water (pp. 96-97), the Creation of Adam (pp. 100-101, 102, 105), the Creation of Eve (pp. 106-107), Temptation, Sacrifice of Noah (or Sacrifice of Abraham, p. 114), Deluge (or Flood, p. 116-117), and Drunkenness of Noah (p. 115).

The five small compartments fit in the intervals between windows, flanked by paired adolescent figures in each of the four corners, sharing a ribbon that holds a discus or medallion decorated with cameo figures. Below is the domain of the Prophets and Sibyls. Still lower at the foot of the arch, juvenile figures carry individual cartouches bearing the figures' names.

For their part, the large compartments extend into corner pieces topped with outstretched figures and triangles framing each into a group, as well as into lunettes split by windows that each contain a prophet, Israelite king, or female saint.

---

The Prophet Ezekiel, edges of ceiling, 1511. (opposite)
Fresco.
Sistine Chapel, Vatican.

The Prophet Isaiah, edges of the ceiling, 1511. (p. 124)
Fresco.
Sistine Chapel, Vatican.

The Eritrean Sibyl, edges of the ceiling, 1508-1512. (p. 125)
Fresco.
Sistine Chapel, Vatican.

Installed as corner pieces for the chapel are the Brazen Serpent (p. 118), the Punishment of Haman (p. 119) and David and Goliath (p. 120).

We now know the ultimate inspiration of this gigantic project came from assiduous study of the Old Testament, bits of sombre Middle Age poetry, and touches of Dante. As Michelet astutely observes: "Whether he realised it or not, his immediate master was not Savonarola, it was the 12th century and the vision of Joachim of Flora, which Savonarola dared not read."

The ceiling was painted first and our examination should begin there. A set of drawings at Oxford University illustrates Michelangelo's approach. They depict him in introspective postures and thinking through his ideas before setting pen to paper. But once his mind was made up, he attacked execution with incomparable boldness and frankness and the vigorous determination to animate his figures down to the last detail, free of any hesitation or regrets.

The first fresco shows Jehovah crossing through space in a powerfully original movement with raised arms, head thrown back, and cape floating behind him. His apparition is both sudden and grandiose. It paraphrases the verse: "The Lord said 'Let there be light.' And there was light." The powerful strokes and extreme liberty of this figure suggest that, after laying down the heavy, tiresome chisel, Michelangelo discovered the voluptuous joys of the paintbrush that enabled him to create gods and mortals at the flick of the wrist.

In his Primal Act of Creation, Michelangelo deploys his flair for imparting sudden unheralded movement in progress, and presents God in just such an action pose. The Supreme Being's powerful head, thick eyebrows, and coarse hair darkening his broad forehead are techniques borrowed directly from depictions of Jupiter.

Surrounded with angels yet airborne under his own power (the supernatural convinces when painted by genius), Jehovah extends one hand in a gesture of sovereign grandeur: suddenly the solar disc breaks through and blinds the angels. Further along in a marvellous foreshortening, the same fresco shows God zipping across the sky like an arrow with naked feet and windswept drapery, back turned to the viewers. As He raises His hand ever so slightly, plant life commences.

In the third compartment, God parts earth from water. Retreating from view in the preceding compartment, God is

EZECHIEL

ESAIAS

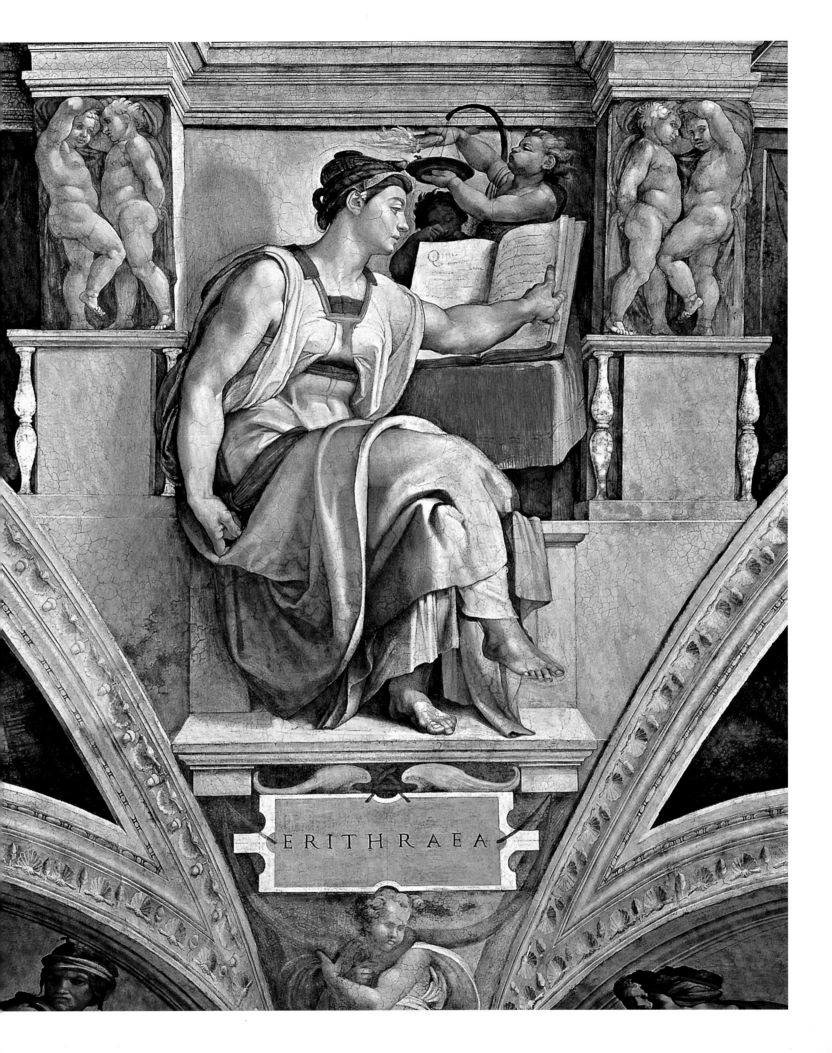

ERITHRAEA

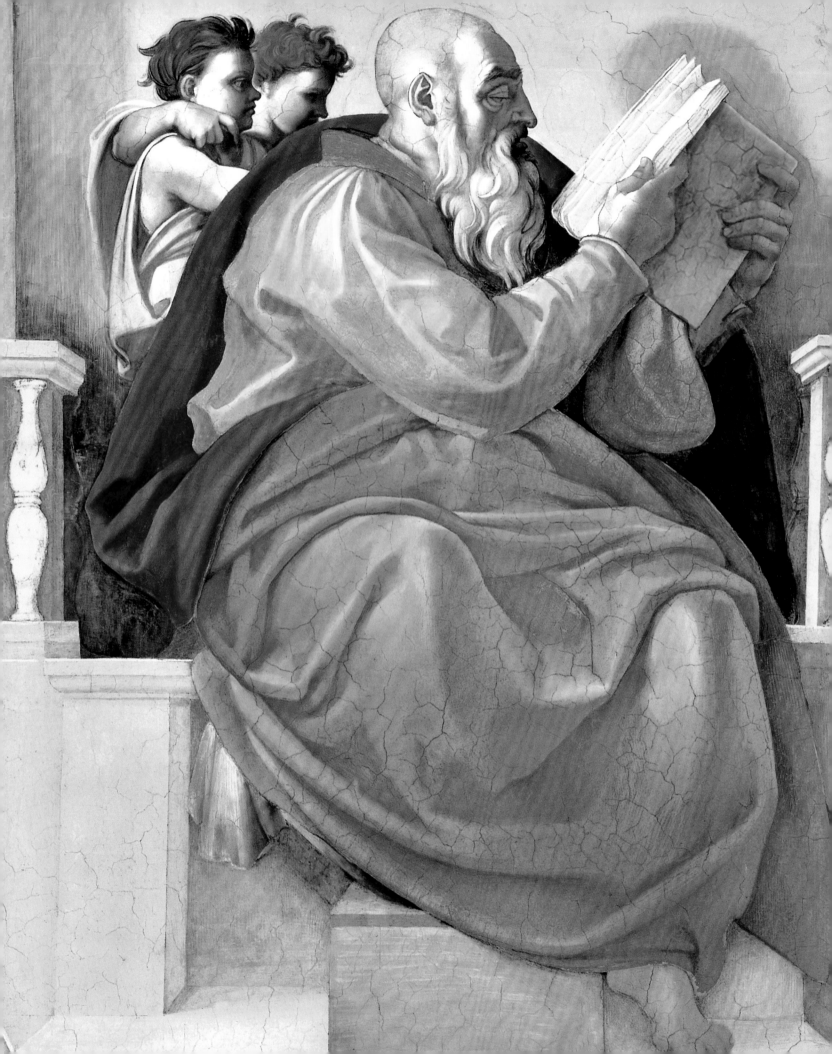

now heading straight at viewers in the sort of contrast so dear to Michelangelo. The wind has inflated His drapery like a sail and his focus on this material detail underscores the significance of a higher, psychological order.

*The Creation of Adam* wrests us out of the supernatural and back to reality. The scene is one of extreme simplicity and indescribable beauty. Sweeping along a bevy of angels in the wake of his impetuous flight, Jehovah heads earthward as He extends the index finger of his right hand.

Suddenly another index finger appears from the opposite direction to meet it, almost close enough to trigger an electrical spark. Sprawled negligently yet elegantly across the ground, Adam presents the fulsome vigorous naked body of the first man. This figure is one of the most radiant conquests of modern art: its simplicity and grandeur recall Phydias' *Theseus* for the pediment of the Parthenon. The name of Phydias constantly comes to mind when looking at the Sistine frescoes.

From Antiquity to present day, only Phydias and Michelangelo have penetrated the mysteries of religion this deeply and incarnated so majestically the ideal of the eternal beauty of the human body. Each had the same nobility of thought, the same blend of grandeur and simplicity of style. The creator of Jupiter has become a Christian, blending the occasional touch of sadness and vehemence into the impassive serenity of Ancient Greece.

*The Creation of Adam* leads into *The Creation of Eve*, easily the most poetic and moving fresco of the entire series. Here, God has descended once again, covered in ample drapery as He advances at a measured pace and lifts His right hand with radiant majesty. Taken aback before time to realise her very existence, she inclines before her creator, imploring Him with clasped hands.

Her hair falls loosely and her entire being eloquently communicates turmoil, surprise, confusion, and emotion. Beside her, Adam is asleep, his body in a pose of careless abandon halfway between life and death, the sort of pose that Michelangelo found terribly endearing.

The sixth fresco contains two distinct scenes. The composition breaks the law of unity of action that was winning general acceptance at the time, though Raphael himself broke it on occasion as well. *Original Sin* is on the left in the foreground and *Fall of Adam and Eve* occupies the middle ground. A tree down the middle of composition separates the two scenes and at least obtains some decorative spin-off.

Moving away from the *Creation* scenes, the décor becomes richer and the layout becomes both more apparent and flexible, as the subject requires.

In *Temptation* and *Fall*, the painter outdistances the poet: Michelangelo wanted naked bodies of beauty equal to their vigour. What power emerges from this vigorous healthy broad-hipped mother of the human species! The angel chasing away the sinners is an entirely different sort of marvel; has the power of absolute authority ever been shown in features so concise? These are but a few of the abundant and highly varied gestures and poses that would have been the envy of Giotto, his glorious precursor and playwright.

We could go on to review his foreshortenings, each an exceptional feat, as well as the considerable difficulties he solved almost before he noticed their existence: in the presence of genius, you become used to prodigal achievements.

How his first frescoes were grave and sublime! Michelangelo could personify the most grandiose events in two or three figures, using language unknown even to the Greeks. His supremely epic style had simplicity, conviction, and eloquence which the artist absorbed through contact with an entire generation animated by a common drive. Such were the creations of the 16th-century Italy that some glibly call frivolous. Let us recognise how deep and strong convictions were then, and that any frivolity was only superficial.

Like the poets of Antiquity, yet victim of his own impulsiveness rather than suggestibility, Michelangelo takes us straight to the heart of the drama. In *The Sacrifice of Noah* (p. 114), the action is in full swing. A fire is burning on the

---

*The Prophet Zacharias*, edges of the ceiling, 1511. (opposite)
Fresco.
Sistine Chapel, Vatican.

*The Delphic Sibyl*, edges of the ceiling, 1508-1512. (p. 128)
Fresco.
Sistine Chapel, Vatican.

*The Cumaean Sibyl*, edges of the ceiling, 1508-1512. (p. 129)
Fresco.
Sistine Chapel, Vatican.

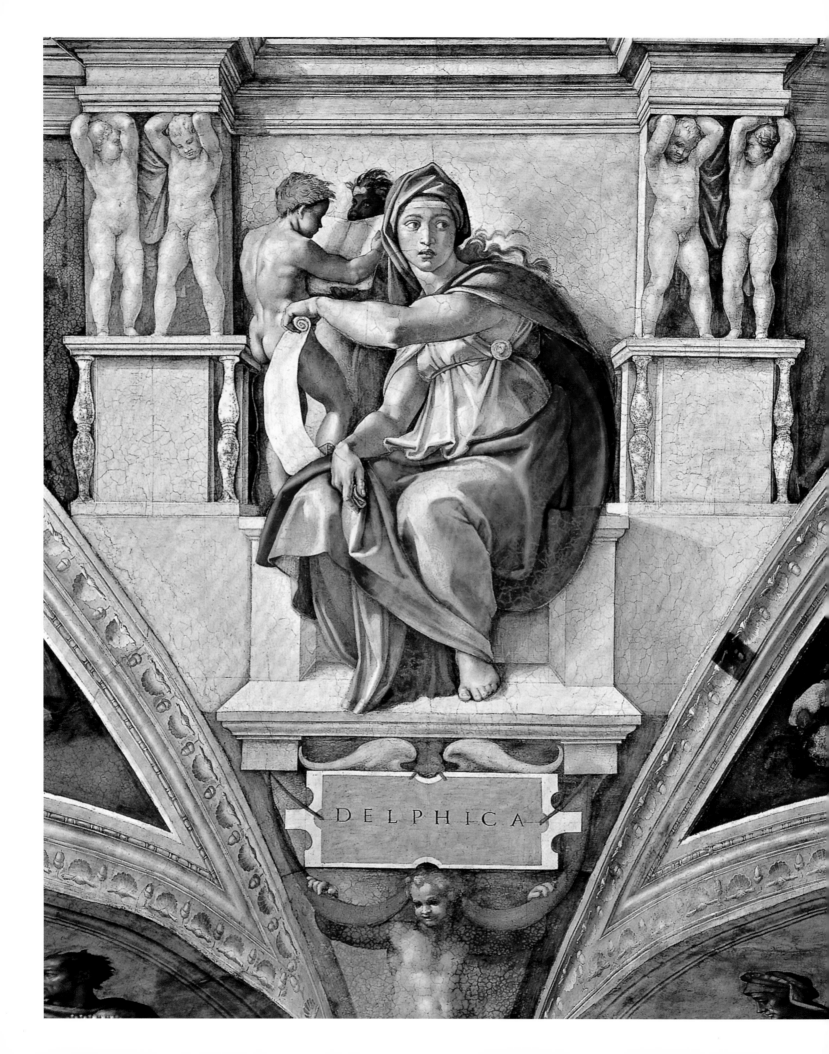

DELPHICA

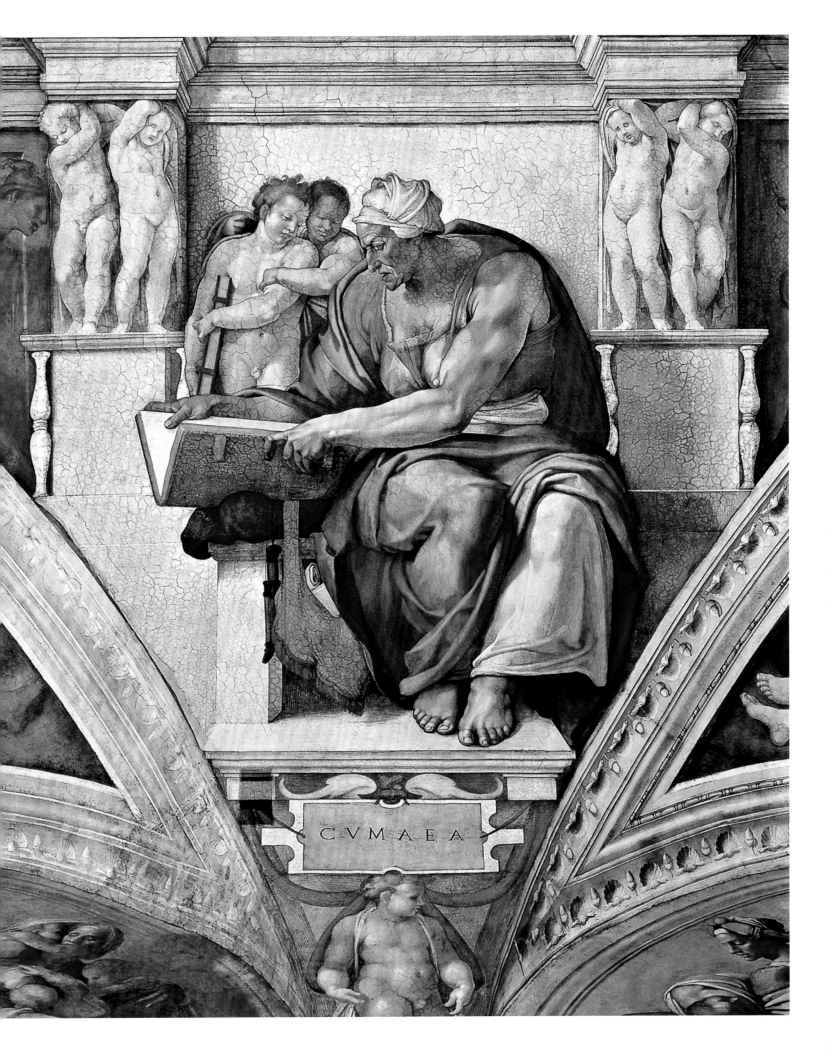

CVMAEA

altar before Abraham, Sarah and perhaps a miraculously rescued Isaac.

In the foreground, one servant brings wood and another, a goat. Extra servants are collecting the blood of a second goat, just slaughtered. This obtains a dual allusion: Michelangelo borrowed the servant in a laurel wreath from Antiquity and from the Primitives he borrowed the background, consisting of an ox, horse and donkey braying with bared gums as it rears its head. Such naïve observation hearkens back to Benozzo Gozzoli or Antonio Pisano (called Pisanello).

In *The Deluge*, we face a more complex scene, multiple groups, and up to three middle grounds – a layout unique among Michelangelo's works. This is only surprising when it happens to Michelangelo after 1508: the master of plastic, abstract, and simplified form suddenly reverts to the errant ways of Primitivism.

In this painting covering the walls of the Santa Maria Novella Cloister, he accumulates episodes like Paolo Uccello. He settles for inventions that are strange rather than picturesque, such as the woman carrying her utensils in an upside down footstool.

The composition is rich in unexpected features both plastic and dramatic, i.e. a naked youth leaning nonchalantly against a barrel (one of his more fortunate details). Further on, there is a father carrying his dead son in a pose that heralds the magnificent group in Mercié's *Gloria Victus!* Then we have brutal life-or-death struggle between the chosen on deck and the unfortunate desperately trying to board the ark. This is boldness and pathos at its finest.

*The Drunkenness of Noah* is an austere energetic scene in true low relief. Spread out on the ground, the patriarch is sound asleep, propped up against a cushion with one leg folded, the other extended. His three sons stand before him as Ham turns to his brothers to direct their attention at the unedifying scene, but Japheth throws an arm around his father, trying to pull him rearward while placing his other arm on Shem's shoulder, enjoining him to let the veil fall and cover their father. Indeed, in a

single impetuous movement, Shem unfolds the veil he brought along and prepares to cover his father, while turning away his gaze.

Outside the grotto on the left, we have a fairly pointless detail: a man hoeing earth (probably Adam).

This beautiful page of consummately narrated drama, so full of eloquently penetrating gestures and lines that blend both unexpectedly and harmonious, seems out of place in the works of Michelangelo who was so ham-fisted when it came to layout.

Among the pendentive frescoes, we can set aside *Judith and Holofernes* and *David and Goliath*, in order to analyse *Brazen Serpents* and *Punishment of Haman*, where Michelangelo derived optimal decorative effect from the technically challenging triangular surfaces at his disposal. What would have caused failure in others became an ingredient of his triumph.

Possibly an inspiration for Raphael's *Bolsena Mass*, *The Brazen Serpent* has all the pathos of *The Deluge*. From one end, the repenting, almost ecstatically fervent Israelites raise up their arms at the monster coiled around a mast. In passing, note the trembling child's touchingly naïve outreach to the bronze. At the other end, the less fortunate are being assailed by fire-breathing serpents, worthy pendants to the *Laocoön* (p. 58) discovered about three years earlier.

The scene is one of darkest tragedy where terrified men and women in deep pain blindly flee in all possible directions to avoid the mortal bites – all human sentiment vanishes as ego, stress, and survival instinct propel husband and wife, mother and father to trample everyone underfoot. Perhaps no other painter has ever achieved such poignant, hideous drama.

*The Punishment of Haman* divides into three distinct scenes. On the left, the first scene shows King Ahasuerus (called Xerxes), Esther, and Mordechai (known as Mardochus) around a table. Ahasuerus and Esther respond with stupefaction or contemplation to Mordechai's highly animated account of Haman's betrayal. On the right, Ahasuerus, in bed, signals his courtesans to put Haman to death.

The final scene in the centre shows Haman writhing in pain with an almost dislocated head, both arms outstretched on a cross, one leg nailed to it, and the second thrown sharply backwards. This figure seems patterned after the flute-playing Marsyas of Ancient

*The Prophet Jeremiah*, edges of the ceiling, 1511.
Fresco.
Sistine Chapel, Vatican.

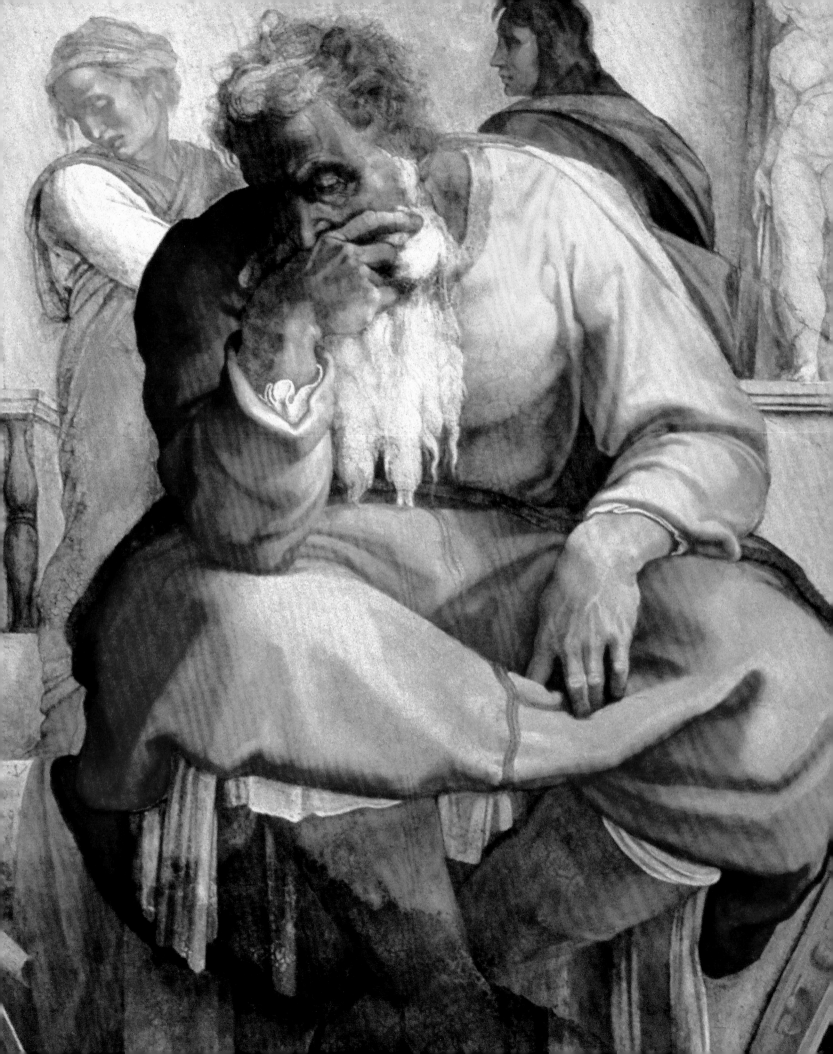

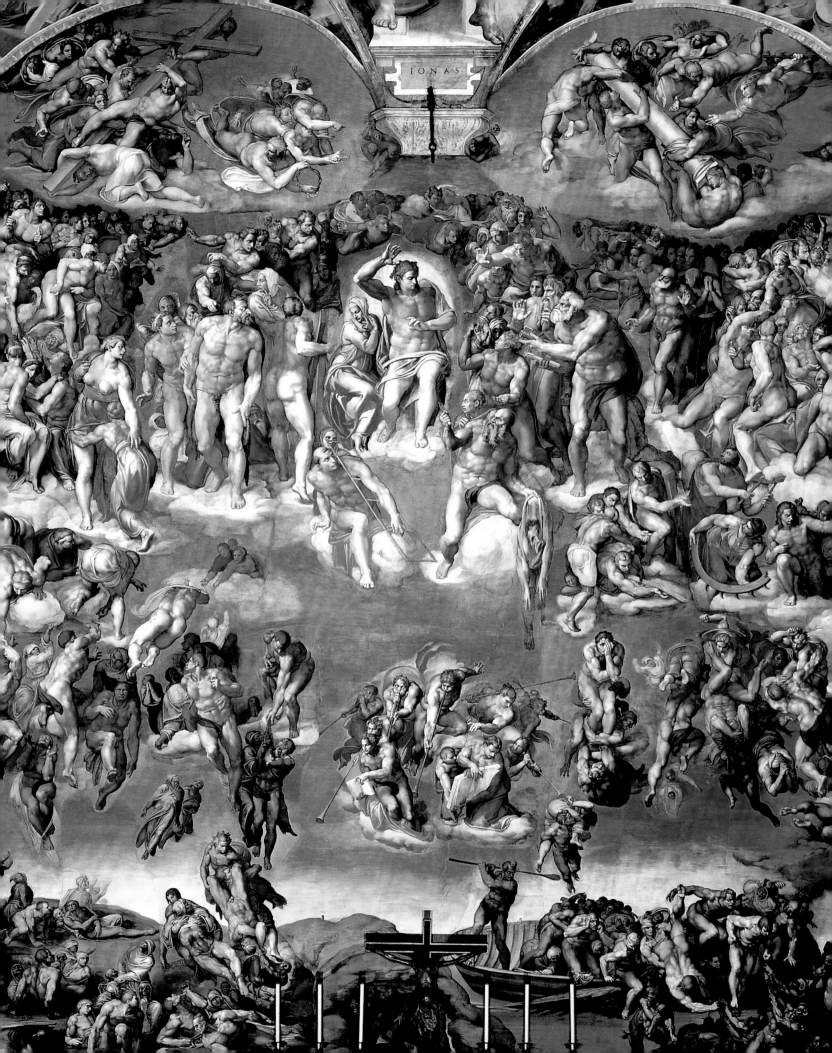

Greece and aspects herald Ruben's *Crucifixion* in Antwerp. It is one of Michelangelo's best examples of concision and nudity.

The *Prophets* and *Sibyls* bear the same relationship to the ceiling compositions as statues to low reliefs. But shorn of elaborate accessories, are these evocations from the Old Testament any less powerful and gripping?

The *Prophets* and *Sibyls* lead into the groups of lunettes, containing figures generally agreed to be the *Virgin's Ancestors*. The beauty remains extreme, but of lower key here. Michelangelo dispensed with perspective, a painter's skill, and relies on motif to obtain relief.

The technique has its drawbacks: figures are disproportionate from one composition to the next. Either gigantic or microscopic, the figures upset the balance and ultimately clash. But why quibble over proportions in a work that remains a masterpiece nonetheless?

One innovation in the Sistine frescoes is recourse to painted ornamentation for relief effect, with an emphasis on architectural motifs. Until then, flat ornamentation had almost always been the rule. In jettisoning this staple technique of the Primitives, even for the Sistine Chapel, Michelangelo revolutionised decoration.

Never before had artists merged decorative figures with their architectural framework so thoroughly. No longer mere afterthoughts, figures became an integral part of the ceiling and it became impossible to conceive the whole without its caryatids and seated figures that infuse that whole with character and meaning.

In short, the figures personified the architectural elements. Had Michelangelo done only the ceiling, it would have sufficed to qualify him as a brilliant architect because of the clarity, vigour, and colour he put into the mouldings, entablatures, and pedestals.

Well before Michelangelo, Mantegna and his talented successors had achieved excellence in ceiling work, but they played on perspective rather than architectural elements. Thanks to Michelangelo, the genre was rediscovered, the problem was solved and, from 16th-century Venice to 19th-century Paris, every artist who tackled ceilings owed something to Michelangelo's Sistine Chapel. The bold poses and anatomical accuracy of these figures show how much a painter can learn from a chisel. As Hippolyte Taine writes:

Nothing equals it in modern statuary and the noble figures of Antiquity do not surpass it; all one can say is that they are different. Phydias crafted happy gods and Michelangelo, suffering heroes; but suffering heroes are equal in worth to happy gods; it's the same magnanimity, down here it is exposed to worldly misery, up there it is emancipated; whether stormy or calm, the sea remains equally magnificent.

As the Sistine figures were sculptural and pictorial at the same time, they were a source of inspiration and motifs for statues and groups to eminent sculptors for over three centuries. Many Sistine prodigies born almost subconsciously from his fingertips remain the bane of imitators even today.

The spirit of these frescoes is foreign to the sweet naïvety proper to 15th-century art. It was like an Iron Age coming in to shut down the Golden Age. The emotional approach of these charming masters is but child's play next to Michelangelo's extreme dramatisations.

They knew how to render tenderness and elegy but how do their techniques stand up to those used to craft these contorted bodies and dislocated limbs in a spectacle of searing passion? Michelangelo would have nothing to do with their bland sentimentalism — it would have been beneath his dignity and that of his art. His attitude to physiognomy is plain: right down to each extremity, he expects the entire body to proclaim the emotions that stir it in order to amplify an illusion of sincerity.

Michelangelo strove to exalt every facet of the heart's innate generosity and the highest faculties of the spirit. From this standpoint, the Sistine frescoes are more than miracles of art, they are the most eloquent moral teachings possible about the passionate quest for truth and goodness, which bursts forth with as much power as the quest for beauty.

Full view of *The Last Judgment*, 1536-1541.
Fresco.
Sistine Chapel, Vatican.

It must be stressed that such works are not only worthy objects of admiration, they also amount to an arsenal from which dozens of generations of artists have been profiting handsomely – such is the size and variety of the technical problems that Michelangelo solved.

In 1515, Michelangelo returned to Florence to execute architectural works for the Medici, i.e. the San Lorenzo façade, New Sacristy, *Medici Tombs*, Laurentian Library and military fortifications. In 1534, Clement VII recalled him to Rome to finish the Sistine Chapel and *The Last Judgment* was to be his final work.

Started before the death of Clement VII, *The Last Judgment* took until 1541 to complete, all of eight years. The artist was almost 60 when he started this gigantic work. There was some thought of subcontracting the interpretation of the cartoons to Sebastiano del Piombo, who wanted to use oils, triggering Michelangelo's remark, "Oil painting is only good for women."

Numerous preparatory sketches for this work survive but we know little of its genesis. What phases did conception go through up until the final version? Did Michelangelo set down a firm outline right from the start or did he toy through different combinations of figures, as Raphael had done for the *Disputa* (also called *Disputation of the Holy Sacrament*)? We shall never know.

However, we know something of what has happened to the masterpiece since its completion. Although of profoundly religious intention, *The Last Judgment* attracted strong criticism, indicative of the gloomy, narrowly orthodox mindset that was poised to smother the enviable tolerance of the Early Renaissance.

---

*Christ and the Virgin*, detail of *The Last Judgment*, 1536-1541. (opposite)
Fresco.
Sistine Chapel, Vatican.

*St Catherine and St Sebastian*, detail of *The Last Judgment*, 1536-1541.
(pp. 136-137)
Fresco.
Sistine Chapel, Vatican.

*Angels Sounding the Trumpets of Death*, detail of *The Last Judgment*, 1536-1541. (pp. 138-139)
Fresco.
Sistine Chapel, Vatican.

Shocked by all that bare flesh, Vatican Protocol Chief Biagio da Cesena declared that *The Last Judgment* was better fit for a public bath or roadside tavern than a Pope's chapel. Spitefully enough, Michelangelo painted him in Hell with a tail coiled round his body just like Minos.

As the story goes, Da Cesena whined to the Pope, who told him that he only had the power to get people out of Purgatory, not Hell. (Later, the unfunny Paul VI wanted the entire work removed). Controversy became so heated that the Pope eventually asked Michelangelo to clean up the more outlandish nudes himself.

When he refused, Daniele Ricciarelli da Volterra found himself saddled with years of work to sanitise the paintings and from that day forward, everyone called him *Braghettano*: 'Pantymaker'. The final touch-ups were Girolamo de Fano's.

In the 18th century, *The Last Judgment* saw further major censorship. After centuries of paintbrush fiddling and candle soot, it was restored to its original glory at the close of the 20th century.

For *The Last Judgment*, Michelangelo was more worried about dazzling his peers with bold poses and sleights of the chisel, rather than inducing the faithful to experience the grave emotions proper to the end of all earthly existence. The work is rich with this draftsman's every variation on a theme open to accommodating any imaginable excess.

It is not the work of a committed believer whose faith in the saintly joys of heaven is rooted in horror of the sins worthy of eternal damnation. In other words, here the painter takes precedence over the poet and puts the anatomist in tow. Nor is there any room for hope: this is entirely about terror. The Celestial Jerusalem, its gem-studded ramparts, and flower gardens are nowhere to be seen.

Poor miserable earthbound humanity has yet more trials to face in the afterlife: what righteous person does not feel queasy before the mechanics of inexorable celestial justice? A clear conscience carries little weight before this towering judge so greedy for revenge. And even after admission among the elect, Michelangelo's idea of heaven hardly looks appealing. Here the artist assembled the gloomiest, most pessimistic side of Christianity, which considers sin and evil as inalienable features of earthly existence.

In Michelangelo's eyes, punishment alone could be the baseline for any grand illustration of the final settlement of

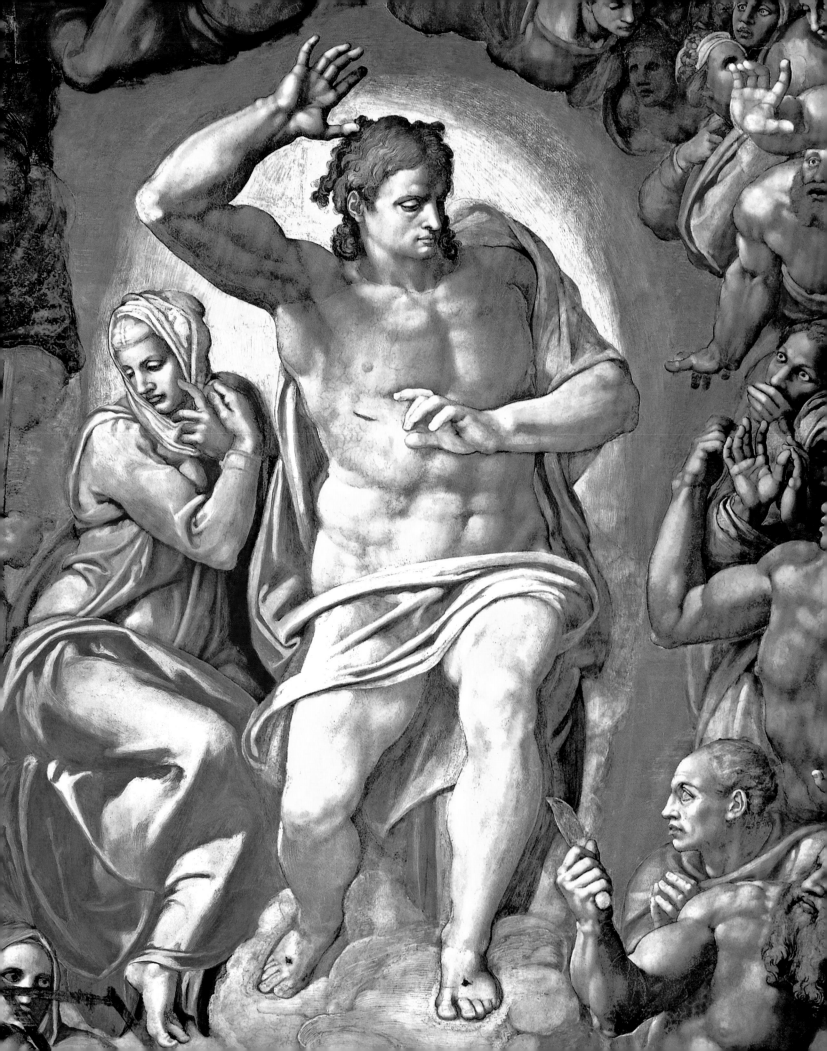

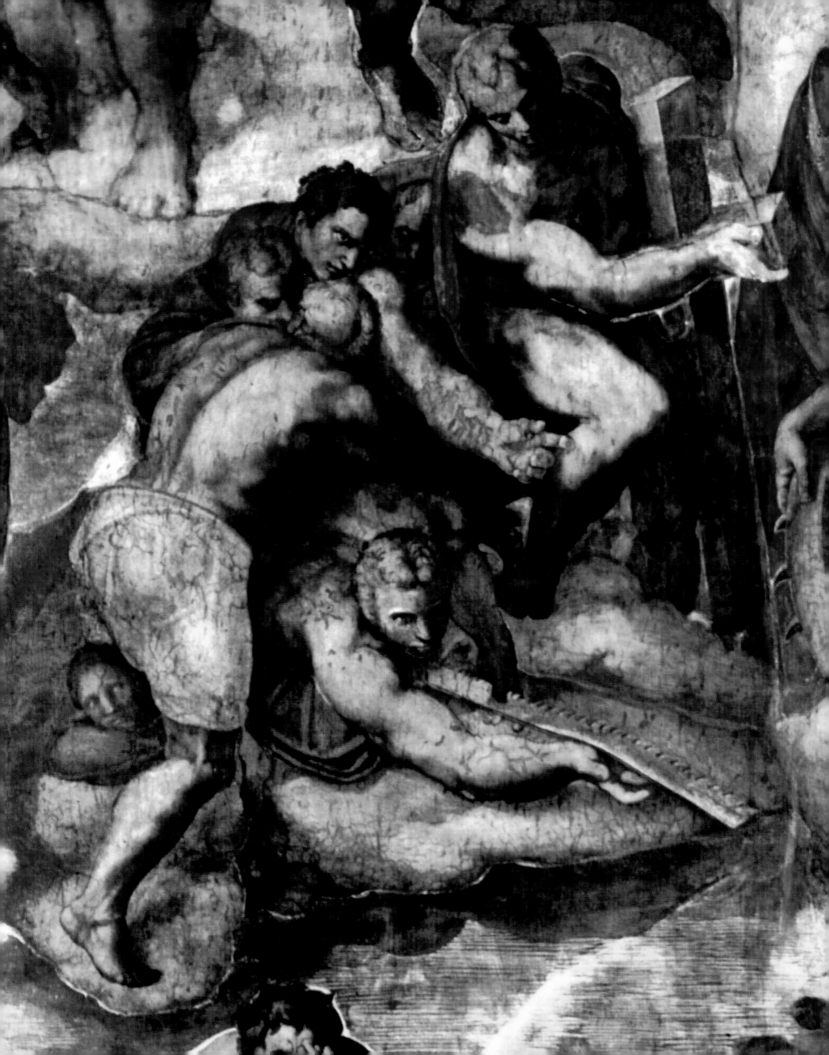

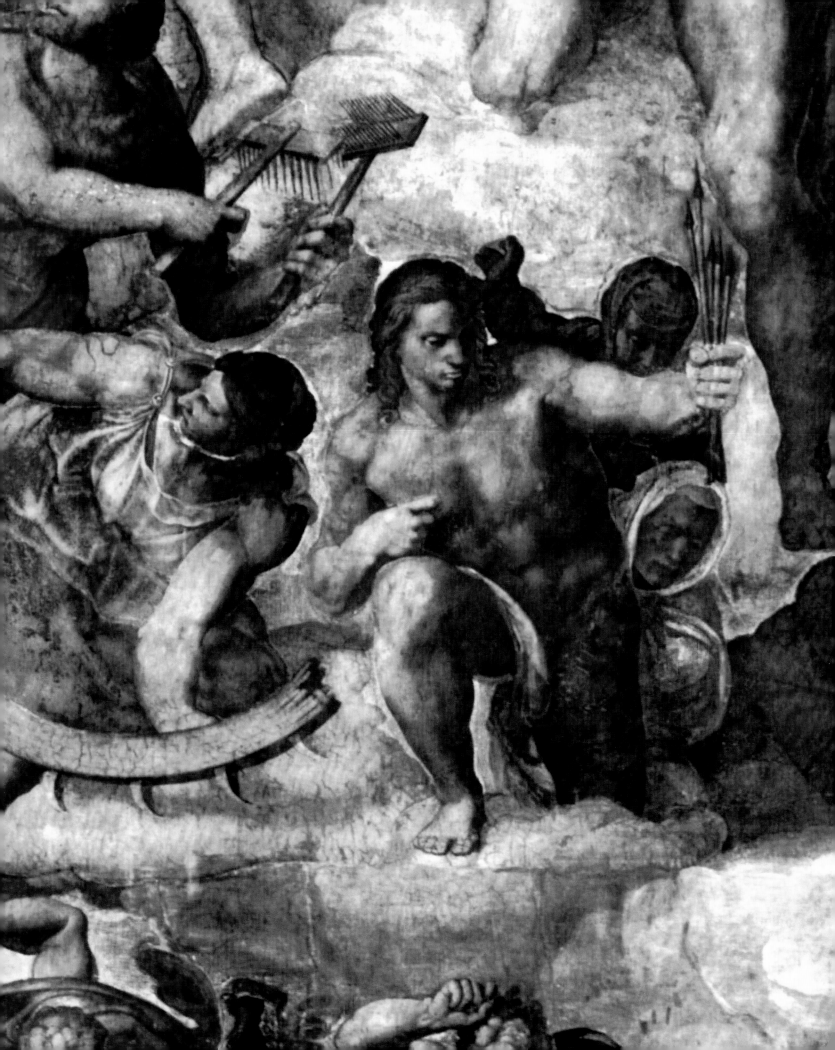

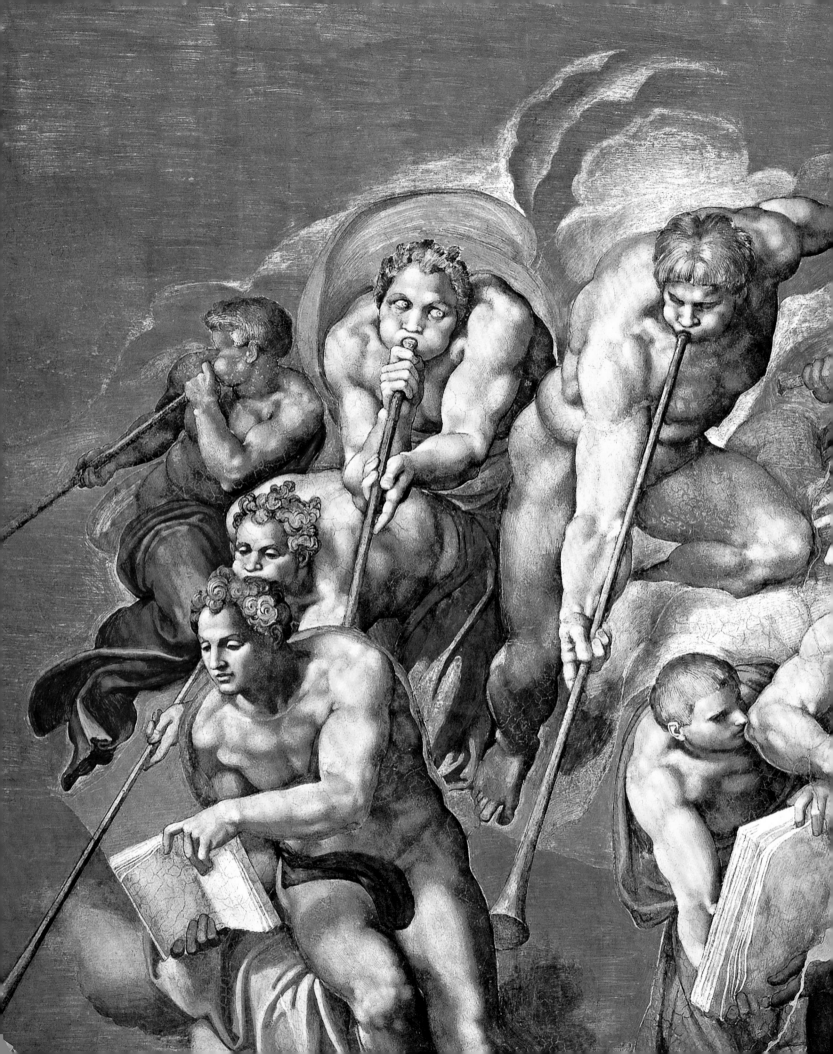

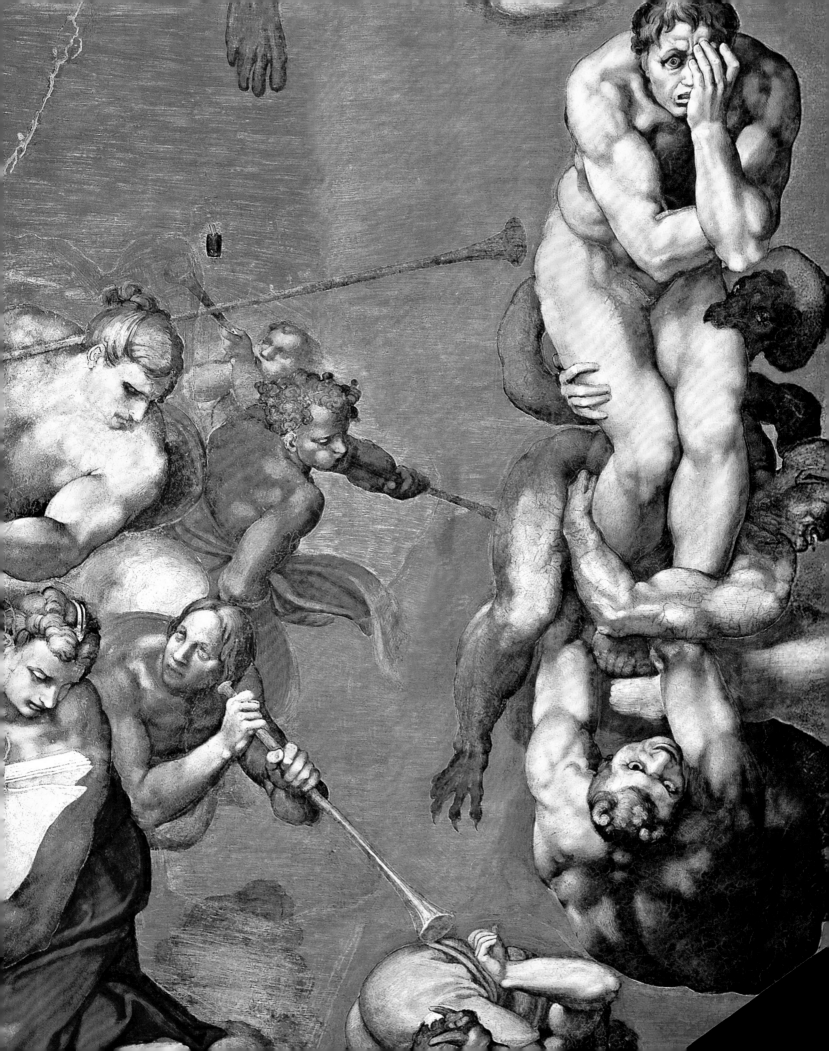

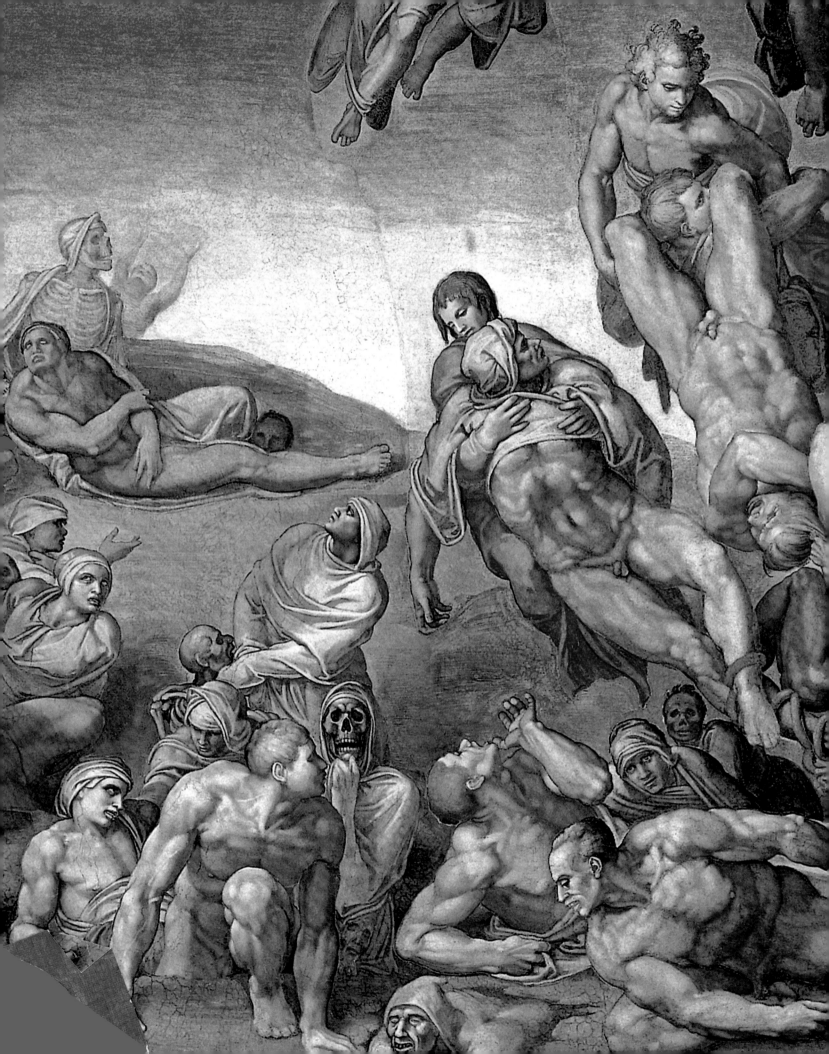

accounts outstanding from the world of flesh. His work was to set the example for the horrors of pain and torture. The dominant idea is *Dies Irae*, the Angry God – and Vittoria Colonna concurs in one of her letters:

> The first time, Christ is full of leniency, only showing his great goodness and great mercy. The second time, he comes armed and demonstrates his justice, his majesty, and his omnipotence. Thus, there is no time for mercy and no room for grace.

Somewhere between the commissions for the Sistine Chapel and *Medici Tombs*, Michelangelo junked joy and laughter. External events and his manic depressive personality combined to bring ardour and gloom to the fore; passion replaced the refreshing idyllic renderings of the Virgin and Child on his medallions, or the graceful nude fauns that deck out the Sistine ceiling.

Focusing inwardly and increasingly imprisoned in his role as a defender of justice and soldier in the war against the religious and moral decadence of his country, he somewhat became Savonarola's spiritual heir as he was gearing up to paint this gloomiest of events called *The Last Judgment*.

Overall, *The Last Judgment* consists of twelve major groups. In the two uppermost lunettes, angels on one side are carrying a column, while others bring along a crucifix from the other end. Further down, Christ presides, encircled by angels and prophets to bear witness. Then comes the group of the elect.

Still further down, we see the elect rising towards heaven, with a group of angels blowing trumpets in the middle as the damned on the right are being offloaded into hell. At the very bottom, the waking dead rise from their tombs while Charon's ark stands right of centre.

Religious inspiration seems most wanting in the depiction of the wingless angels holding the instruments of Passion. Like some Correggio, Michelangelo resorted to mass-scale foreshortenings: the figures are arranged with no rendering of depth, using readymade overconfident foreshortenings that make them look like two-dimensional cutouts, cloned one after the other with no attempt at individualisation.

Set near the base of the column, one upside-down figure with his legs in the air is irreverently painted in a way that suggests he is turning a somersault – this is a clear sign of decadence.

Michelangelo was by then already over sixty and, whatever his talents, age had cooled his ardour and cramped his imagination. Did he realise his inferiority? Not without melancholy one day, he told Vasari that he was more knowledgeable in his youth than in old age.

Towering in anger from above the clouds with his right arm raised as if to throw a curse, the Christ figure looks thoroughly agitated, very far removed from the grandeur and majesty that Michelangelo awarded his Jehovah for the ceiling frescoes.

Next to Christ, the Virgin backs down by turning her head away. Around them, the just and the elect are troubled and worried for fear that this divine, merciless anger will strike them down too. St Peter also looks insecure as he enters the scene, with an anxious, hesitant look on his face as he produces the keys, these now suddenly useless symbols of his authority.

Slinging a frame from his shoulder, a terrified St Lawrence looks furtively at Christ. Flayed skin in hand, St Bartholomew holds up the skinning knife to Christ's view (the execution is brilliant, by the way). Throughout the work, there is only anguish and terror, not a whit of serenity.

Still further down towards the right, Michelangelo sets aside his loftier side and abruptly reverts to standard sacred iconography by laying out a spread of the instruments of torture: heavy-gauge saws, Catherine's wheels, bone-breaking mallets, and meat hooks – all in unforgivably bad taste.

Here again, the work offers superb torsos that would dazzle divorced from their context by the grace of a spacious museum, even if the torsos fail to make this transcendent scene feel real and some only recall a gym session or workout at the palestra.

---

*The Resurrection of the Dead*, detail of *The Last Judgment*, 1536-1541. (opposite)
Fresco.
Sistine Chapel, Vatican.

*The Damned*, detail of *The Last Judgment*, 1536-1541. (pp. 142-143)
Fresco.
Sistine Chapel, Vatican.

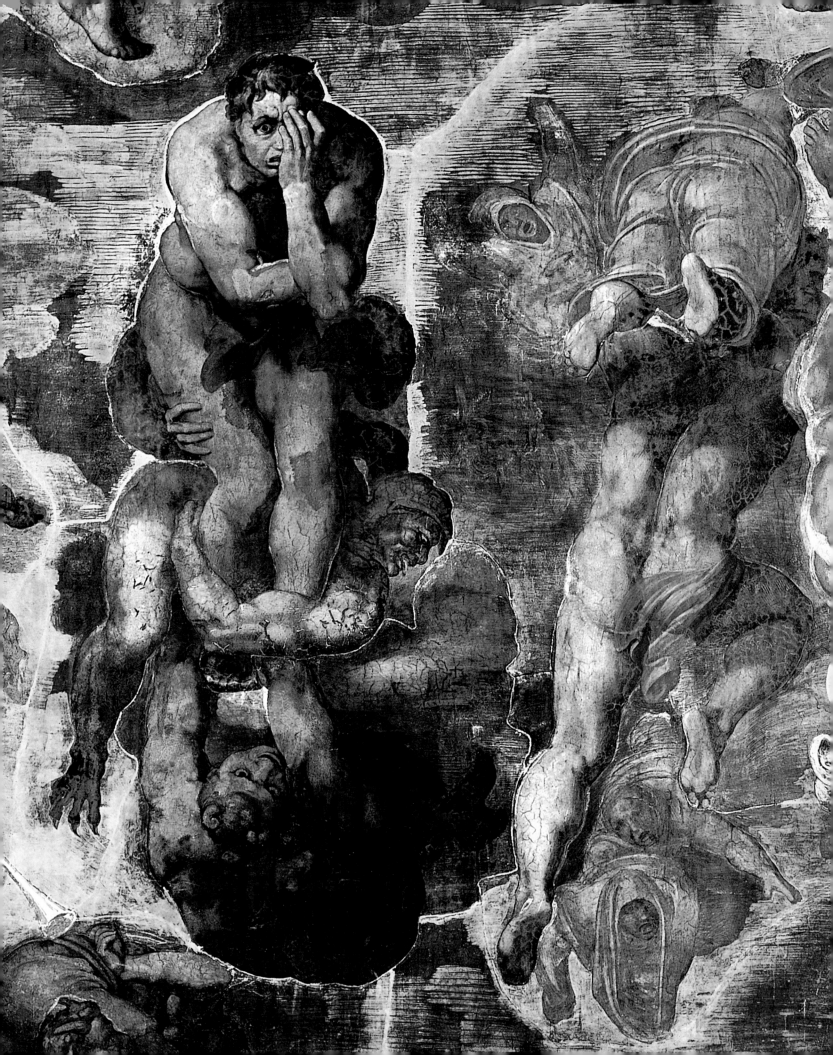

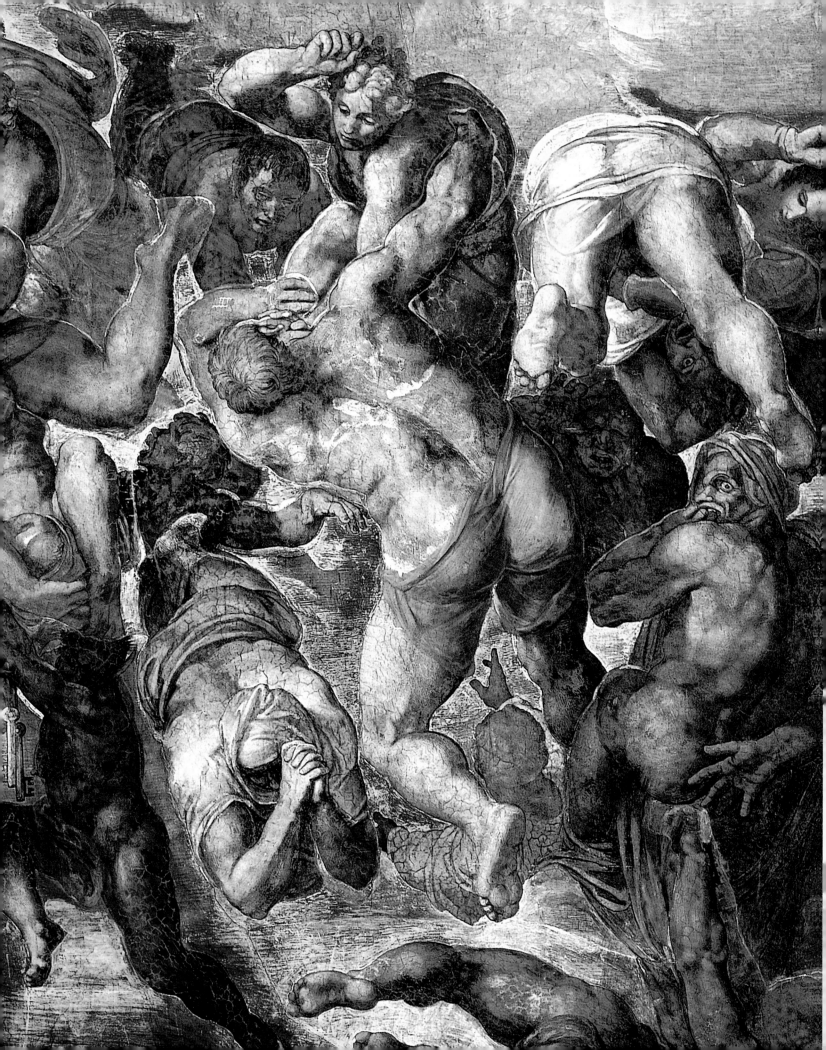

Once dear to Michelangelo, the realism that replaced lofty spiritual doctrine in *The Last Judgment* transpires principally in the lower left scene depicting the resurrection of the dead. Looking strong and healthy except for a few skeletons, the dead rise up with more or less difficulty; some arch their backs to throw off the soil, others cross the divide one step at a time, still others throw their hands behind them for leverage to stand up. In one place, a good angel takes under his wing a resuscitated but still wobbly member of the elect.

Further along, a demon is yanking back down by the hair some poor but undeserving soul for brazenly attempting ascension. Left of middle, a kneeling man reaching out to a companion recalls the *Cascina* soldier in the same pose and he too seems to have been borrowed from a group in the *Combatants* at the Palazzo Tribunale in Florence. The figures and poses show infinite vitality and variety but with none of the refreshing spontaneity seen in *The Battle of Cascina*, the *Creation* series, and *The Deluge* (p. 116-117).

Also worth mentioning are the hideous death's heads and bestial grinning demons with horned foreheads so foreign to Michelangelo's admirable frescoes under the same roof! There, temptation is a beautiful adolescent stepping out from between the branches of the fateful apple tree; there, we are carried off to worlds of serenity lying far above the world of evil, vulgarly incarnated by a leftover satyr from Antiquity.

By now, Michelangelo was in pain and had become embittered. Dogged by gloom, he renounced lifting his contemporaries up to his own level by ensnaring them into the celestial spheres of existence; using any available trick of the trade, he now stooped to them by serving up imagery within their reach.

The most poignant and famous episode is that of Charon's ark, best approached through the enigmatic little scene in the lower middle. There we see a cavern befitting Cyclops, packed with demons watching for the damned as their beastly appearances aggravate the horrors of hell, a theme ill-suited to painting.

To the right, the River Styx unfurls its rolling muddy waters as an overcrowded skiff ferries the damned to their fate on the other bank. Upright at one end of the teetering vessel, a naked man with a horned forehead and claw-tipped feet raises his oar to press the grim masses onward. Who has not recognised Charon, whom Dante describes as "the fiery-eyed demon whose oars strike the hesitant"?

After covering a copy of *The Divine Comedy* in sketchwork, Michelangelo applied his boundless admiration for Dante to borrowing that author's Leah and Rachel for the tomb of Julius II, as well as his Minos for his *Final Judgment*. When Dante's ashes arrived in Florence, Michelangelo asked Leo X to let him sculpt the "divine poet's" tomb. Obviously, Dante's influence on Michelangelo could only be indirect and his flashback to paganism should not astonish. He did not need to reach back to Dante or Virgil for the paganism, he needed only consult Luca Signorelli's *Last Judgment*. At all events, representations that mixed two different religions and civilisations were hardly suited to the personal chapel of the Popes where they might provoke introspection at the expense of action.

This part of *The Last Judgment* offers a scene of stunning horror, full of verve and pathos. Fleeing Charon's oar, the damned huddle at the other end of skiff; scared and panting, their survival instinct prevails, just as for the Israelites in *Brazen Serpent* (p. 118), a pendentive in the same chapel. In their flight, they cover their ears, jump into the water, or crowd too tightly together. Every swimming stroke or acrobatic pose is rendered with marvellous self-assurance.

On the riverbank, demons wielding ropes and meat hooks stand ready to pull in stragglers and the hesitant. And they perform their task with all the ferocious joy and fiery tools of divine vengeance. Exactly as Signorelli did, Michelangelo depicts a winged demon straddling a victim on his back, holding him fast by the legs for express delivery to his vertical fate.

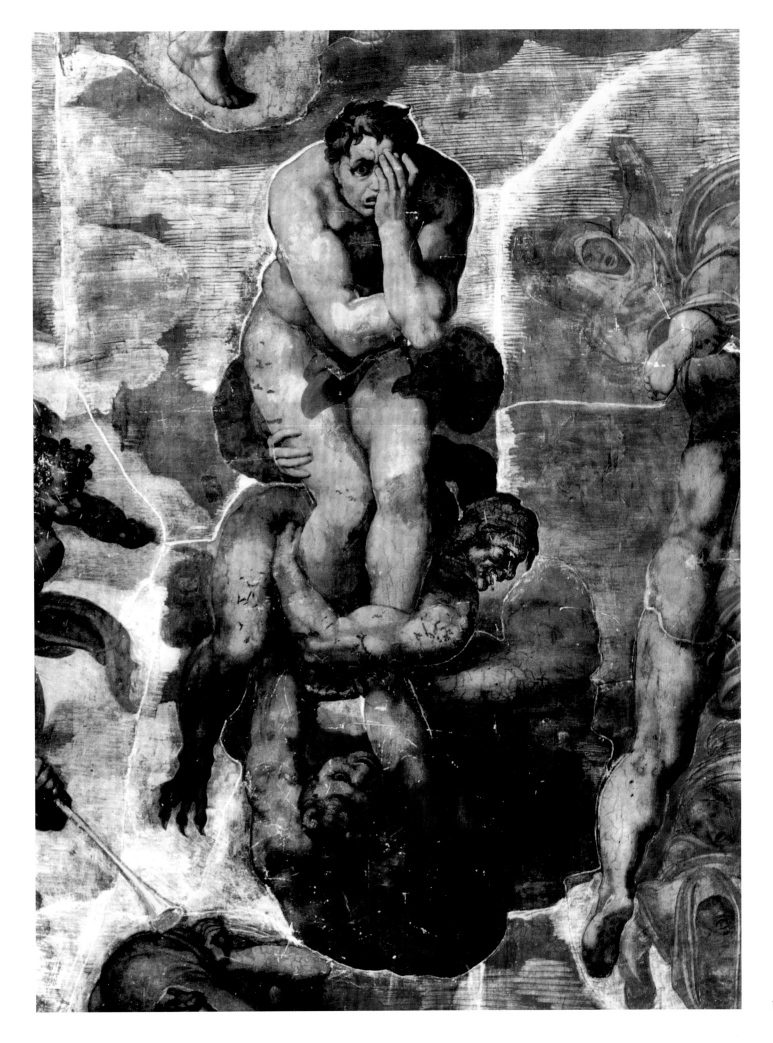

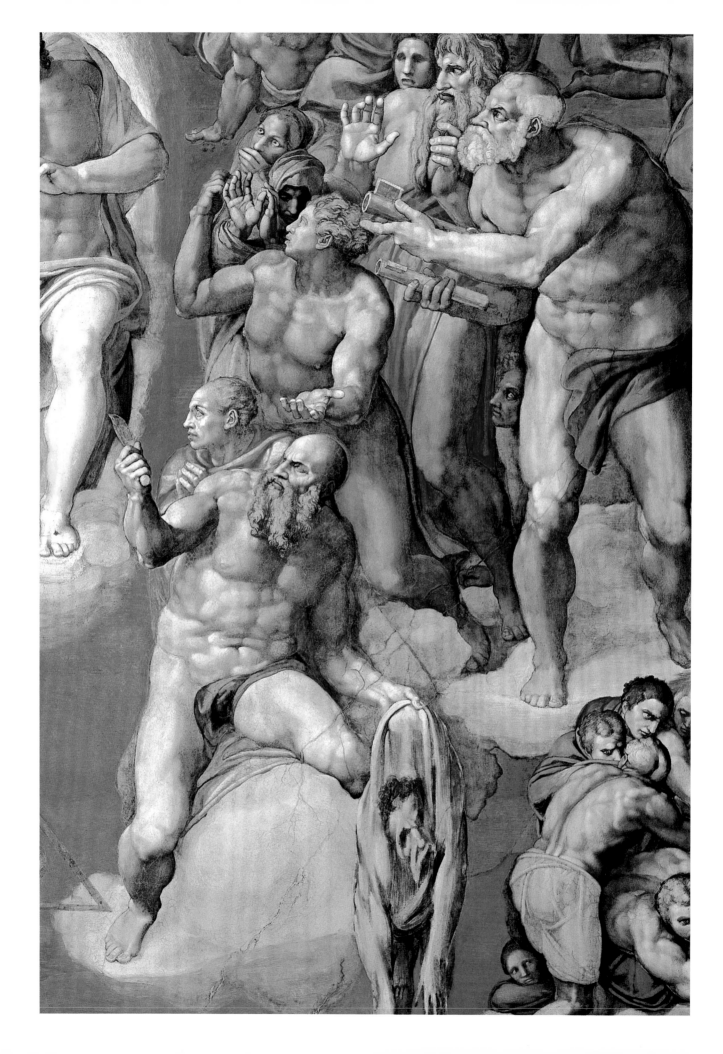

With his own legs tucked in at the other end, the taller standing figure with a tail coiled round his body is Minos, best defined in Song V of Dante's *Inferno*:

> Thus I descended from the first circle down into the second, which girdles less space, and so much more woe that it goads to wailing. There abides Minos horribly, and snarls; he examines the sins at the entrance; he judges, and he sends according as he entwines himself. I mean, that, when the miscreant spirit comes there before him, it confesses itself wholly, and that discerner of sins sees what place of Hell is for it; he girdles himself with his tail so many times as the degrees he wills it should be sent down. Always before him stand many of them. They go, in turn, each to the judgment; they speak, and hear, and then are whirled below.

Not only did the layout of *The Last Judgment* prove controversial, so did other elements of Michelangelo's Sistine frescoes as they shattered Middle Age and Early Renaissance convention: the clergy were disappointed to see that it lacked the strong unambiguous message needed to galvanise the masses.

Up until then, the standard iconographic tradition made it easy for the faithful to recognise the main figures of the saga of Christianity. The conventions lasted into Raphael's earlier works, arguably up until his *Disputa*. Then Michelangelo came along and trampled the game rules underfoot, as he did with any other rule he deemed irksome.

Instead of building on the techniques developed by his forebears, he found delight in their demolition in order to serve up something of entirely personal manufacture: he saw himself as the beginning and end of all art. Where Raphael gladly drew on the artistic heritage of centuries gone by, Michelangelo was driven to start art from scratch!

The most flagrant innovation in *The Last Judgment* is the clean shave: Christs had all been bearded for centuries, although both depictions coexisted up until the 6th century – one is at San Vitale in Ravenna. But from that point onward, the beard was official and mandatory.

Did Michelangelo skip the beard in a bid to make some statement at the expense of needlessly offending the faithful?

Who knows! Was his Christ a paradigm of beauty or nobility? Not really! The weak chin and prominent jaws make him look exceedingly ordinary. Here, as elsewhere, Michelangelo was innovating for the sheer heck of thumbing his nose.

Another shortcoming of Michelangelo's was to perceive the world as a landscape of figures, causing him to outlaw dress, furniture, architectural context, landscape, and any other image-enhancing accessory. *The Last Judgment* deploys an abundance of near and full nudes, bereft of any flora, fauna, or ornament in a way that beckons nausea.

The fresco contains no figure or object likely to relax or distract the viewer, who is left to face an atmosphere of highly charged point-blank tension. The artist's mass deployment of nudes suggests his inspiration for the work may lie in the Holy Scriptures rather than personal aesthetic preferences.

In any case, the viewer's instinctive reaction is to flee the hype and seek fresh air in the *Disputa* or works of the Primitives.

While mentioning that noble, radiant work of Raphael's, its qualities contrast sharply with the many flaws of *The Last Judgment*. Raphael's single-minded intention stands out distinctly in the fullness and clarity that inhabits the painting from end to end.

The apostles and patriarchs near Christ are neatly defined, forming a harmonious well-rounded and majestic group. This is because Raphael knew exactly how much inspiration to borrow from his predecessors. The *Disputa* crowns a long string of interpretations of the Last Judgment and related themes by generations of painters who invested them with faith and talent. Finally, he respected tradition like a true representative of progress whereas Michelangelo was the turbulent iconoclast who needed to restart art from scratch every time. Such was Michelangelo's moral rage that secured him so many triumphs – and as many crushing setbacks.

This is only a smattering of the valid criticism *The Last Judgment* deserves and there is more. Already in the

*The Conversion of St Paul* (detail), 1542-1545.
Fresco, 624 x 661 cm.
Pauline Chapel, Palazzi Pontifici, Rome.

*The Conversion of St Paul*, 1542-1545.
Fresco, 624 x 661 cm.
Pauline Chapel, Palazzi Pontifici, Rome.

*Martyrdom of St Peter*, 1546-1550.
Fresco, 625 x 661 cm.
Pauline Chapel, Palazzo Pontifici, Rome.

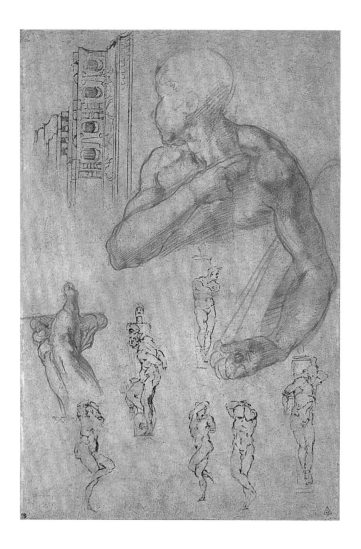

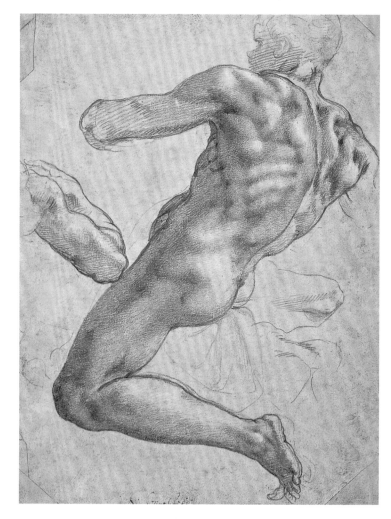

cartoon for the *Battle of Cascina*, his initial masterpiece, the literary dimension regrettably takes a backseat to purely technical considerations: the artist was more interested in bold foreshortenings than verisimilitude. That attitude reappears in *The Last Judgment*, all the worse for the greater age and obstinacy of an artist incapable of allowing that he might be wrong.

Michelangelo's *Last Judgment* used to pass for the ultimate masterpiece. Today, opinion is perhaps too harsh. Geniuses such as Michelangelo are fascinating to research even where they err. Moreover, this Sistine fresco contains a wealth of first-rate beauty and extraordinary detail that make this artist and thinker a worthy subject of study. Restoration was undertaken from 1979 to 1999, enabling Pope John Paul II to inaugurate the refurbished *Last Judgment* on 8 April 1994.

Michelangelo went on to paint *The Conversion of St Paul* (p. 148, 150) and *The Crucifixion of St Peter* for the Pauline Chapel inside the Vatican. *The Conversion of St Paul* offers an acceptably composed scene lacking any sense of decorum. In the heavens, Christ comes bolting out from among three groups of angels while, below, Saul's horse is all reared up and the future apostle's companions stand helping him recover from a fall. His escort is in disarray: some are staggering, others gaze

Various studies for the Sistine Chapel ceiling and the tomb of Pope Julius II (recto), studies of a man's leg (verso). (above left)
Red chalk, black chalk, brown and black ink on paper, 28.6 x 19.4 cm.
Ashmolean Museum, Oxford.

Study for *The Nude* above the *Sibyl of Persia*, 1508-1512. (above right)
Teylers Museum, Haarlem.

Study for the *Libyan Sibyl* (recto), (more) studies for the *Libyan Sibyl*, and a small sketch for a seated figure (verso), c. 1510-1511. (p. 153)
Red chalk, 28.9 x 21.4 cm.
The Metropolitan Museum of Art, New York.

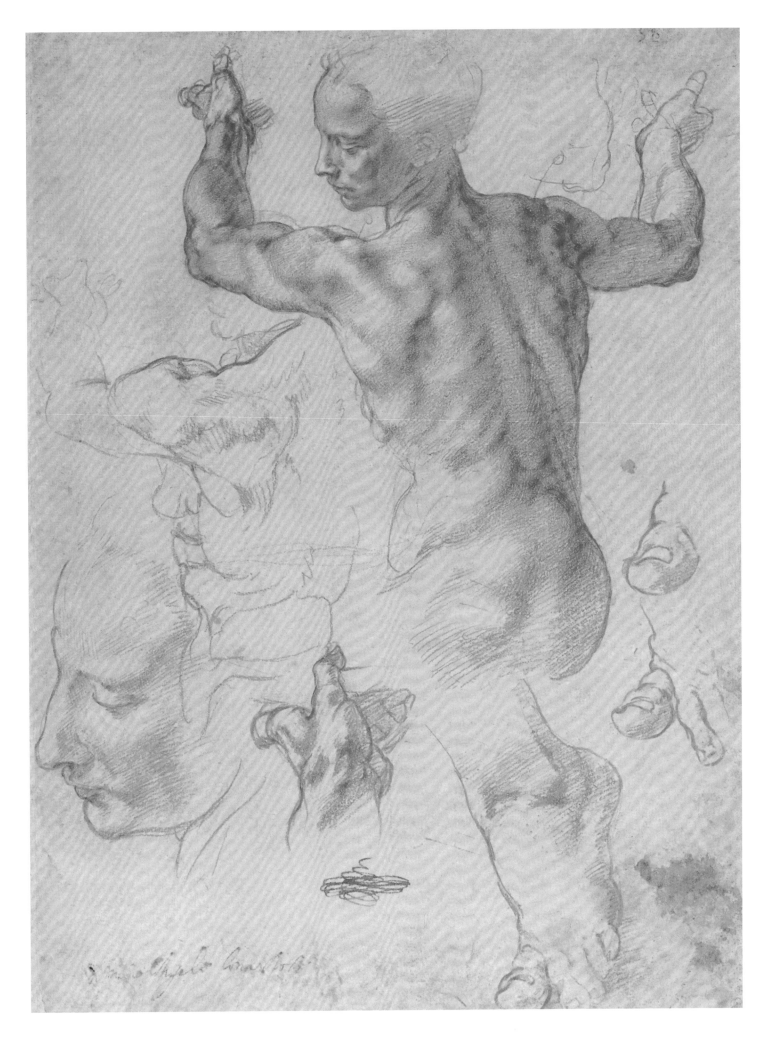

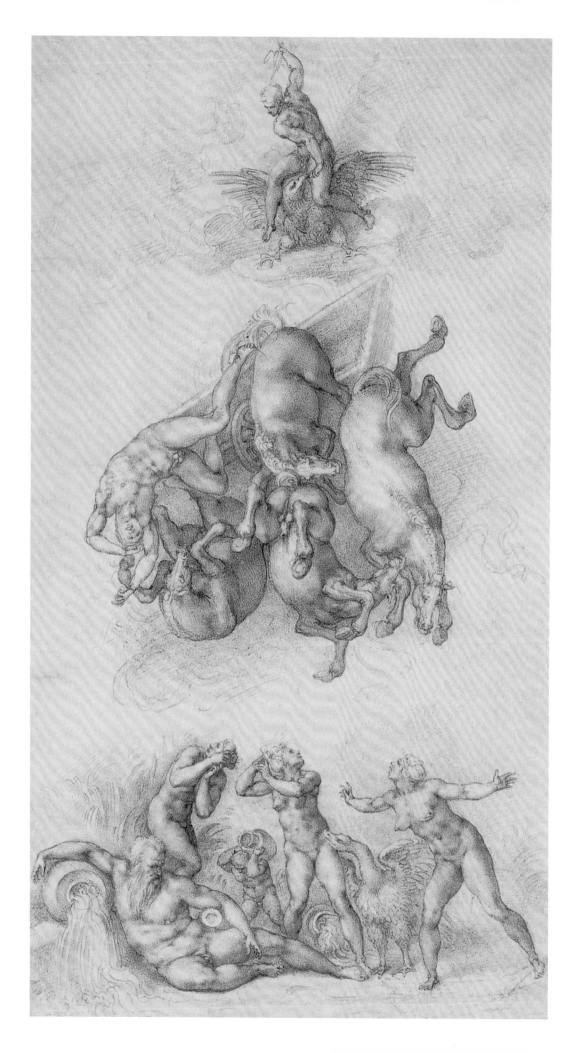

skyward and the remainder are thrilled or distraught. Every movement is an exaggeration. Unfettered by inspiration or sincerity, Michelangelo simply serves up a menu of even weirder foreshortenings than those of *The Last Judgment*.

Michelangelo's biographers report that, in old age, the artist did drawings for friends, including Tommaso dei Cavalieri who would pass them on to peers for translation into paint. Such was the genesis of Rosso's *Three Fates* in the Pitti Palace, of Sebastiano del Piombo's *Flagellation of Christ* at the San Pietro Church in Montorio, and Salviati's *Fall of Phaeton* and *The Archers (Il Bersaglio)* in red chalk at the House of Windsor Collection. The last two were copied by Raphael's students at the Villa Borghese. Vasari reports that *Venus Reclining with a Cupid* was also a cartoon of Michelangelo's while the tender but unimpassioned *Leda* that turned up at the National Gallery recently also arguably belongs to this category.

A number of paintings bear the title *Allegory of Human Life*. They show a nude male seated on a pedestal while leaning against a globe with both hands as he lifts his head to watch

---

*The Fall of Phaeton*, 1533. (opposite)
Black chalk, 41.3 x 23.4 cm.
The Royal Library, Windsor.

*The Resurrection of Christ, Floating above the Tomb, with Terrified Onlookers (Soldiers)*, 1532-1533. (above left)
Black chalk, 32.5 x 28.5 cm.
The British Museum, London.

*Pietà*, 1538-1544. (above right)
Black chalk, 28.9 x 18.9 cm.
Isabella Stewart Gardner Museum, Boston.

*Crucifixion*, 1538-1541.
Black chalk, 36.8 x 26.8 cm.
The British Museum, London.

*Crucifixion between the Virgin and St John*, c. 1550-1560.
Black chalk and white lead, 41.2 x 28.5 cm.
The British Museum, London.

the phantoms circling overhead. Yet more food for contemplation of life's most sublime dilemmas!

One series of drawings found mainly at Oxford University seem destined for a *Crucifixion* that may never have been started. The red chalk shows one thief on his cross, with the seated Virgin collapsing in a disciple's arms as he looks away. It is one of the master's most touching compositions.

In black chalk, another drawing shows Christ nailed but alive. The body is well shaped with slightly exaggerated limbs. Two half-length figures in the sky add a jarring effect.

---

*Male Nude Seen from the Back with a Flag Staff*, c. 1504. (above)
Black chalk, heightened in white, 27 x 19.6 cm.
Albertina Museum, Vienna.

*Cleopatra*, c. 1535. (opposite)
Black chalk, 23.2 x 18.2 cm.
Casa Buonarroti, Florence.

Finally, a brilliantly composed drawing at the British Museum is remarkable for its unusual crosses: Christ's is topped by an upside-down triangle while those of the thieves are T-shaped. All three figures are agitated and overdramatised. One thief hangs heavily from his arms like another Marsyas while the second is trying to leverage himself up the cross. Meanwhile, Christ lifts his arms skyward parallel to the sides of the triangle. Below, a mass of anxious people empathises. The general impact is quite strong.

A black chalk drawing at the British Museum illustrates an idea for *The Resurrection*. Stunned or horrified, sentinels stand around an open tomb as Christ rises effortlessly skyward with folded arms and legs pressed shut. The effect is graceful, noble, and vibrant.

All these compositions show that Michelangelo's best interpretations of the Gospels are to be found in his drawings. But alas, sketchwork is not as powerful as a finished painting.

159

# THE ARCHITECT

## Late Renaissance Architecture

The greatest achievements of the Late Renaissance were architectural. Except for the *Medici Tombs*, sculpture had shot its bolt by the time of Leo X's death. Except for the schools of Florence and Parma, painting had been at a standstill since the Golden Age. But Bramante is hardly the beginning and end of Renaissance architecture. It would take another full century for the art principles of Antiquity to sink into lifestyles before they could take a firm and stunning hold. The Late Renaissance saw a generation of energetic builders who would transform entire urban districts, along with the architects who could make their mark on vast ensembles and not just individual edifices. As construction technology advanced, aesthetics became more assertive. Bramante's successors wielded volumes with such freedom! They had a wealth of resources to set up contrasts through more geometric planes and exploitation or creation of various levels. In short, architecture was becoming serious business while painting and sculpture were becoming frivolous.

The vitality of the Italian schools shows up in their broad variety of aspirations. Take the example of two radically different masters: where Michelangelo stressed movement, Palladio sought harmony through pure gentle lines.

But beyond the wide range of efforts and tendencies, the most striking feature is that impulsiveness and spontaneity had yielded to deliberate reasoning. The era of intuitiveness and inspired genius unfolded into another of patient detailed calculation. More than one inspired masterpiece was yet to appear but the content would reflect more hard thinking and less emotion or wild imagination. If the architects of the period were now able to evolve so freely along different tangents, it was because they had fully mastered the trade secrets and formal rules of Antique style, with some leaning towards harmonious rhythm and, others, dynamic movement. When personal conviction and spontaneity fail, the easiest option becomes extremism. The artists of Primitivism and the Golden Age were incapable of the introspective reflection that gives an individual a unique direction to strike out in; rather, they just seemed to be obeying some inner need. Thus, when it came to innovation and style, we see science and reason gradually replacing inspiration and imagination. Except for Michelangelo and his school, the great architects of the Late Renaissance kowtowed to the art rules of Ancient Rome.

In a manner consistent with public taste, avant garde architects implemented radical change to the layout of cities, streets, and piazzas and to the treatment of ensembles right down to the smallest details, marking a break with the Middle Ages as they ardently strove for symmetry and regularity. They transformed dark narrow winding streets into sunny spacious avenues – all a daring series of improvisations by the last great builders of the 16th century.

When it came to creating public squares, it no longer sufficed to merely make them look monumental. Michelangelo failed in his bid to add a system of loggias similar to that of the Loggia dei Lanzi to the Piazza dei Signori (also called Piazza della Signoria). The piazzi needed fountains, obelisks, and equestrian statues as seen at the preceding piazza and Piazza Annunziata in Florence or at St Peter's Basilica and Lateran in Rome. For the Piazza del Campidoglio, the architect exploited the lay of the terrain with ramps and staircases.

By this time, the construction industry had finally resolved all its technical problems. The dome of St Peter's Basilica and displacement of the Vatican obelisk demonstrate that Fontana and Michelangelo mastered the skills of building and art equally well.

Science and calculations notwithstanding, any larger construction project begins with a wooden model. These scale models were usually crafted by people who were skilled

---

Staircase, 1530.
Marble.
Laurentine Library, Florence.

architects themselves. Antonio da Sangallo subcontracted the model of his project for St Peter's Basilica in Rome to Antonio Labacco, one of his closest assistants, for a fee of 5,184 gold crowns. However, that fee was high enough to doom Sangallo's tender and Michelangelo's project won by unanimous vote after presenting a scale model costing only 25 gold crowns.

Applying sculptural technique to architecture, Michelangelo skipped wood and submitted a clay model for his Laurentian Library and San Giovanni dei Fiorentini projects. Numerous innovations such as Michelangelo's broken pediments were developed for doors, windows, and other openings to add variety alongside semi-circular and triangular pediments.

Emphasising vigorous fulsome forms, the Late Renaissance abandoned the pure elegance of low relief for high relief and sculpture in the round. Though latecomers

such as Simone Mosca lovingly developed arabesque, Michelangelo's successors wanted boldness and vigorous health. The upshot was that architecture could exploit the discredited status of flat ornamentation to take over surfaces formerly devoted to arabesque, coats of arms, and other decorative works. However, sculpture encroached on architecture for historical themes whenever the two fields came into direct competition and the sculptor was tough enough to impose his will on the architect.

It has been said that statuary art overtook decorative sculpture. In fact, it depended on the architects involved in a given project but the disciplines merged ever more completely, except in the case of Michelangelo and his disciples. Instead of the low reliefs of the 15th century distributed randomly around doors and partitions, caryatids sit under arches and statues line balustrades, i.e. statuary art was now an integral part of the architectural work that it rounded out and emphasised.

Inevitably, Renaissance Art fell prey to the same pitfalls as its prototype, Ancient Roman art. On the eve of the first millennium, Vitruvius loudly complained that everyone was painting figures having no real significance, that candelabras were being used to support urinals, and that pediments were being replaced with fluted consoles decked out with curled leaves and helixes. His

---

Reading room of the Laurentine Library, Florence, 1530. (above)

Detail of the vestibule wall, started in 1524. (opposite)
Laurentine Library, Florence.

Reading room of the Laurentine Library, Florence, 1530.

Wooden model for the façade of the Basilica of San Lorenzo, c. 1518.
Wood, 216 x 283 x 50 cm.
Casa Buonarroti, Florence.

Project for the façade of the Basilica of San Lorenzo, c. 1517. (opposite)
Casa Buonarroti, Florence.

remarks are also relevant to Michelangelo and his school in the 16th century.

After justifying recourse to composite order, Vasari goes on to laud Michelangelo's innovations for doors, tabernacles, vases, columns, column capitals, cornices and consoles, whether in the San Lorenzo sacristy, Laurentian Library, Palazzo Farnese or St Peter's Basilica. He congratulates him for discovering such a wide range of extraordinary ornaments, such beautiful mouldings, so many different cornices, such a variety of tabernacles, and an infinity of other motifs so different from those of Antiquity. In 1560, Michelangelo wrote to Cardinal Rodolfino da Carpi to declare that the limbs of the human being were the basis for the limbs of architecture. He added that no one could understand architecture without a solid mastery of human anatomy and figure portrayal. Finally, he stressed the need for symmetry.

Michelangelo was the first to break the fertile bond that gave the Early Renaissance the lovely layout of its façades, tombs, and tabernacles; he sacrificed the architectural parameters to give his marbles their free and spontaneous movement but alas, soon any pretext would justify lots of nudes and draped figures, caryatids, busts, and more – never had abuse of anthropomorphic ornamentation gone so far.

Even considered in isolation, Michelangelo's approach to decoration still has its flaws. They are essentially due to poor scaling of figures with respect to each other inside a given composition: figures are either gigantic or microscopic and this generates clashes and imbalance. True to himself, Michelangelo also kept ornamentation to a strict minimum. Vasari reports that he said, "Ornaments (*intaglio*) enriched a work but created confusion among the figures." Although the tomb of Julius II is rife with arabesques and other ornamentation, the blame lies with Michelangelo's successors rather than the artist himself, who had long since lost interest in the work – the fauns, grotesques, and other empty trivial motifs are deeply at odds with the terrifying majesty of Moses.

The Late Renaissance still had too much intellectual vigour to simply play by the rules, as other more pedantic schools would later do. Thus, façade painting (which is the very negation of architectonics) could hold its rank for some time despite the dictatorial sway of Michelangelo, Vignola, Sanmicheli, Sansovino, Palladio, and others. Incompatible

with older masonry work because of the rough working surfaces, polychromatic art focused on spreading itself across less monumental works.

Interior decoration uses a wide variety of sculptures in marble, stucco, wood, and paint; the Vatican Stanze, Palazzo Te in Mantova, Palazzo Ducale offer room after room done in rich, sober and harmonious tones where oil painting blends smoothly with gilded woodwork.

Though it might seem there were little left for the stairs, Michelangelo took pleasure in dislocating, breaking up and refashioning the staircase into the Laurentian Library as if it had been made of wax.

Turning to the form of the buildings, we can begin with religious architecture, which enjoyed even broader foundations than during the papacies of Julius II and Leo X. Assisi, Bologna, Florence, Genoa, Mantova, Milan, Naples, Rome, Verona, Vicenza, and many a smaller town graced themselves with monuments affirming a return to fervent faith. More powerful than ever before thanks to the Council of Trent, the Vatican encouraged this splurge – the only splurge that

hardliners such as Pius V would tolerate. But if fittings and decorations for sanctuaries became more austere, it did not rule out all display of wealth: Renaissance style was giving way to Jesuit styling, after all.

Italy was now the last country in Europe to have any truly religious architecture. Moreover, one art historian with no particular love of Italians notes that the architectural layout of Italian basilicas and their domes is highly original and borrowed from Antiquity or Byzantium only in appearance.

Nevertheless, detailed analysis is pointless because there is such a variety of models and crossover in styles that an architect's choice of one layout over another does not pin him down to a particular personal conviction. Whether based on the Greek or Latin cross, the floor plans are all boringly well studied.

Despite the failings, the architects of the late 16th century made prodigal efforts. To understand the intellectual

Italian School, View of the Capitol before Michelangelo's changes, 16th century. (above)
Pen and brown wash, 28.2 x 42.5 cm.
Musée du Louvre, Paris.

Ceiling of the Medici Chapel, 1526-1533. (opposite)
Marble.
New Sacristy, Medici Chapel, San Lorenzo, Florence.

Filippo Brunelleschi,
Basilica of San Lorenzo, Florence, 1421-1440. (pp. 170-171)

gymnastics that faced Gaelazzo Alessi, Domenico Fontana, Girolamo Genga, Michelangelo, Andrea Palladio, Giulio Pippi, the Della Portas, Michele Sanmicheli, and Jacopo Barozzi da Vignola, we must remember that they were investing their works with the spirit of Christianity such that none would dare copy hexagonal or octagonal windows, or gird church walls with a perimeter of stand-alone columns. Imitation was strictly confined to details of construction and ornamentation, where they prevailed throughout.

Convents were erected in no smaller numbers than churches in the Late Renaissance. Rome concentrated its efforts on the Diocletian Baths that Michelangelo transformed into a Carthusian monastery called Santa Maria degli Angeli, establishing therein his famous cloister of a 100 columns.

Funerary architecture took inspiration from Michelangelo's grandiose creations such as the tomb of Julius II and the Medici Chapel which became prototypes for countless other tombs where sculptor took precedence over architect. Often, the allegorical figures are shown either lying on their backs, propped up on an elbow or seated beside the deceased, i.e. *Day* (p. 74), *Night* (p. 75), *Dawn* (p. 68), and *Dusk* (p. 69).

Finally, however heavy-handed the layout may be, the funerary art of Florence at the time is truly grave and imposing, such as the Medici Chapel next to San Lorenzo Church.

Late Renaissance religious architecture has several failings, unlike its civil counterpart so worthy of esteem and affection. Apart from the Zecca mint in Venice, the Mercato Nuovo of Florence, Venice prison, hospitals, concert halls, and other public works, we see construction of libraries, special-purpose buildings that generated a number of interesting approaches from the very start of the 15th century. The Late Renaissance also welcomed two new masterpieces: Michelangelo's Laurentian Library in Florence and Sansovino's San Marco Library in Venice. And the two offer a striking contrast. The first sacrifices the exterior to focus on the reading room, which is well-lit and unpretentious with elegant, restrained decorations. The second deploys a wealth of architectural and ornamental resources on the façade, obtaining the most stunning building that Italy had seen to date.

The Late Renaissance excelled at major official works plus urban renewal of public squares, streets, and all manner of transport arteries as already described.

Aerial view of the Capitol, Rome.

**Étienne Dupérac**, Michelangelo's project for the Capitol, 1568. (opposite)
Engraving.
Bibliothèque nationale, Paris.

It established the rule that gates to a city or quarter should be of monumental nature, a view to which sovereigns and local governments subscribed. But disagreement arose over the means. Some wanted arcs of triumph with columns, low reliefs, and statues as happened in Rome for the Porta Popolo erected under Pius IV with four thick insipid Doric columns. Others headed by Sanmicheli treated city gates like military fortifications. Far removed from Michelangelo's Porta Pia with its vulgar ornaments, helix-laden crenels tipped with cannonballs, clumsy scallops, and overcomplicated frames, Sanmicheli's gate incorporates Doric styling with austerity that stops short of nudity.

The Late Renaissance saw construction of several bridges, fountains, and well copings that served as fountains, principally in Venice but the period is most famous for its magnificent villas and gardens where art and nature merge most pleasantly through an infinite variety of grottoes. Despite the importance of architecture to Italian gardening, Michelangelo never touched gardenscaping.

Never before had civil and military architecture been on such intimate terms. Alessi, Michelangelo, Peruzzi, Sanmicheli, and Sangallo are typical examples: every great architect of the period excelled at both because rare was the work of military engineering that was not also a model of high artistic standard.

Late Renaissance painting is much easier to divide into schools than its architecture. This is because every architect in Italy studied in Rome and because only two schools developed: Sansovino's Venetian School and Giulio Romano's Mantova School, whose influence extended all the way to Verona. In contrast, the founders of each major school of painting were native to the region they depicted.

If it is hard to draw neat lines between the architects of Central and Northern Italy, it is even harder to distinguish architecture as Florentine or Roman. From city to city, the crossover and hybridisation is rampant except that Florence supplied the artists while Rome indiscriminately provided ample quantities of

Façade of the Palazzo Farnese, Rome, 1548.

Façade of the Conservative Palace, Capitol, Rome, c. 1560-1570.

Palazzo Farnese, façade of the inner courtyard, detail of the second storey designed by Antonio da Sangallo the Younger in 1517 and the third by Michelangelo between 1549-1569, Rome.

Ancient Roman models and the Vatican imposed the inspiration. A mere tally of the total number of architects born in Florence would exaggerate the importance of its school. An enumeration of works along the Arno River would not help. Actually, if Rome and Venice owe their main monuments to Florentine artists, the talent of the latter was nourished by exposure to works outside Florence and that city only deserves partial credit.

Be it Florentine or Lombard, Renaissance architecture up until the early 16th century came into its own thanks to Bramante (Donato di Pascuccio d'Antonio) who gave it the specific flair and universal appeal that prevail even today. It should be added that it was only normal to see increasingly rigorous imitation of Ancient form as already advocated by Brunelleschi at the start of the 15th century. Through each step of the way, it inevitably became both more precise with ever rounder forms. The rest resulted from the influence of Rome where the final act of the Renaissance played out.

After all, Rome nicely fits Montaigne's description: "The world's most ordinary city, where national differences and ethnic exoticism rate the least attention because it is by nature a patchwork of foreigners where everyone feels at home."

## The Oeuvre

French historian Paul Letarouilly gives the Palazzo Farnese the following rave review:

> No other edifice reunites such beautiful lines, more perfect proportions, and better studied detail or nobler character in so grandiose a volume; the excellence of the structure is second to none…its strong robust constitution still guarantees it a long existence even after three centuries.

This palace was to inspire numerous others, including the Domenico Fontana's Lateran Palace built under the papacy of Sixtus V.

Whatever the merits of the Farnese, its designers never achieved the wide popular acclaim reserved for Michelangelo who was the centre of attention everywhere. Sangallo's technical capabilities and Peruzzi's refinement were powerless in the face of his tantrum-driven genius.

Said to have studied briefly under his friend Sangallo, Michelangelo took up architecture late in life. It began with a commission from Leo X to complete the façade of the Medici Chapel, to which end he sketched out a set of different proposals. But his first roughs for the San Lorenzo Basilica came to nothing.

However, his proposal for a new sacristy at that location had a happier ending: it became the Medici Chapel. More specifically, the chapel has a square floor plan crowned with a dome. It has fluted pilasters and pediment-topped niches to enhance various parts of the structure and to diversify line patterns. The result is both simple and elegant, with ample reliefs of rare firmness. From end to end, it radiates focused coherence that animates the structure's every constituent element and stands aloof to any odd detail too gaudy or complicated for its setting.

Michelangelo was related to the Brunelleschi family and shared their penchant for abstraction. Like his forebear, he steered clear of any familiar, personal ornaments that add so much flavour to 15th century architecture. Like the Ancient Greek and Roman models that inspired them both, Michelangelo only allowed motifs of purely architectonic nature, such as consoles, astragals, and egg-and-dart motifs. And architecture is where Michelangelo copied Antiquity most heavily.

But when he copied, he picked up where Roman art had left off in the 3rd century with a search for overdramatised movement. He hated straight lines which he would obsessively shatter with barrages of pilasters, niches, and festoons in order to break up the monotony of the clean low-key lines typical of traditional Florentine facades: the result is much livelier – or violent. Michelangelo's architecture proved highly controversial. In the *Gazette des Beaux Arts*, Charles Garnier, designer of the Paris Opera, openly accused him of ignoring the syntax of architecture:

> He has [good] lines, strength, scope, willpower, and character, which makes for a master of composition but he doesn't know the grammar and barely knows how to write.

---

Lateral view of the façade of the Palazzo Farnese, Rome, 1548.

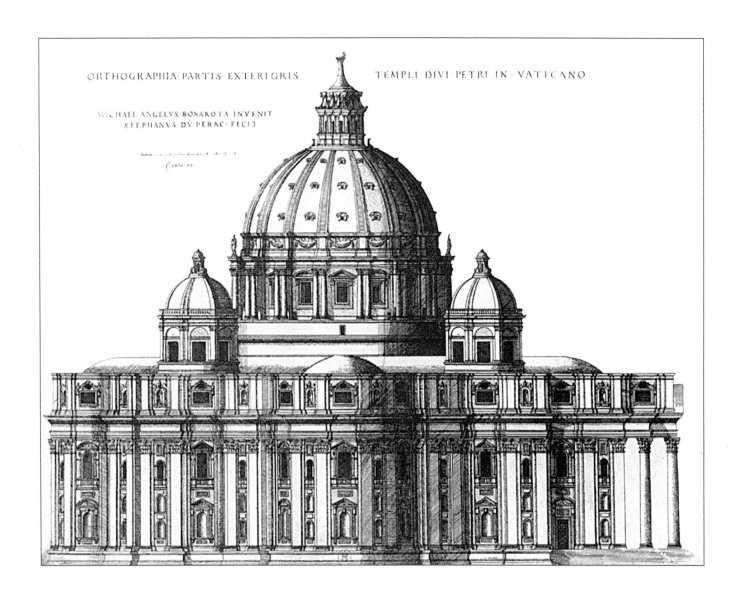

ORTHOGRAPHIA·PARTIS·EXTERIORIS     TEMPLI·DIVI·PETRI·IN·VATICANO

MICHAEL·ANGELVS·BONAROTA·INVENIT
STEPHANVS·DV·PERAC·FECIT

Garnier's attack triggered strong counterattacks. But Michelangelo's mistakes were fortunate because they completely overhauled the science of building and left us masterpieces such as the Medici Chapel and St Peter's Basilica in Rome.

From the Medici Chapel, Michelangelo went on to start the Laurentian Library in 1525, though we owe completion in 1560 to Ammannati and Vasari. Here again, Michelangelo's product triggered bitter reproach: the columns were packed too tightly, the staircase was but a thinly disguised booby trap and more. The design was indeed bold and high-powered. His blend of Serena stone, light marble, and white walls achieves true elegance.

It was in Rome that Michelangelo stood out as the founder of a new school of architecture. Like Raphael, he devoted his last years to that discipline and Michelangelo went on to take over completion of St Peter's Basilica from that fellow master.

Michelangelo's first major commission was for redesign of the Campidoglio but work dragged out long enough for several successors to denature his original project. Work on

Palazzo Farnese, main corridor of the piano nobile, Rome, 1517. (opposite)

**Étienne Dupérac,**
*Michelangelo's Project for Saint Peter's*, 1568. (above)
Engraving.
Bibliothèque nationale, Paris.

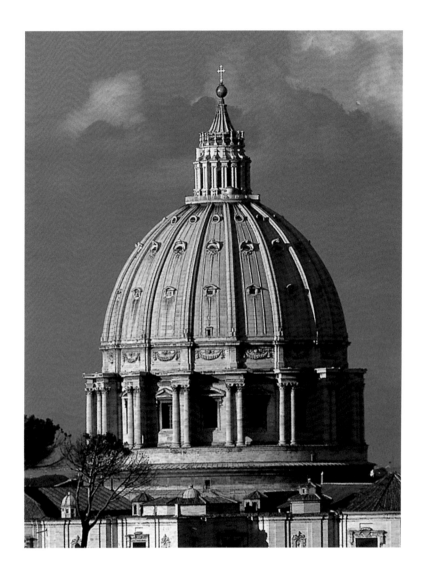

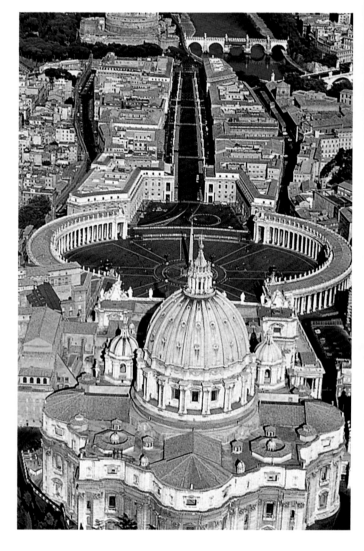

Aerial view of the Basilica of St Peter, Rome.

View of the dome of St Peter's Basilica, Vatican, Rome, 1546-1564.

View of the dome of St Peter's Basilica, Vatican, Rome, 1546-1564.

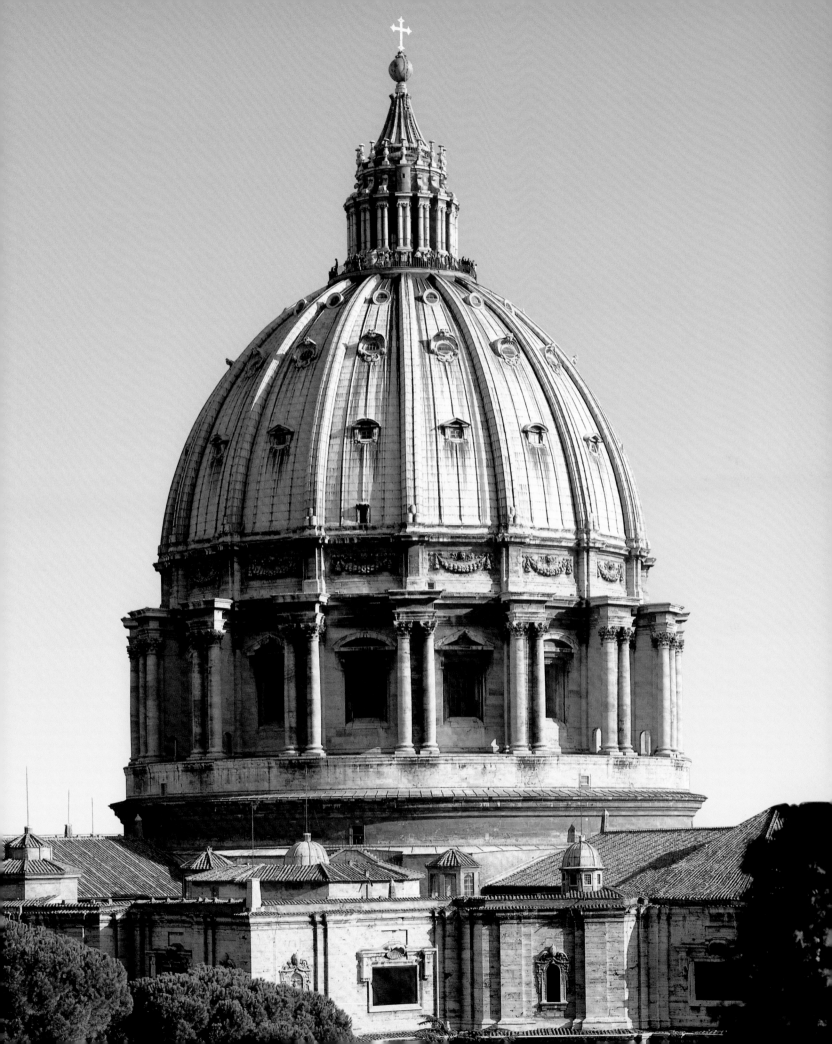

In architecture, Bramante was undeniably second to none since Antiquity. He did an initial project for San Pietro [St Peter's Basilica] exempt from confusion, which was clear and simple, clear in every aspect and isolated on all sides, such that the church would nowise detract from the [Vatican] palace. This project was always considered a work of beauty and everyone who deviated from Bramante's layout, as Sangallo did, deviated at the same time from truth.

Although he merely saw himself as the executor of Bramante's project, Michelangelo nonetheless left his brilliant, despotic mark on the structure: he grouped together the elements more tightly as he replaced Bramante's clean elegant lines with more vigorous, arguably more heavy-handed reliefs.

There is much to write on this vast worksite that spanned 16 years of the artist's life but the most beautiful and grandiose achievement was the cupola that would become the prototype for hundreds of others and would overshadow Brunelleschi's octagonal cupola for the Dome of Pisa. Where Brunelleschi's work shows painstaking calculation, Michelangelo's peerlessly suave lines reflect the spirit of an artist. As Charles Garnier wrote:

> It is the curve given to the cupola that charms, seduces, and makes this crowning achievement unique in the world ... creation of majestic harmony; it's this curve, so often studied, that has been called a *chainette*, parabola, and ellipse – it is all of this yet amounts only to a stroke of emotion or a bolt of lightning sired by genius.

Of course, it is impossible to employ mathematical formulae here. Rarely did the Late Renaissance allow imagination so much prominence alongside science. But Michelangelo would never experience the satisfaction of contemplating the finished product: work had only reached the drum (cylindrical substructure of the dome) when the artist passed away although it took Giacomo della Porta just one year to complete the project.

Michelangelo's final years also saw transformation of the Diocletian Baths and annexed convent for the Santa degli Angeli Church and the Porta Pia Gate.

the piazza had barely begun when Paul III asked Michelangelo to help with the entablature for the Palazzo Farnese. We know how his cornices of matchless proportion and fullness were installed in preference to those of Sangallo, the official palace architect. Moreover, Michelangelo supplied a design of Corinthian inspiration for the upper level facing the courtyard. Here the sense of proportion and ornamentation all command respect. The rear façade and loggia giving out onto the Tiber River neatly clone Michelangelo's motif for the uppermost tier of the courtyard.

Sangallo's death in 1547 handed over the St Peter's worksite to Michelangelo. With his characteristic individualism, Michelangelo pleaded the case for his enemy Bramante's original project and secured its acceptance to supersede Sangallo's. Then we have this odd remark to Ammannati written just before setting to work:

Detail of the dome of St Peter's Basilica, Vatican, Rome, 1546-1564.

View of the dome of St Peter's Basilica, Vatican, Rome, 1546-1564.

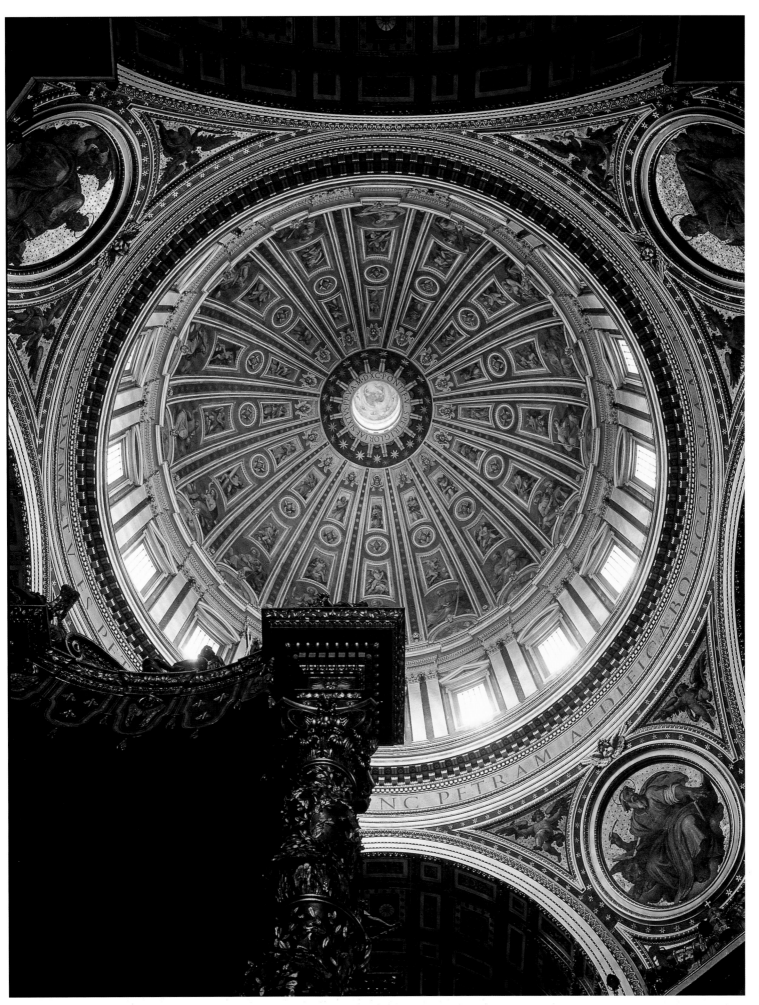

Irresistibly drawn to architecture, Michelangelo designed a host of gigantic projects that never took off because of their vast scale. One project would have extended the arcades of the Lanzi loggia at the Piazza dei Signori in Florence and installed in the Belvedere Fortress a fountain consisting of a rock and statue of Moses, from whom water would flow. Another project was for a bridge from the Palazzo Farnese to the Villa Farnesina. All of his projects show a passion for colossal sizing on a scale no human being had ever attained.

Alessi and Della Porta are among the few students Michelangelo trained personally but his teachings dominated the entire 16th and 17th centuries and this makes him the true father of Baroque. Here again, a distinction needs to be made between the master's oeuvre and those of his disciples. Michelangelo's style contained the germs of most dangerous tendencies but it is unfair to blame him for the abuses of his less gifted imitators.

One assistant of Michelangelo's who was to embody a new trend in architecture was Jacopo Barozzi (1507-1573). After vacillating between painting and architecture for several years, Barozzi finally opted for the latter and need never have regretted the choice. His enviable works covered both France and Italy and, upon Michelangelo's death, he would succeed him as chief architect of St Peter's Basilica in 1564.

Barozzi's love of regularity, balance, and proportion characterise this painstaking codifier, but he was admittedly heavy-handed in his exceedingly spare recourse to openings, after the fashion of 15th-century Florentine art. Vignola grounded his talent in science and rational thinking, perhaps making it incompatible with the expression of emotion, and his pride exceeded his gracefulness. It is difficult to find nourishment for the heart in his works: everything reeks of mathematical calculations in this creator of the academic style.

Late Renaissance works typical of Ancient Roman architecture had lost the spirit of their era. The transition to Baroque, long held in low esteem, ushered in tasteless heavy-handed forms of lopsided bias into colour and movement at the expense of rhythm and harmony. Initiated by Michelangelo and Palladio, it was a facet of the decline of the Renaissance and we are left to wonder how Michelangelo himself might have evolved out of Baroque.

Porta Pia, Rome, 1561. (opposite)

View over the Via and the Porta Pia. (above)
Fresco.
Latran Palace, Salla all Coneistroro, Florence.

# CONCLUSION

Michelangelo was a complex, well-rounded artist of many talents who surpassed all his 16th-century peers. However, he was also born into a period favourable to the full forceful deployment of his genius thanks to the spadework of his predecessors. He was also a moody loner and workaholic. Very pious and spiritual, he was not immune to Savonarola's fundamentalism and it influenced his oeuvre. *The Last Judgment* (p. 132) neatly illustrates the torment of an artist at death's door. His many over-muscled macho nudes reflect homosexual tendencies which troubled him deeply and if Renaissance Florence tolerated this sexual orientation, the Vatican did not, thereby further aggravating his inner conflict.

He also was lucky to experience first hand the wealth and freedom of the city's elite and their lifestyle. The Popes, the Medici, and other prominent families were perfectly suited to their role of art patron, essentially driven by motives of vanity or pleasure for its own sake. This explains the high degree of trust and intimacy in the bonding between artists and their patrons. Of course, artists buttered their bread with commissions and even Michelangelo had to bend to their wishes — witness the tomb of Julius II that went unfinished over some forty years, plus the protracted renegotiations with his heirs.

Since Michelangelo's time, 'Medici', 'Renaissance', and 'Florence' are inextricably anchored in the collective mind. The Renaissance heralded the rise of reason. It was the triumph of logic, perfection, beauty, and the quest for ideal values. This was the context into which Michelangelo evolved and he would revolutionise art in the 16th century. The Renaissance was no exception to the inevitable bell curve of rise, zenith, and decline. Moreover, the foundation of schools responded to the need for rules and authority symptomatic of any institution that has topped out. As creative drive started tapering off, it was replaced with a set of rules and guidelines. A huge gap arose between the ancient guilds with vested interests or religious obligations and the new academies that were asserting their right to legislate standards for good taste. The Florentine school was founded in 1563 and headed by Vasari. The Renaissance started into the down-slope as Mannerism was getting into its upswing. Generally admitted to be a decadent form of Italian Renaissance art, Mannerism is the

**Auguste Rodin**, *The Thinker*, 1881. (opposite)
Bronze.
Musée Rodin, Paris.

**Auguste Rodin**, *The Man with the Broken Nose*, 1864. (above)
Bronze, 26 x 18 x 23 cm.
Musée Rodin, Paris.

baseline for the start of the Late Renaissance. Mannerism took a tangent into France where it evolved into French Classicism.

In the late 15th century, Savonarola fought lust and libertine morals in a bid to steer Florentine civil society and the clergy back into acceptable standards of morality, a task that fell to the Vatican in the last half of the 16th century. Early in that century, Julius II wanted to tear down St Peter's Basilica and commissioned Bramante to rebuild it, a project he financed through sale of indulgences only to attract all the fury of Martin Luther. In 1517, Luther's 95 *Theses* threw Catholicism into a crisis which became the Reformation. Paul III responded by convening the Council of Trent in 1534 that launched the Counter-Reformation. By 1563, the Council had hammered out a decree for a cleaner church and government. Meanwhile, the Society of Jesus was founded as an arm of the papacy and it enabled development of a new emotionally charged art form called 'Baroque' or 'Jesuit' art. It thrived throughout the 17th century and was intended to stimulate a mystical approach to God (the term 'Baroque' first appeared only in the 19th century). Baroque is the art of sensory overload: it is a mix of wild imagination, boldness, eccentricity, luxuriant decors, hallucination, and sensuality. Michelangelo himself initiated this with his contorted torsos, action poses, and wide palette of colours. Based in Rome, Baroque became the official style of the Counter-Reformation; two leading artists of this period are Gian Lorenzo Bernini and Francesco Borromini. Despite Bernini's high reputation, King Louis XIV and his finance minister Jean-Baptiste Colbert abandoned a costly project to have him rebuild part of the Louvre in Paris that had caught fire – after the artist had come to France. Cost aside, neither Frenchman wanted an art style that matched Vatican blessing and the French sovereign did not like to share the spotlight. As a result, Baroque never took hold in France but then again this art style disorients the ration-based balance-seeking Cartesian mindset of the French anyhow. Baroque is too playful and perhaps even pathologically imaginative.

19th century France was anti-Classical and anti-Baroque, even if Théodore Géricault did not hesitate to paint his *The Raft of the Medusa* (1819) right after returning there after a month spent studying Michelangelo's works in Florence. The intertwined bodies in that work distinctly recall those of Michelangelo. Finally, Auguste Rodin stands out as a worthy spiritual heir of Michelangelo, Bernini, and Antiquity. Like Michelangelo, Rodin became famous in his lifetime after dropping out of the Beaux Arts, the French national art school. Undaunted, he scraped together his art education single-handedly through long sessions at the Louvre Museum studying Michelangelo's *Slaves* and the works of Antiquity – he, too, had a photographic memory. There is also the strong likeness of Rodin's *Man with a Broken Nose* to Daniele da Volterra's *Portrait of Michelangelo* based on the death mask. Like Michelangelo, Rodin aslo developed an affinity for muscular macho males in the nude. He left works unfinished, including his *Bronze Age*, which he abandoned in Brussels in 1875 to head for Italy early in the following year. He arrived in Florence in the midst of celebrations for the 400th anniversary of Michelangelo's birth right after inauguration of the Casa Buonarroti, entirely dedicated to the hometown hero's works. Already 36 years old, Rodin was very impressed that the works he saw were the products of someone so young. He pored over the Medici Tombs, Bargello, and Accademia before continuing to view the masterpieces of Antiquity in Rome and Naples. It is fair to say that Michelangelo was Rodin's master. They both manipulated body movement to enhance the expression of emotion and emphasise musculature. Upon his return to Paris, Rodin went back to *Bronze Age* and we find he demonstrates the same sort of feisty drive that inhabited Michelangelo. Rodin's unfinished *Gates of Hell* recalls Michelangelo's style in several ways. His *Thinker* instantly connects to the *Pensieroso*. However, Rodin's style is sufficiently personal for him to escape classification as an imitator but the Michelangelo touch is arguably implicit in Rodin's oeuvre. Both sculptors triggered advances in modern sculpture, both were haunted by the search for perfection in the human body, and their works burn with inner rage. Both became famous in their lifetime, secured the esteem of their peers, and made a fortune.

Michelangelo's oeuvre is classified as Florentine Renaissance art under the Medici and Baroque under the Popes. He has become an immortal legend while his brilliant and prolific oeuvre continues to ride on the momentum of 500 years of worldwide acclaim.

**Auguste Rodin,** *The Gates of Hell*, 1880-1917.
Bronze, 635 x 400 x 85 cm.
Musée Rodin, Paris.

*The Publisher*

# BIOGRAPHY

1475
Born 6 March in Caprese, Tuscany, second child to Lodovico di Leonardo Buonarroti Simoni and Francesca di Neri di Miniato del Sera.

1481
Enrollment in Francesco da Urbino's Latin school following his mother's death.

1483
Birth of rival, Raphael Sanzio, in Urbino.

1488
Start of a three-year apprenticeship under Domenico Ghirlandaio.

1489
Stays with Bertoldo in the Medici gardens near San Marco where he studies its ancient and contemporary works of sculpture.

1492
Death of Lorenzo de Medici; completion of *Battle of the Centaurs, Madonna of the Stairs* (*Madonna of the Steps*) and a wooden crucifix for Santo Spirito in Florence.

1494
Flight to Venice and Bologna as the armies of Charles VIII threaten to take over Florence and rumours predict the imminent fall of the Medici.

1496
Arrival in Rome to become a protégé of Jacopo Galli, who commissions his *Bacchus*; completion of *Sleeping Cupid*, now lost.

1498
Commission from Cardinal Jean de la Grolaye de Villiers for the *Rome Pietà*.

1499
Death of Cardinal Bilhères shortly after completion of the *Rome Pietà*.

1500
Creates altarpiece for Sant'Agostino in Rome as King Louis XII of France invades Italy.

1501
Return to Florence and commission for *David* in marble.

**1503**

Commission for statues of the Twelve Apostles slated for the cathedral dome in Florence – only sketches for St Matthew were ever completed; death of the 25-day Pope Pius III; election of Pope Julius II; commission for the *Bruges Madonna*; completion of *Tondo Taddei* and *Tondo Pitti*.

**1504**

Completion and inauguration of *David* at Piazza dei Signori; portfolio work for *Battle of Cascina*.

**1505**

Commission from Julius II for his tomb in Rome and the start of stormy relations with the Vatican; subsequent stay in Carrara to secure the marble needed.

**1506**

Return to Florence.

**1507**

Execution of *The Holy Family (Tondo Doni)* for Agnolo Doni (possibly completed within 1503 and 1505).

**1508**

Arrival in Rome to paint the Sistine ceiling.

**1509**

Start of decoration work for the Stanze of the Vatican, concurrent with the Sistine worksite.

**1512**

Unveiling of the new Sistine ceiling.

**1513**

Death of Pope Julius II and election of Leo X, son of Lorenzo de Medici; renegotiation of the contract for the tomb of Julius II.

**1515**

Leo X dubs Michelangelo Count Palatino.

**1516**

Return to Florence; commission from Leo X for the façade of San Lorenzo.

**1520**

First drawings for the Medici Chapel.

**1521**
Death of Leo X (Giovanni de Medici) and election of Hadrian VI; Michelangelo receives no Vatican commissions and works on the Medici family tombs.

**1523**
Election of Clement VII (Giulio de'Medici)

**1524**
Start of *Dusk* and *Dawn* for the tomb of Lorenzo de Medici and a commission for the Laurentian Library.

**1527**
Sack of Rome; flight of the Medici.

**1528**
Almost one year of army engineering, urban planning, and architecture to defend Florence from the Medici.

**1529**
Appointment as army engineer in the Nove della Milizia, the nine-man military leadership of the Florentine armed forces.

**1530**
The Medici retake Florence; commission from the Duke of Ferrara for *Leda and the Swan* – highly acclaimed and now lost; execution work on the Medici chapel.

**1531**
*Noli me Tangere* portfolio.

**1534**
Final goodbye to Florence; death of Pope Clement VII and election of Paul III who commissions *Last Judgment*; permanent residence in Rome.

**1536**
Start of *Last Judgment* for the Sistine Chapel.

**1538**
Completion of working drawings to install the statue of Marcus Aurelius in Campidoglio.

**1541**
Inauguration of the *Last Judgment*.

1542

Worksite start-up for the Pauline Chapel.

1545

Completion of the tomb for Pope Julius II, one of Michelangelo's most time-consuming achievements.

1546

Appointment as chief architect to St Peter's in Rome; work on St Peter's and the Farnese Palace.

1547

Death of Vittoria Colonna, long-time friend and accomplished poetess, whom he met while working on the *Last Judgment*.

1549

Death of Paul III and election of Julius III; reconfirmation of the artist's commissions.

1550

Completion of the Pauline Chapel frescoes; start of the *Florentine Pietà*.

1552

Completion of the Capitoline stair.

1555

Death of Julius III, followed by Marcel II and Paul IV; reconfirmation of his appointment as chief architect of St Peter's.

1556

Flight to Spoleta from Rome, now under threat from the Spanish Army.

1560

Drawings commissioned by Catherine de Medici to glorify her husband, King Henry II of France; design of a tomb for Giangiacomo de'Medici di Marignano and drawings for the *Porta Pia* – a hectic year.

1563

Appointment by Cosimo de Medici as "head" of his newly-founded Accademia in Florence.

1564

Council of Trent orders moralistic touch-ups to the *Last Judgment*. Dies at home in Macel de Corvi three weeks later on 18 February 1564 of a "slow fever", according to Vasari.

# INDEX

## S

## T

## V